BARBARA HEPWORTH

A. M. HAMMACHER

Revised Edition

181 illustrations 18 in colour

THAMES AND HUDSON

Translated from the Dutch by
JAMES BROCKWAY

Epilogue translated by
MARY CHARLES

Any copy of this book issued by the publisher as a
paperback is sold subject to the condition that it
shall not by way of trade or otherwise be lent,
resold, hired out or otherwise circulated without
the publisher's prior consent in any form of
binding or cover other than that in which it is
published and without a similar condition
including these words being imposed on a
subsequent purchaser.

ISBN 0-500-20218-4

Printed and bound in Singapore by C.S. Graphics

Contents

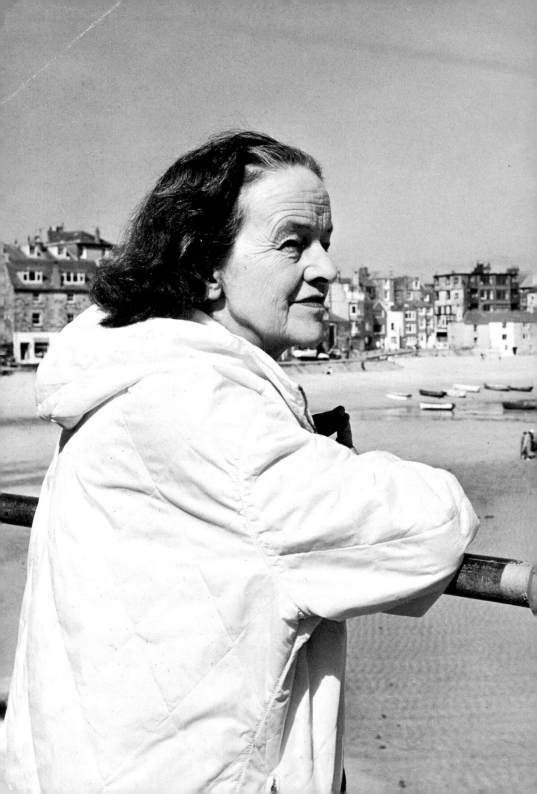

Introduction

The first world war did not leave artistic life in England unaffected. Slowly, laboriously, it emerged from the rarefied atmosphere of *fin de siècle* art, which, in this insular society, still prevailed as late as 1914.

In Chelsea this style of art had been associated with the names of Whistler, Wilde and Henry James, while in architecture Voysey and Mackintosh – to leave Morris and his circle out of the discussion for the moment – had introduced a new look, both indoors and out, which was echoed on the Continent. Figures of such diverse talent as Sargent and Sickert represented the world of painting. One has only to read the diary and correspondence of a man such as Ricketts to realize how richly differentiated yet art-minded in a picturesque sort of way, how refined yet creatively debilitated, artistic and society life were right up to and, indeed, well into the twenties. Add to this – though it should really have been mentioned first – the Bloomsbury group, where the tone in art and criticism was set by Roger Fry, and of which Virginia Woolf and her husband, Leonard, Clive and Vanessa Bell, Duncan Grant and others were the luminaries, and this highly cultivated scene would seem to leave little to be desired. Yet that little proved to be of vital importance. The preoccupations of the period were determined by the Shannon-Ricketts mood of nostalgia for the past, by the definitely more forward-looking Bloomsbury group and, where art was concerned, by post-impressionism. Fry introduced Van Gogh and Cézanne, gave the English a glimpse of the Negro art of Africa, organized exhibitions in 1911 and 1913 which featured cubism – but as a painter he did not break new ground, while as a critic, though discriminating, he was not truly identified with the aspirations of the younger generation, with cubism, futurism and pure abstract art.

7

Had it not been for the vorticist movement, had not Wyndham Lewis, Ezra Pound, Epstein and Gaudier-Brzeska, in the magazine *Blast*, promoted the active, more militant spirit of futurism and cubism, the prevailing mood of refined contemplation would have persisted; the new unrest of a turbulent age would not have found expression.

But Gaudier-Brzeska died on the battlefield in France and the poet and philosopher T. E. Hulme perished too. At this time Epstein began to concentrate on the production of bronze heads and busts, on portraits, although he did not abandon carving in stone. In the work of David Bomberg (1890–1957) and others, painting, it is true, made remarkable strides in the direction of abstract art between 1912 and 1914, whilst Wyndham Lewis (1884–1957) introduced an uncompromising rhythmic violence into his pictures. In 1915 Edward Wadsworth (1889–1931) was engaged on abstract compositions. Cuthbert Hamilton (1885–1959) and Lawrence Atkinson (1873–1931) contributed to an active modernism that had its own English emphasis, quite distinct from what was being done in France. But these were sporadic outbreaks, individual and unco-ordinated, so that by the end of the first world war in 1918 there was still no evidence of a concerted modernist movement in British art, comparable with that which was developed in Paris. Admittedly, this is in the nature of a generalization, and further facts may still come to light which will lead us to modify our views in one or other particular. Yet nothing can alter the fact that, viewed in an international context, no major influence was excited by the British modernist movement as represented by Roger Fry and his associates on the one hand or the vorticists on the other. The Shannon-Ricketts idea, whose supporters recoiled from what they saw as an approaching era of cynicism and barbarism, was clearly played out. As Ricketts wrote: 'music has consoled me most and I have used it much as a man uses a narcotic or as an opium-eater goes to his opium den'.[1]

The situation in architecture between 1900 and 1914 was little better. After 1900 the powerful impulse which had gone out from England between 1885 and 1900 and made its influence felt on the Continent, especially where interiors and country houses were

concerned, seemed to have lost its impetus. Nikolaus Pevsner has summarized the situation excellently:

> There was in England between 1900 and the last war neither an architect at the same time as revolutionary and as consistent as Garnier and Loos, nor a movement as widespread amongst the architects of the generation just coming to the fore as that leading to the formation of the Werkbund in Germany. But there were a few individual architects working independently of each other and carrying out designs just as advanced or nearly as advanced as those Continental and American examples, which appear in the textbooks to illustrate early twentieth-century architecture at its most adventurous.[2]

He adds: 'A tradition of contemporary forms was still entirely absent ten years after the end of the last war, which applies to the situation in related fields as well.' None the less gifted young people were already preparing themselves for the task of creating a contemporary English architecture and they were beginning to make a name for themselves, as were certain sculptors and painters, among them Leslie Martin and Maxwell Fry, Wells Coates, Colin Lucas, Amyas Connell, Owen Williams, Christopher Nicholson (the brother of Ben).

Unlike in the world of letters, where by 1918 she was occupying a leading place, England had to wait for more than a decade for the visual arts, which had been fermenting beneath the surface, to throw up new and original talents.

Three such figures, who were to influence the whole course of British art, were even then laying the foundations of their brilliant careers: Herbert Read, Henry Moore, and Barbara Hepworth, all of them, curiously enough, in the provincial milieu of their native Yorkshire. But it was in all probability this very independence of an urban environment, away from the all too self-conscious and tired aesthetics of the Bloomsbury group, that enabled them to develop along their own individual lines.

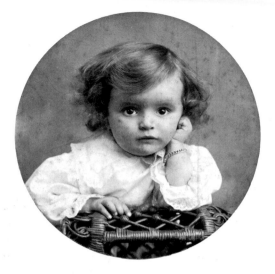

3 Barbara Hepworth, aged 2½ years

4 Herbert R. Hepworth CBE, aged 21 years. 5 Barbara Hepworth, aged 3 weeks, with her great grandmother, grandmother, mother and father

Early Years in Yorkshire and London

In the year 1919, a determined young girl of sixteen, Barbara Hepworth, went to see her headmistress, Miss McCroben, at the Girls' High School in Wakefield, to tell her she had decided to become a sculptor; she had no wish, she said, to go to university, which in any event would put a strain on her parents' limited means.

Miss McCroben must have been an extraordinary woman, capable of detecting her pupils' special gifts and guiding them, where possible, into the proper channels. For she not only encouraged Barbara's independence of mind but took active steps to secure a scholarship. These, in a sense, were decisive factors in determining the young girl's future.

There are other known instances of a percipient teacher intervening with happy results between hesitant parents and the growing desires, the dreams and aspirations of a young person destined to make a name in the world. In the case of Henry Moore there was a certain Miss Gostick, who played much the same role. Such people are deserving of our recognition and gratitude.

Thanks to Miss McCroben's help and encouragement, and to her own determination, Barbara won a scholarship to the Leeds School of Art in 1919; there she joined Henry Moore, who was studying sculpture. Earlier that year her grandfather had taken her with him to Paris, where she availed herself of every opportunity to escape from her escort in an attempt to observe something of the art world and the street life of the French capital. Thus she was not entirely uninformed about what was going on in Paris in the immediate post-war years, since she made a point of renewing her aquaintance with that city during her vacations while at art school, and after.

There had been no tradition of sculpture, indeed a complete absence of an artistic background, in the Hepworth family. It had

produced doctors, civil engineers, but not a single artist. The home in which she had grown up was scarcely of the kind likely to inspire artistic contemplation or artistic feeling. Before long the difference in outlook between parents and daughter was beginning to manifest itself. When, on a visit to London, her mother showed her the Albert Memorial, expecting her to admire it, Barbara's disillusioning response was, 'Oh, how frightful!'

Her father, Herbert H. Hepworth was a civil engineer in the West Riding of Yorkshire, who by dint of hard work and application ultimately reached the top of his profession. The four young children had to do their homework in a comparatively small living-room, while mother worked at her sewing-machine and father sat huddled over his textbooks. It was difficult, in these circumstances, for them to concentrate on their work. The parents realized that despite their limited resources they ought to do their utmost to encourage the artistic leanings of at least two of their children. Barbara was the eldest and shared a pronounced enthusiasm for eurythmics and music with one of her sisters, Elizabeth. She was allowed to take music lessons and for some years learned the piano. As might be expected music has continued to play an essential part in her life.

At school she took a lively interest in Greek, but showed little liking for Latin. She seemed to have no difficulty at all with mathematics and geometry, including solid geometry. But it was extra-curricular subjects such as drawing, painting and sculpture that soon began to claim her passionate attention. For the summer holidays the family often went to Robin Hood's Bay, a place frequented by painters, and here was born her deep-rooted desire to enter their world, which at this time was associated with the aroma of turpentine and oil, an aroma she still finds evocative and nostalgic.

In the company of the other schoolchildren she proved reserved. Aware at an early age of being different from the rest, who were quite happy to occupy their leisure hours with games, she tried to draw and paint in an attempt to get beyond her immediate surroundings. As subjects Barbara chose bones and anything anatomical she could get hold of; she also collected seaweed. White mice fascinated her particularly by their quick, agile movements.

6 Barbara Hepworth, aged 10 years *7 Barbara Hepworth, aged about 18 years*

She speaks warmly of her family life and recalls her father with particular affection; to her he always seemed to represent the ideal, poised, self-controlled and bringing a proper sense of proportion into their lives. Never did she see him angry or hear an unpleasant word pass his lips. He enjoyed taking his eldest daughter along with him on his tours of inspection through the countryside, for which purpose he used a car – still a comparative rarity before the first world war.

When at a later stage we see her art becoming non-figurative, this was part of a trend which she shared with a number of her contemporaries. Yet, even in these early days, she had shown leaning towards the abstract; mathematics was a source of stimulation. Thus,

before she had had an opportunity to become acquainted with the continental movements that were evolving an abstract art, her father's work had already familiarized her with designs for bridges and roads. This familiarity with technical drawings may have played as important a part in her development as the aesthetic theories of art movements, in particular those for which the Russian constructivism of Gabo and Pevsner had paved the way.

It was at the age of sixteen that Barbara entered the Leeds School of Art, to become a fellow-student of Henry Moore, who was five years her senior. Whereas Moore was greatly helped by Michael Sadler, the then Vice-Chancellor of Leeds University, who owned one of the finest collections of works of art in Great Britain, Barbara benefited less from this contact. This was no doubt owing to the fact that, as Moore has pointed out, in those days a young woman studying sculpture was not taken seriously.

The sculpture course turned out to be shorter than had been foreseen. 'What was ordinarily supposed to be a two-year examination course I squeezed into one year and in it was a Royal Exhibition, which was a scholarship,' Moore is said to have remarked.[1] And in 1920 Barbara too, instead of doing the compulsory two years, was allowed at the end of her third term to go up to the Royal College of Art in London with a similar senior scholarship.

In 1921 the Principal of the Royal College of Art was William Rothenstein, who showed a considerable, spontaneous and generous interest in the two newcomers. He held 'at homes' and Henry and Barbara were often among the younger guests. The actual teaching was, in truth, still conservative and academic.

In London, where she lived in a small room, she soon became aware of conflict between the conventional advanced teaching of art and those who sought a freer, more direct, more essential form of artistic expression. There was one member of the College staff, however, who formed the exception. Leon Underwood's fervent interest in, and thorough knowledge of, African plastic art is well known. True, he did not give lessons in sculpture, but in drawing. Yet his views must have differed from those of the majority of his colleagues, as his own work in sculpture attests. It cannot be said of

Barbara Hepworth (as it can of Henry Moore, even in his early days in Leeds as a result of his contacts with Michael Sadler) that she had been deeply moved by non-European sculpture. Henry Moore, for his part, had fallen under the influence of Roger Fry's books on art and especially of his assertions with regard to Negro art. On this score, too, Barbara Hepworth's sensibilities prove to have been both of a different kind and differently orientated. She even had an intuitive antipathy towards the Bloomsbury group.

Gaudier-Brzeska must have made a far greater impression. Although he died early on in the war, 1915, the vorticist movement and Ezra Pound's book on Gaudier, published in 1916, were not without their effect. Moreover, his work found an early and loyal admirer in the critic, Haldane MacFall and especially H.S.Ede, who had worked at the Tate Gallery, collected examples of his work, and in 1930 published a life of the artist. Ede, who had friends in the circles in which Barbara Hepworth and Ben Nicholson moved, was in the habit of showing Gaudier's works to as many people as possible. Thus these sensitive and gifted young people cannot possibly have failed to encounter it. The doves which Epstein sculpted in 1914 are sometimes supposed to have owed their existence to Gaudier's influence,[2] but this has still to be proved. Stylistically, Epstein's work lacked that degree of sensitivity which characterized Gaudier's. However that may be, there was a Brancusi-Epstein-Gaudier impetus. Henry Moore and Barbara Hepworth undoubtedly became acquainted with Epstein's simple, stylish and tense forms; these were among the few works in London that exhibited certain features to which the younger artists of the day, restless and discontented within the walls of the Royal College of Art, themselves aspired.

During the period of almost three years spent at the Royal College, Barbara Hepworth – and Henry Moore, too – were unable to resist the temptation to try their hand at carving in stone. This craft was not taught at the time in the colleges of Europe, where it was believed that modelling in clay constituted the best introduction to sculpture. The example set by Rodin with his powerful sculpture had, for that matter, done much to preserve this Renaissance tradition.

15

8 The hands of the sculptor, 1960

Carving and 'Truth to Material'

At the time of writing, the 'truth to material' concept has been abandoned by some of the present generation of sculptors. This shows not merely how relative all convictions are, but also how essential to one's concept of form some knowledge of the nature of the artist's own relationship to his material and his understanding of it is. Carving and 'truth to material' involve more than the artist's attitude to art and technique, they involve his basic attitude to life as well.

It so happens that we have been provided – by what Barbara Hepworth and Henry Moore have said on the matter – with clear expositions by the artists themselves, thus enabling us to trace the doctrine's English phase almost from its very source; this unique circumstance would seem to justify an interpolation here, giving a brief account of its history.

The campaign against modelling in clay as an initial stage prior to transferring the modelled form to the stone with the help of the pointing machine, coincided with the movement away from impressionism in the direction of symbolism, and the subsequent reassessment of all nineteenth-century doctrines in the light of the 'isms' of the twentieth.

No one will deny that Degas's figures of ballet girls, which depended on his capturing the most characteristic stance or movement, would have been inconceivable without resort to modelling in clay. So much that was volatile was involved, so much of the fleeting, the mobile, that modelling in a malleable material was clearly the required technique. Where sculpture was concerned, the technique of modelling in clay undoubtedly belonged to the same category as that of the impressionist painters. But Rodin's intentions went beyond this. In romanticism he had formed an inspiring source of

motifs (from Dante and from history) and, thanks to the wide range of his interests, he possessed an understanding of the monumental sculptural art of Ancient Greece and the Middle Ages, both of which differed in the motifs employed and in their potentialities from impressionist sculpture.

Rodin did what the Italian, Medardo Rosso, avoided – he strained the technique of his day by aiming beyond its capacities. His group, *The Burghers of Calais*, on its venerable site on the bank of the Thames, with the Houses of Parliament for company, would be inconceivable in the absence of casting in bronze and its intermediate stage, modelling. Yet impressive as they are, these figures stand helpless in space. They become lost in their surroundings despite their dramatic power, which, in common with all dramatic gestures, soon exhausts itself in space. In any case, the *Burghers* lack all architecture, all relation to a setting.

Bourdelle, who was to introduce monumental sculpture after Rodin, was still influenced by him, yet perfectly understood what the age of impressionist modelling lacked, compared with that of the romanesque and gothic sculptors, who worked in stone. To us today it seems that it was the age itself which turned its back on impressionism.

The first wave of carving and 'truth to material' was inextricably associated with a revival of the architectural concept which might be termed 'the monumental'. The extensive knowledge of the Middle Ages of a man such as Viollet-le-Duc, is evidence that some awareness of this spirit had been present in France in the second half of the nineteenth century. In Germany, Holland, Belgium and Spain the efforts of the architects during the art nouveau period to free themselves from the historical style of nineteenth-century architecture coincided with the urge on the part of the younger sculptors (who had their medieval forerunners in mind) to start carving with their own hands. This coincidence did not, all the same, mean that every effort to arrive at the new involved art nouveau.

It was in this same period that, inspired by what he had seen of the Romanesque art and the folk-art of anonymous artists in Britanny, Paul Gauguin began to carve in wood and stone – mainly reliefs, a

type of work to which he reverted later in Tahiti. He, too, based his ideas, at least in part, on 'truth to material'. Limited though they may have been all these endeavours, made outside the academies and not by any means confined to the sculptors alone, signalled a gradually emerging, intuitive urge on the part of the artist to achieve direct contact with the material he was working in. The successes were limited and often achieved only after a number of abortive attempts.

All the same, it was accepted in principle, even prior to 1914, that this was the right road for art to take. Eric Gill (1882–1942) brought a more theoretical approach to the carver's craft, an achievement which, unfortunately, was not accompanied by any convincing creative ability *vis-à-vis* the material. Gill's architectural sculpture was as delicate as it was decorative, yet it lacked plastic strength.

In Paris, Brancusi became the persuasive advocate of carving, though his background differed from Bourdelle's. For Bourdelle bore witness to the old medieval tradition of France, seeing sculpture in the broad context of architecture, round which everything revolved. Brancusi, no less an artist with his roots in the crafts, was more independent of architecture.

We should make it clear, too, that at this juncture, when futurism and cubism were already astir, carving was not the only recognized method. For example, Boccioni was scarcely its advocate. In France, Duchamp-Villon, a figure of the utmost importance, had been no forerunner of the technique's revived prestige. Lipchitz would probably have taken it further, had not an injury to his arm prevented him from continuing. He succeeded more than anybody in proving that where sculpture is concerned a thorough knowledge of the craft of casting in bronze is no disadvantage. Zadkine, too, proved a true disseminator of long-established tradition, also in his teaching. Laurens and Csaky demonstrated the application of 'truth to material' to cubism too. Thus a climate had been created in which carving could evolve, even though the background varied from place to place. From the quiet of his studio, however, Brancusi passed the most critical and incisive remarks on the subject, purifying its practice of all rhetoric and portentous theorizing. What he had

to say was restrained, pointed and at the same time founded on principle:

> Working direct in stone or wood is the truest path to sculpture, but for those who have not yet learned to walk it is also the worst path. And in the last resort it matters nothing whether the sculptor works directly or indirectly; it is the finished work that counts.[1]

Brancusi at the same time voiced his criticism of Rodin, finding that in his marbles the material had been sacrificed to the anatomy,[2] and also his criticism of the nineteenth century.

So the first but short-lived influence Brancusi exerted in England was in the Epstein-Gaudier era (1910–14). We may infer from the fact that Ezra Pound wrote about Brancusi[3] that a few of the best minds in England were taking a deep interest in him. It was by a very circuitous route that knowledge of his manner of working in stone became known – through the *Head* which Modigliani had

9 Amedeo Modigliani. Head, c. 1913

10 Constantin Brancusi. Head of a woman, 1908

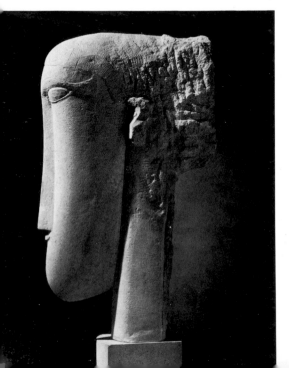

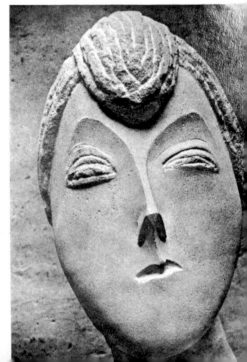

made in 1913 and which is now in the Tate Gallery. From 1922 onwards, the students at the Royal College of Art had had an opportunity of seeing this *Head*, since the College was housed in the same building as the Victoria and Albert Museum, where it was then on exhibition. With its stylized, mannered form, simple, taut, clean, it is *Ill. 9* sufficiently striking to convey the essentials of the concept, even to those who are unaware of the relationship which existed for years between the Italian painter-sculptor and Brancusi. Respect for stone as such is but one aspect of the form which has been conjured into existence here. A form which comes near to perfection, thanks to the restrained tension of the volume and the exceedingly sharp precision of the linear relief – the unusually long and thin vertical line of the nose, the minute, precious eyes, the shape of the mouth.

Thus the initial approach to carving and 'truth to material' was of a twofold nature. To some it seemed a means of reviving the old communion between architecture and sculpture, a means which failed to begin with, while to others it simply restored the physical and psychological contact with the material, without any reference to architecture. The resistance offered by the material was discovered to have an influence on the conception of form. There was a fruitful contact between the creative will of the artist and the forces, as it were, latent in the material. The subjection of the material by means of the pointing machine, whereby it had to take on the form predetermined by the artist's design, had come to an end. Instead a new dialogue had come into existence.

We are probably doing the versatile Eric Gill an injustice by failing to lay greater emphasis on the share he had in this revival. He was without doubt inspired by sincere principles of life and suffering. He is to be commended for reviving by word and deed the old craft of the wood- and image-carvers, in the spirit of the 'arts and crafts' idea and according to the principles of William Morris. Yet his voice lacked the almost magical ring of Brancusi's; he did not kindle the spark that sent Dobson, Skeaping, Moore and Hepworth upon their pioneering way as carvers in stone. His was the sensitive, backward glance at generally admired styles of the past, the refinement of a creative power which was indisputably tasteful yet which

lacked true force and met with no response from the younger generation.

From what both Henry Moore and Barbara Hepworth have told us, there can be no doubt that the impulse to embark upon the dialogue with stone carving came from within. It was taught by no professor, prescribed by no critic. It was a new physical and psychological experiment, an experiment rich in promise and warranted by examples from the ancient civilizations.

Thus the significance of carving and 'truth to material' entered upon its second phase. It was only then that the specific potentialities of twentieth-century sculpture employing this technique evolved an independent life of their own. Where Barbara Hepworth is concerned, the road thence led by way of Tuscany. Having obtained the Royal College of Art Diploma in 1924, a West Riding Scholarship enabled her to work and travel in Italy for a year.

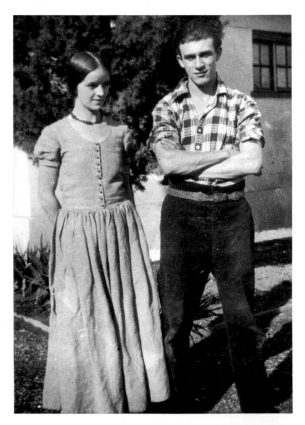

11 Barbara Hepworth in Rome with her first husband, John Skeaping, 1926

The Italian Intermezzo

This intermezzo was of great importance. Except for Paris, Barbara Hepworth had seen nothing of Europe and her first impressions of Tuscany were overwhelming. The quality and power of the light acted as fertilizing influences. They conferred on colour and form a new, a special value. After London and its traditional, grey weather of rain and mist – teeming with possibilities as they had been for Whistler, Sickert and the impressionists – to make the acquaintance of Tuscany was, to a young sculptor, like experiencing the rebirth of form, an intense, personal experience. The region, which had seemed oppressive to the vehement futurist living in Milan around 1914, was ten years later to prove a major stimulus to this young Englishwoman.

She rented rooms in a house situated between Florence and Fiesole, and from here she made her excursions, tirelessly absorbing the Early Renaissance in all its different aspects. Another student from London was staying in Italy at the same time, the sculptor John Skeaping.

Although neither of them had more than the meagre proceeds of a scholarship to live on, they were married in the Palazzo Vecchio in Florence. An impressive setting indeed for the wedding of two young people who had come here to breathe in the atmosphere of art, to explore the landscape of Tuscany and Umbria, and to prepare themselves to become sculptors!

Barbara must still have looked rather like some pre-Raphaelite figure in the perennial morning light of Tuscany, a region then highly rated and much frequented by everyone studying art or art history. For her the main attraction turned out to be the Brancacci Chapel with its frescoes by Masaccio.

Thanks to Ruskin, Giotto and Fra Angelico had for years been the goal of many an artistic pilgrimage, but Piero della Francesca and

Masaccio were genuine rediscoveries for the art world. Piero had, for that matter, already served as a pattern for Seurat, back in the nineteenth century. The collective worship of a few chosen masters of past ages is one of those curious phenomena which characterize a period. Apparently quite independently, and with all the fervour and conviction of having made some personal discovery, a student or practitioner of art will discover that a work or an architectural style belonging to the past suddenly answers his supreme artistic needs. Soon, however, he finds others with similar convictions and discovers that he is, to all appearances, no more than the instrument by means of which a period develops its own stylistic ideal or by which a group of like-minded persons sees its stylistic ideal realized or confirmed. Such encounters act at the same time as generative influences, promoting a sympathetic relationship to the particular work of art in question and its period, while not in any way diminishing the finely strung tension between past and present. The gulf which inevitably continues to separate what was from what is, which sometimes assumes the guise of a powerful nostalgia, is never completely bridged.

Masaccio's work as a painter was sculptural in nature. His figures were static, imposing, beautifully modelled and placed in relation

12 *Masaccio. The Tribute Money, c. 1427*

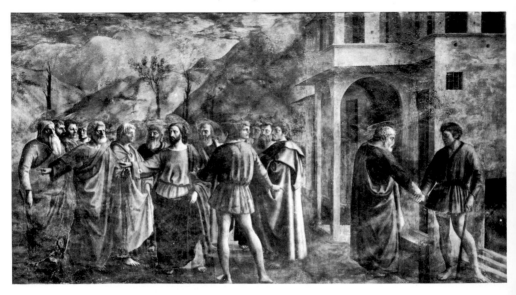

to the landscape and architecture in a manner that was both sensitive and carefully calculated. Their colouring made them seem almost *Ill. 12* tangible, yet by virtue of the way in which the wall has absorbed the colour, they are innocent of all emphasis. If there was a painter in this period, apart from Piero della Francesca, who was capable of fascinating a young sculptor, it was undoubtedly Masaccio.

In certain quarters, in short, a fresh wind was beginning to blow, a longing for purity of line and form was being wafted through the rarefied air. As yet it was tentative, and few were aware of it, but its effects could be detected here and there, in some utensil, some item of furniture, some unorthodox piece of architecture. At the great Paris Exhibition of 1925, at which the modern decorative style could be seen in full flower, it was still not clearly evident. Yet, aided by futurism and cubism, the quiet but powerful influence which emanated from the idea of abstract art had made itself manifest in sufficient measure to invest life in the twenties – wavering as it was between the decorative and the emphatically functional, and consequently still exceedingly variegated – with a new promise for the future. Clarity, purity, precision – at one and the same time ethical and aesthetic goals – went hand in hand with increasing inflexibility and ossification among those who refused to accept abstract art.

John Skeaping's scholarship enabled him to continue his studies in sculpture at the British School in Rome. But before they settled in that city the couple went, late in January 1926, to live in Siena for two months.

In Rome, the master-sculptor Ardini, from whom both received a thorough schooling in carving, did not confine his instruction to technical matters but also taught his students the importance of the artist's individual relationship to the marble, that everything he does in the way of carving from then on depends on his own personal attitude.

John Skeaping is to be classed among those sculptors who followed Gill and, later, Dobson, working in stone, marble and wood with love and understanding. Yet he and Barbara, approaching the problem from different angles, were eventually to tread quite different paths, even if this was not yet evident. About this time Skeaping

carved a head of Barbara in stone, which was later sold to Georges Eumorfopoulos, the collector; it disappeared after his death.

In Rome they lived in the British Institute, which is splendidly situated, next to the Galeria d'Arte Moderne, with a view over the Pincio Gardens and the Valle Giulia. This meant that they were in the vicinity of the rare collection of Etruscan art in the Villa Giulia Museum down in the valley. This Etruscan work likewise made an indelible impression upon the young sculptress.

But Barbara had to return to England for a while to meet her parents-in-law and visit her own family. It was necessary, too, for her to report to the Scholarship Board, give them an account of her stay in Italy and show them what she had accomplished there. Their astonishment and indignation were great when it turned out that she had nothing to show. There had been so much to see, to assimilate, so much to experience, she said calmly, that all her work was in her head. The fact that she had also got married while in Italy probably strengthened the Board in their conviction that here was no serious artist; there and then they decided never again to award a scholarship to a woman candidate. The couple returned to Rome for a time, in order to continue their studies, living on a mere pittance.

In the dark November of 1926 they returned to London for good. Italy had provided them with all the artistic and moral armament they required for the trial of strength which braving the art world of London, notorious for its uncompromising attitude, called for. Their period of apprenticeship was over; the creative years were at hand.

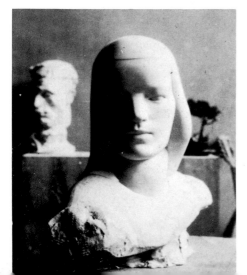

13 John Skeaping. Head of Barbara Hepworth, Rome, c. 1926

The First Exhibitions; The Emergence of the Hole

Since no art dealer was prepared to take the risk of holding an exhibition of John and Barbara Skeaping's early work, the artists arranged an exhibition themselves in their own studio in St Ann's Terrace, St John's Wood, in December 1927. It was there that they made their first contacts with people interested in what they were doing and with an art collector. Richard Bedford then Head of the Department of Sculpture at the Victoria and Albert Museum, a man of advanced views and himself an amateur sculptor, introduced them to George Eumorfopoulos, a well-to-do connoisseur of Chinese porcelain. Eumorfopoulos was on friendly terms with the staff of the British Museum and in particular with Laurence Binyon, the poet and author, a prominent figure in English life at the time and a connoisseur of Asiatic art. Binyon's young daughter, Nicolete, also came to know Barbara Hepworth and John Skeaping and their circle of young and as yet relatively unknown artist friends. Sir George Hill, Curator in the Coins Department of the British Museum, was interested not only in coins but also in sculpture – an exception in his day. It was he who took Nicolete Binyon, then scarcely sixteen years of age, to Barbara and John's studio, where she bought two drawings from them, one of a horse, the other of a hind. Hill gave her a drawing of a woman by Barbara, which she took with her when she went to study at Oxford University.

Eumorfopoulos bought *Seated Figure*, *Doves*, and two other *Ill. 14* carvings from Barbara. He was in the habit of holding an informal 'at home' for about twenty guests on Sundays, and Barbara was among the many young artists to be found there. His example acted as a stimulus; his collection of Asiatic art, coupled with the latest efforts of the younger artists of the day was something new and out of the ordinary for London. Not only did it possess novelty

value, but it provided an excellent yardstick. The value of these informal circles of friends, though they later split up, should not be underestimated. Sir Michael Sadler's circle, which meant a great deal to Henry Moore, was another instance. Sadler, more eclectic in his tastes than Eumorfopoulos, was primarily interested in English and French work; the gathering in his large and pleasant country house in Headington, Oxford also provided a stimulating artistic environment.

The second exhibition was held from 8 to 30 June 1928 in the Beaux-Arts Gallery in Bruton Place, Bond Street. It comprised thirteen sculptures and ten drawings by Barbara Hepworth, and also etchings and drawings by William E.C. Morgan and work by John Skeaping. It was at this exhibition that Nicolete Binyon, who was later to marry Basil Gray of the British Museum, formed a closer acquaintance with Skeaping and Barbara Hepworth. At her father's request, Skeaping made a portrait bust of her; this work, in a soft stone, remains impressive by virtue of its purity of style and its sensitivity.

It was this second exhibition which provided the first catalogue of Barbara Hepworth's works. There were two masks, two heads (a portrait from the E.M.B. Ingram Collection and one of Skeaping), a bust of a girl dancer and four bird figures (*Doves*, *Dying Bird*, *Fan-tail Pigeons* and *Goose*). Only two of the works shown were in bronze (*Bust of a Dancer* and the *Head of John Skeaping*). The predominence of marble over bronze indicates that from the very outset her work was based on carving. Where style is concerned, the bird motifs merit a careful study.

Ill. 14 *Doves* (now in the Manchester City Art Gallery) bears the date 1927 and was, in fact, sold to Eumorfopoulos from the studio in that year. One of the other works has been dated 1925–27. The earlier of these two dates falls during the Italian period when she was primarily dedicated to observing and absorbing Italian art and the landscape of Italy, becoming more active in the later period in Rome. Another item is dated 1926. All three were on show at the Beaux-Arts Gallery in 1928.

During the same period Henry Moore carved *Dog* in marble

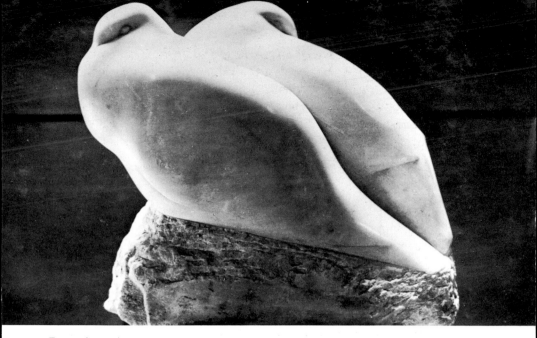

14 Doves (group), 1927

(1922), *Snake* in marble (1924), *Bird* in polished bronze (1927), *Duck* in cast concrete (1927), and *Head of a Serpent* (1927).

Neither the themes nor the style were peculiar to Moore or Hepworth. They had been developed by Gaudier and Epstein during the hey-day of the vorticist movement in London. Epstein had produced four versions of birds – ducks and doves. They were known as 'the masterpieces of Epstein's vorticist period', according to Richard Buckle.[1]

It is clear that at this juncture Moore and Hepworth were to a certain extent deriving their work from similar sources, having had the same training and both being drawn towards carving. Yet each was approaching the problems involved in a different way and a difference of emphasis was already discernible in their interests, Moore leaning more to Negro and Mexican art, while Hepworth was finding less to interest her in British and Italian museums, much as she had been attracted by the Etruscan art in the Villa Giulia Museum in Rome; the works of the early Cycladic carvers had made a great impression on her already at an early age.

15 *Seated woman, 1928*

It is proper to mention John Skeaping in this connexion as well. He was wholly receptive to what Gaudier had done, receptive, too, to the work of Modigliani and to African and Sumerian art. He was friendly with Epstein. The partnership of Skeaping and Hepworth contributed much to the art of that time.

Moore's *Snake* and *Standing Woman* of 1924 remind one chiefly of Gaudier, who seems to have signified far less to Hepworth. Epstein and Hepworth share the enclosed volume, the utmost simplification, the polished surface; but where Epstein is angular and sharp, Hepworth is smooth and flowing.

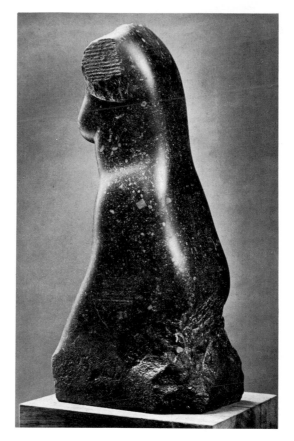

16 *Torso, 1927*

The masks invite comparison with those Moore made in the 1927–29 period. They confirm that the influence Mexico had had on Moore is absent in Hepworth, while, generally speaking, the physical impression influenced her vision more powerfully. This is clearly discernible in the difference in the treatment of the eyes. In Moore's there is a pronounced pattern for the form of the eyes and nose – the underside of the nose being a simple, triangular surface in which two holes have been bored, while the mouth is a brief slit. In Hepworth's everything is still permeated by an acute feeling for the physical, one detail flowing into the other. Moore's heads reveal a tendency to use

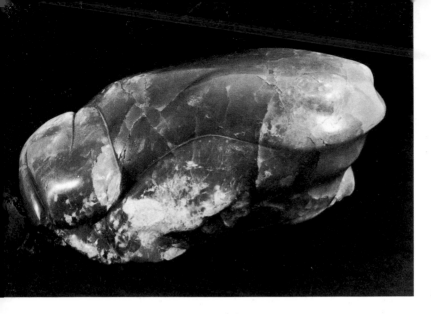

deformation for the purpose of increasing the work's expressive power, a feature hardly, if at all, present in Hepworth's. What the half-naked figures do have in common is the posture, the heavy hands folded under the breasts, the broad curves of the shoulders. Here, too, the nuances are subtle, yet an essential part of the work. Moore is almost brusque in the way he effects the transition from one member of the body to the other, in the contrast between the vertical and the horizontal, achieving a wholly monumental style, an architectural construction. Hepworth lays greater stress on the unity of each member, her transitions from the one to the other being smooth and harmonious.

In 1928 Barbara and John Skeaping moved house to No. 7, The Mall Studios, Parkhill Road, Hampstead. There they had a fair-sized studio and a garden where they could work out of doors.

Ill. 18 On 3 August 1929 a son, Paul, was born, of whom Barbara carved a likeness in wood, showing him with arms upraised, the same year. Their circle of acquaintances grew. What was taking place in art was no isolated development. It was merely one of the many outcrops of an unorganized movement of like-minded artists of highly diverse talents. Another important factor was that living environments, both

exterior and interior, were beginning to be modernized on fundamental lines, the furnishing included. So far it was no more than a beginning, and it was not until the thirties that this 'purifying' movement acquired any authority, thanks to the sustained and disinterested efforts of convinced disciples like Herbert Read.

Ten years after the end of the first world war, little had still been achieved in British architecture, as Nikolaus Pevsner has recorded (see p. 9). After 1925, however, there are signs of a renaissance in this important field, both in town and country. Admittedly Pevsner remarked that 'even when Peter Behrens built New Ways for Mr Bassett Lowke at Northampton in 1925 in what we now call the modern idiom, the bewildered citizens of Northampton did not know what to link it up with'.[2] But this German architect – he was a painter and draughtsman, too – product of the Jugendstil movement, who had played a significant part in Darmstadt and elsewhere, was not the first harbinger of new things to come in England.

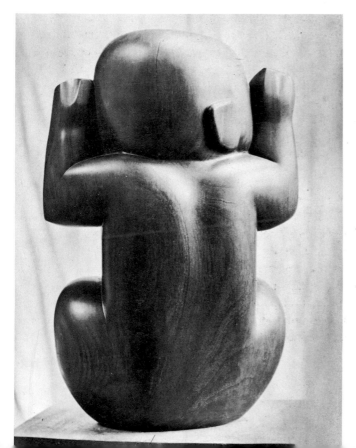

18 *Infant, 1929*

By 1923 Erich Mendelsohn was already becoming known for his architectural style and he attracted attention again in 1926 with his book about America. Gropius had been introduced to the readers of the *Architectural Review* in 1924, and Le Corbusier's growing reputation was now also beginning to be recognized in England. At the time no one could have foreseen that in the next decade this *avant-garde* of German architecture would be attempting to carry on in England the work they had begun in Germany, forced into exile there by the impossible situation created by Hitler and the Nazis.

In the late twenties, however, things had not yet got this far. Fresh talent was being discovered among the younger generation of English architects, some of whom were to forge links and become

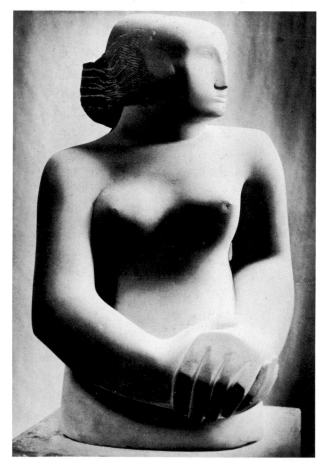

19 Figure of a woman, 1929–30

friends with certain artists during the years 1930–33. The École de Paris, steadily growing in stature, was arousing more and more interest. For Londoners the theatre and the ballet were useful sources of information about what was happening in music and décor, working in conjunction with the École de Paris.

Even though little was known as yet about Naum Gabo, his work had nevertheless already penetrated as far as London via the ballet *La Chatte*. The Russian ballets were highly popular there and it was through them that music-lovers and ballet-fans got to know the work of Picasso, Léger and others, apart, that is, from the art exhibitions, which attracted a different public.

From childhood on, Barbara Hepworth had possessed a strong sense of rhythm – especially the rhythm of the human body. Her sister, Elizabeth, felt strongly attracted to dancing and trained for the ballet, despite her family's disapproval. She found a home with the young Skeaping family in London and as a result Barbara became familiar with the world of ballet, often going to watch the students being coached. A sister-in-law of Barbara's danced too, and so she came to make repeated studies of dancers' attitudes and movements. It was not simply an interest in dancing as such but a response to a sense of rhythm in herself, involving every part of the body. This awareness can be of vital importance to the sculptor. Standing, moving to and fro at one's work, particularly when engaged on carving in wood or stone, which calls for certain well-controlled movements, involves a very special experience. The sensations of one's own body are translated into a spatial sensation, in which the physical centre – the source of the movements one makes – becomes a spiritual centre too. The condition in which the artist finds himself when creating form becomes an active condition, related to the dance. But whereas the dancer's attitudes and movements are ever changing, never fixed, the sculptor arrives by way of his spatial sensations at a definite form. Thus at this point the dance and sculpture part company, even though each had its origins in a spatial awareness.

The sculptor's awareness of the spatial by way of movement, is undoubtedly an all-important factor in determining the nature of the

form he creates. Would it be closed or open? Would sculpture in the near future be dominated by the kinetic problem which the futurists had already tackled, whose principles the Russians had set out in 1920 in Pevsner and Gabo's famous manifesto, and which Tatlin had as good as solved in his design for the cylindrical tower of culture in 1920?

Thus, in Europe in the twenties, the sculptor was faced with a new problem of form and space. The experiments of the constructivists or semi-constructivists had been few, yet they were of fundamental significance, even though there had been no question of any powerful, general influence.

At this stage, the answer that Moore and Hepworth were to provide before many years had passed was still unknown. But, as always, the preparatory stages were bound up with personal factors, with the inner structure of their feeling for form, with the nature of their feeling for the spatial. These were already becoming evident, but it was not until the early thirties that it became clear what the direction of these young British artists was going to be.

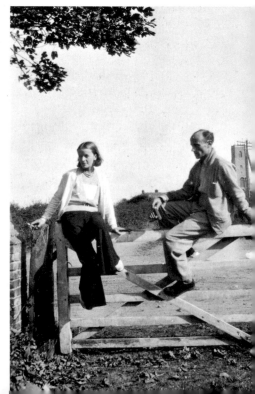

20 Ben Nicholson photographed by Barbara Hepworth, c. 1931

21 Ben Nicholson and Barbara Hepworth at Happisburgh, 1931

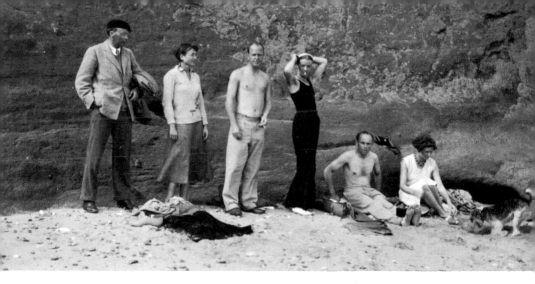

22 *Ivon Hitchins, Irina Moore, Henry Moore, Barbara Hepworth, Ben Nicholson and Mary Jenkins, Happisburgh, 1931*

The summers of 1930 and 1931 were spent on the Norfolk coast. This meant renewed contact with Henry Moore, who had married Irina Radetzky in 1929. Ivon Hitchins, the painter, was there, too. In 1931 Barbara rented a farm near Happisburgh. A photograph taken in the Norfolk coast period shows that Henry and Irina Moore, Ivon Hitchins, Ben Nicholson, Barbara Hepworth and T.D. Jenkins (who took the photograph) and his wife Mary were all there at the same time. The East Anglian landscape and the close presence of the sea acted as stimuli. She was all mobility and her interest in what was going on round her and elsewhere was intense. She concentrated not only on her own work but also on that of others, which called for orientation. For the artist, orientation is not the same as for the critic or the observer. It entails a need for resonance, an endorsement of one's own endeavour, the discovery of a fellow-mind. It entails, too, the need to put to the test what one is doing oneself by comparing it with what others are doing. Her first meetings with the painter Ben Nicholson in 1931 were of vital importance in this respect, affecting the personal life and future artistic development of both of them.

Ill. 22

That year she became a member of the 'Seven and Five Society', a group of seven painters and five sculptors. It had been formed as

early as 1920, that is, before the artists of the thirties could have had any influence on it. Ben Nicholson had joined the society in 1923, Moore in 1930. The members were elected each year to permit of change and flexibility. From 1930 onwards the Society became increasingly abstract in tenor. Its importance lay not so much in the current activities of the group as in the fact that membership meant a painter or sculptor had been 'chosen'. From then on, one was *engagé*.

Opposed methods and principles divided the expressionists and surrealists from the abstract artists even more sharply than the figurative from the non-figurative artists. Surrealism had acquired a certain following in England, which centred round Roland Penrose, artist and collector. Belgian and French surrealism became a factor to be reckoned with in London, thanks to E. L. T. Mesens, a Belgian who had many ties in dada and surrealist circles on the Continent, but who resided in the English capital. In 1938 he became the editor of the *London Bulletin* and introduced various artists whose convictions history was to justify only much later. To another section of the art world in England – the one to which Barbara Hepworth and Ben Nicholson belonged – English romanticism in the first place, and to a lesser degree surrealism and expressionism, represented attitudes and convictions which were to be combated and rejected. The search for the pure and unadulterated meant overcoming all that was obscure, restless and confused in one's thought and feeling where the imagination and the aims one pursued were concerned. The climate of art in England, which had favoured pre-Raphaelite romanticism in all manner of watered-down guises and disguises for longer than in any other country, permitted an abstract clearing of its heavily clouded skies only after a small group of painters, sculptors and writers – and architects, too, shaping 'environments' – had obstinately persisted in introducing repeated gusts of fresh air.

These winds came from various points of the compass and in practice an artist adhered to one or other aesthetic group. Only figures like Henry Moore and Herbert Read could permit themselves the luxury of co-existence. In Hepworth's work, the year 1931 revealed a remarkable urge towards what we may call 'abstract

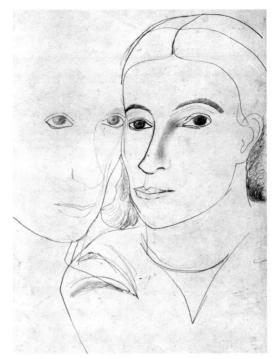

*23 Ben Nicholson. Drawing of Barbara
Hepworth and Ben Nicholson, c. 1931*

styling'. It was then that she made a sculpture in pink alabaster
(destroyed during the war) which was exhibited at Tooth's Gallery
in 1932 and at the 'Seven and Five Society's' exhibition at the Lei-
cester Galleries under the title *Abstraction*.

It is referred to by Read, however,[3] simply as *Sculpture*, but I think
it best to adopt the later title *Pierced Form*. It was an irrational, *Ill. 24*
inorganic piercing of the closed form – a significant invention, which
was to become one of the main elements in all her further work,
now steadily developing. The artist herself, recalling the emotional
component of this process – which, after all, entailed a literal and
spiritual breakaway from the tradition of the closed volume and
everything associated with this attribute of sculpture – as an experi-
ence of the senses, has written:

> . . . in *Pierced Form* I had felt the most intense pleasure in piercing the
> stone in order to make an abstract form and space; quite a different
> sensation from that of doing it for the purpose of realism.[4]

39

Was this hole the very first? As far as her own work is concerned it undoubtedly was. Where England is concerned, one automatically thinks of Henry Moore in this connexion, yet his 'year of the hole', as we shall see, was 1932. Where modern European sculpture as a whole is concerned, we are faced with a different situation again. But the importance of this matter does not, of course, lie in the more or less academic historical question as to *who* took the first step. In an era when certain developments are obviously 'in the air', a pioneer artist usually finds another doing the same thing. The one is not imitating the other but expanding the possibilities in his own manner, since, living in the same age and in similar circumstances, he is conscious of a similar need.

In the first place, the constructivists in Russia had substituted the problem of the open space for that of the closed volume; the change in the nature of sculpture as a result of the use of different materials and techniques, which raised the matter of transparency. Not, therefore, a 'hole problem' proper. Before this, Jacques Lipchitz, working as a young cubist in Paris in 1916, had arrived at an inorganic piercing of a standing cubist figure. He, too, found the experience exciting.

It is an incontrovertible historical fact that in European sculpture the 'hole problem' had already appeared on the scene, even if only to a limited extent, before it appeared in England, where, we may take it, there was unawareness of its emergence abroad. I am leaving Archipenko out of account, since his holes were realistic and organic in origin, a case of stylizing, outlining rather than forming an open space.

Up to 1931 there is no mention of the hole in the available catalogues and literature on Henry Moore, comparable to the *Pierced Form* of 1931 by Barbara Hepworth. Furthermore, Donald Hall writes in his book,[5] which Henry Moore tells us has been checked for all possible factual inaccuracies, that 1932 'was the year of the hole'. He claims that 'Henry Moore stands for the hole' and after an obscure passage about the hole in the work of Archipenko and Lipchitz, we read: 'But the hole did not *arrive* until 1932 in Hampstead, when Henry Moore finally exploited its potentialities and made it central to his work.'

40

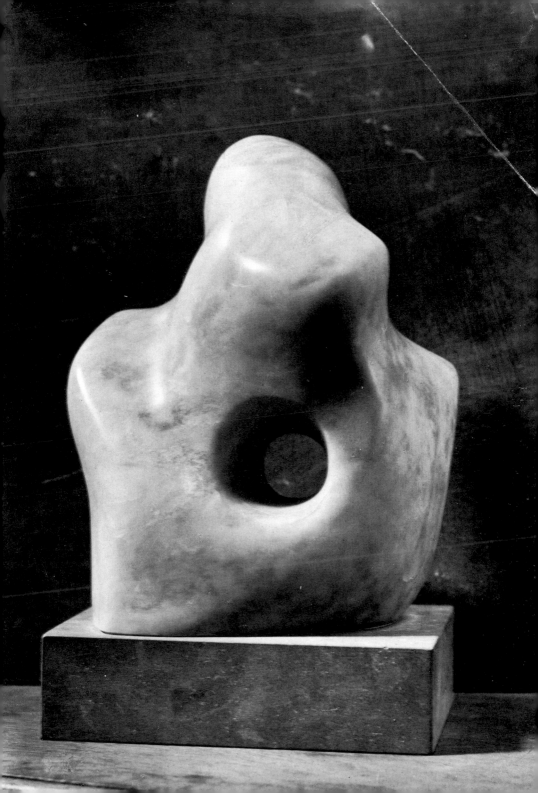

Moore himself has spoken in sober terms about the 'holes', confining himself to technical principles: 'The first hole made through a piece of stone is a revelation. The hole connects one side to the other, making it immediately more three-dimensional. A hole can itself have as much shape-meaning as a solid mass. . . .' But there is also a rather romantic, prehistoric touch about the words: 'The mystery of the hole – the mysterious fascination of caves in hillsides and cliffs.'

We may, therefore, accept it as a fact that in England the hole, introduced by Barbara Hepworth in 1931, followed by Moore in 1932, was her invention; it was not a case of her following Lipchitz's earlier cubist example of 1916 of which the English were not aware, but was the first step in her own attempt to solve the problem of the closed mass. Henry Moore's participation in this quest turned it into an English stylistic development of fundamental importance. Barbara Hepworth, neither a constructivist nor a cubist, but urged on by her own growing sense of the spatial, was seeking a balance between form and indefinite, vacant space, one which differed from that which allowed the human figure. Prior to this, form had still meant closed form to those who had rejected constructivism. From surface treatment, in the Rodin-Matisse manner, and light effects closed form now graduated to a tauter, simpler and more powerful configuration, which was more clearly three-dimensional and which was to give Hepworth the opportunity, as she herself put it, 'to build my own sculptural anatomy dictated only by my poetic demands from the material.'

The closed form occupies space without bearing any relation to the space surrounding it. It is a 'thing' along with other 'things' devoid of any anti-form. Greek columns arranged in lines had 'anti-form' – which lay in the spaces between the closed form of the columns. Anti-form is just as important as form itself. A relation exists between the succession of full, closed forms and the empty or hollow spaces. There is no interruption of form, but a form-series: scanned space.

This points to rhythmic spatial feeling, as distinguished from mythological spatial feeling. When Henry Moore evokes the

'mystery of the hole' in caves and cliffs, the imagination is working on associations. Memories of childhood years and of man in pre-historic times may be active agents here. It involves a special sensitivity to the cave, the crypt, and the dreams and visions the play of light and shadow in a cave evoke.

No one has analysed and explained what he calls 'le regard de la grotte' better than Gaston Bachelard.[6] In Moore's later work there are any number of original features in the way of cavernous spaces, arches, openings, which could act as illustrations of what Bachelard tries to substantiate by quoting from literature. There is something here, too, of Moore's sensitivity to surrealism, even though this does not imply that he ever was in fact a surrealist. The fact remains that he never wanted to be taken for one of its opponents. Taking into account the period at which they appeared and their subsequent evolution, I would term his 'holes' mythological – possibly rather too strong a term, yet useful, nevertheless, to distinguish them from Hepworth's which, though they may have sprung from an earthy mythology, are to be explained by the demands of a three-dimensional rhythmic feeling for the spatial.

This piercing of a shaped mass, this abolition of the closed form, placed volume in a different category overnight. The traditional closed form had assumed a role of supreme importance in relation to the space in which it stood, which was vague and indeterminate. But the pierced form immediately falls into a category in which form and space are intimately related one to another, in which there can be no question of the one being superior to the other. Here there is equality between the opening, the hole representing anti-form, and the mass, the form in which it has been pierced. A balance, a harmony has been achieved, the outcome of a newly awakened spatial feeling. Expressed in simple terms, space now passes *through* the figure, which relinquishes its defences (its 'closedness') and enters into a marriage with infinite space. The result is discernible in a sensation of spaciousness and clarity far transcending the actual dimensions of the sculpture itself. Out of little something grand, something infinite, has been conjured into life, which, miraculously enough, is both clear and precise. A movement goes out from the

form into vague, indefinite space, and there is a movement, too, in the opposite direction, from infinite space towards emergent form.

In Hepworth's work, as in Moore's, we must make a distinction between the hollow and the tunnel. The hollow, which need not always be open; the tunnel, which is a corridor and justifies its existence through its open-ness.

In the years from 1931 to the outbreak of war in 1939, both Hepworth and Moore were to achieve results which often all but coincided. It is not a case of 'influence' in the old-fashioned sense of the word, as used in art history, but of the emergence of a common language among a number of artists. Since this situation was relatively complicated, comparable perhaps with the situation during the first cubist period in Paris, from 1909 to 1941, I intend to devote special attention to it.

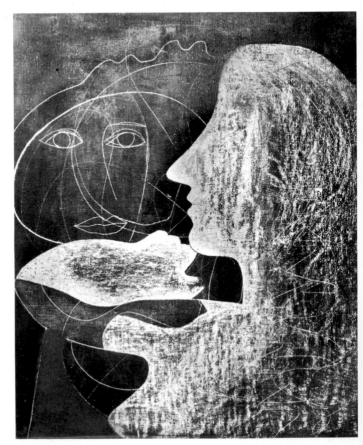

25 Ben Nicholson.
Girl and mirror,
c. 1931

1932 – The Crucial Year

The encounter with Ben Nicholson – he was married at the time to Winifred Dacre, the painter – hastened the process which had been becoming increasingly evident in Barbara Hepworth's work and approach to art since 1930. Her days with John Skeaping had come to an end. A new, difficult and tumultuous period was beginning, one of great intensity in both her private and artistic life. Living with Ben Nicholson meant the beginning of a discussion between the two of their respective viewpoints and work. It also meant assimilating impressions of artists on the Continent, selecting, appraising.

The impression they made is charmingly conveyed by Frank Halliday.[1] Writing of the year 1949, he says:

There was nothing formal about Ben. Although immaculately dressed, it was after his own fashion, in a light, loose golf jacket, his tieless blue shirt decorously buttoned at the neck. His fringe of grey hair and deep-set eyes gave him the austere and almost fanatical appearance of the medieval saint, an appearance that was strangely at odds with the mischievous mouth, athletic body and youthful grace of his movements. In some ways Barbara was the antithesis of Ben. When she walked it was certainly not after a ball, for she knew little about and cared nothing for games, and impishness was the last word that could be used to describe her appearance, that resolute mouth and the serenity of those eyes under the deep and prominent brow. And yet there was a comparable duality. Although small and slender, leaf-like in her movement and dance, she gave the impression of being much bigger than she was, partly because of the breadth of her head and the thick brown hair that fell from her shoulders, partly because of the scale of her work. . . , but mainly because she combined an essentially feminine nature with what can only be called a masculine power of intellect.

45

26 Saint-Rémy, 1931

In 1932, towards Easter, Ben and Barbara went on a journey and saw Braque, Brancusi, Picasso and Sophie Tauber-Arp in Meudon. Arp himself was not present. They visited Braque in Dieppe several times and got on well together. She left photographs of her work with Brancusi, as well as the *Pierced Form*.

Artistic impressions alternated with impressions of the landscape. They went to Saint-Rémy in Provence, which left her with lasting memories. Perhaps the most important impression of all was that made on her by this inspiring region, where Van Gogh had worked in the eighties and had been nursed in the former monastery of St Paul. We have already been apprised of the keen impressions her journeys with her father through Yorkshire had made on her in childhood days. We have seen what emotional riches she had derived from her stay in Italy, and particularly in Tuscany, in 1924–26.

The special light of Provence, with which both Cézanne and Van Gogh had been so familiar, the new life with Ben Nicholson, the ferment of new aesthetic impressions, all these had an intoxicating effect on her. These were the years when new technical developments and modern methods of travel were for artists a source of aesthetic excitement. Functionalism in the new architecture, both in theory and in practice, resulted in a keener awareness of the technical beauty of the machine, and its products. It was still possible in those days to become lyrical about a trend which in our own time seems to burden life, to hamper it with unsolved problems, rather than to help us to live it.

A year after the founding of a new group of eleven artists in 1933, a book entitled *Unit One* was issued, under the editorship of Herbert Read, to which the artist-members had contributed. In it, Barbara

27 *Carving, 1932*

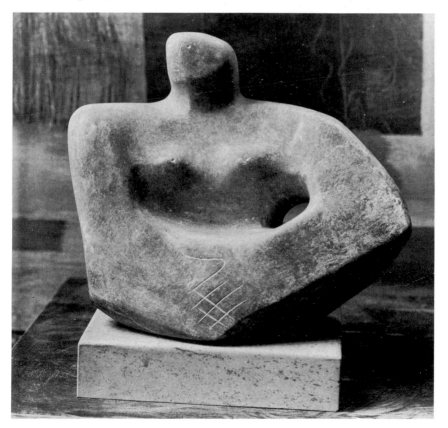

Hepworth, evidently still influenced by the impressions she had gained in Provence, near Saint-Rémy in the spring of 1932, wrote:

> . . . there is freedom to work out ideas and today seems alive with a sense of imminent discovery.
> . . . easy walking down the street with green red traffic lights – a stone arch two thousand years old standing on green flat spaces of earth against stony mountains – olives quietly growing in obeisance at their feet and Café Robinson hidden by trees . . . the wireless filling the air with music from some foreign station – we can dance at the feet of these lovely undulating stony hills. . . .

It is remarkable to see how she moves directly from this modern pastoral landscape mood to what she seeks to achieve in her sculpture:

> It is relationship and the mystery that makes such loveliness and I want to project my feeling about it into sculpture – not words, not paint nor sounds.

The words: 'to project my feeling about it into sculpture' seem to remind one of the great nature romanticists in which England was so rich during the eighteenth century – a point to which I shall return later to see how the projection of feeling was mastered and not realized in the romantic's way. Now she defines form:

> It must be stone shape and no other shape . . . right relation of masses, a living thing in stone. It must be so essentially sculpture that it can exist in no other way, something completely the right size but which has growth, something still, and yet having movement, so very quiet and yet with a real vitality.

Insight into what form had to become, how it was to be, could hardly be put more concisely or with greater conviction.

The year 1932 also saw an exhibition of Barbara Hepworth's and Ben Nicholson's work at Tooth's Gallery in London, which was an event of great significance. It saw the critics come forward who

would shortly be in the vanguard in disseminating knowledge and understanding of the new art. It was a miracle – a blessing too – that the small group of artists who introduced new ideas into English art in the thirties should have found an equally small, but eager and gifted group of critics ready to fight their battle side by side with them. The most important of these – and he was a poet as well as a critic, trained in aesthetics and philosophy and one who exercised a growing influence in cultural matters – was Herbert Read.

This battle was, indeed, no easy one and for the time being brought no victories. Nor was it only London that was to put up a protracted resistance. The Continent, too, where Paris set the tone, was unresponsive to the young English artists, though for different reasons.

28 *Woman with folded hands, 1932*

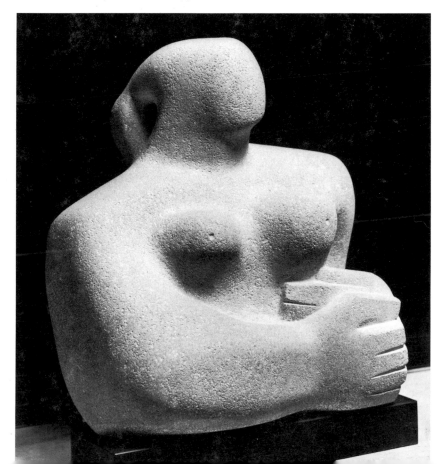

Paul Nash, painter, and author and founder of 'Unit One', was one of those who wrote about the exhibition at Tooth's. This brought Wilenski in on their side. Here then was a first response from a significant source. In his introduction to the catalogue of 1932, Herbert Read wrote:

> The revival of the art in our time is due to nothing so much as to the re-assertion of this vital connection between the artist and his material. To this revival England is making a vigorous and original contribution – a fact already recognized abroad, particularly in Germany – and among English sculptors taking part in this revival, Barbara Hepworth occupies a leading position. In her work the two essential principles of sculpture – the organisation of masses in expressive relation and the revelation of the potentialities of the sculptured material – are clearly expounded without equivocation and without irrelevant compromise.

Paul Nash went so far as to draw a comparison between Barbara's sculptures and Ben Nicholson's painting. In the *Week-end Review* of 19 November 1932, he came to the conclusion that there was an affinity between them. He sought, considerately, to avoid any 'research into the personal psychological sympathy between these two artists as too dangerously inquisitive and inevitably misleading'. Yet, despite 'the different media of sculpture and painting', he discerns a 'similarity of finished achievements'. 'The carved abstractions', he goes on to say, 'seem not to have been fashioned by tools; they have much more the appearance of stone worn by the elements through years of time. . . . But when we turn from these to Mr Nicholson's paintings, we have the same feeling of things weathered and beautifully worn.' Nash also discusses the 'tactile properties' in both the sculptor's and the painter's work, saying of Barbara's that this 'has not been imposed, but has inhabited the stone and grown within, outwards, as a child grows in the womb'. Of Nicholson he writes: 'The painter has not applied, but built up from the plane of his canvas outwards, a horizontal edifice of infinitely subtle balance.' Both artists make things which 'exist by virtue of themselves; their life depends on every plane and tone, every line and spot, the very vibration of their surface is their breath'. This tallies with what

Barbara herself has said: 'It must be so essentially sculpture that it can exist in no other way. . . .'

Finally, there was the December 1932 issue of *The Studio*, which carried a discussion with the artists to mark the occasion of the exhibition. Naturally, the matter of the choice between 'carving' and 'modelling' arose, a subject about which it seems relatively little was known at the time. What is important to us here are Hepworth's words about the way she conceived her sculptures. 'An idea for carving must be clearly formed before starting and sustained during the long process of working. . . .' From this it appears that she did not – nor ever could – naturally belong among those artists who commence work without knowing what they are going to do or with only a vague idea of their intentions. She also excludes any connexion with the 'somnambulant' creative act, the half, or almost wholly, unconscious process, and with 'leaving it all to chance'. There must, therefore, be a fundamental difference between her work and that of a sculptor such as Jean Arp – and many others.

Hepworth has been gifted with a rare talent for three-dimensional representation. Yet it would be wrong to suppose that this conscious and controlled phase which precedes the actual sculpturing is primarily a matter of intelligence, of the mind. For we are still left with the question: how does she receive her ideas for her sculptures? What are the roots from which her sculpture springs? She herself declares it to be a mystery. The image comes to her at random moments, during the daytime and at night too. Sometimes it appears as a nocturnal vision, all complete in her mind's eye. Then comes the problem of giving this vision form. Drawing has not always formed an intermediate phase. In the thirties she did comparatively little drawing. There were a few, sometimes small sketches, worked out in more and more detail, but drawing had not at this stage the significance it was to acquire after 1940. In his contribution to *Drawings from a Sculptor's Landscape*,[2] Alan Bowness writes that both the twenties and the thirties produced relatively few drawings because 'carving seemed all-absorbing'. He quotes Hepworth's own pronouncement: 'Carving becomes increasingly rhythmical and I was aware of the special pleasure which sculptors can have through carving, that of a

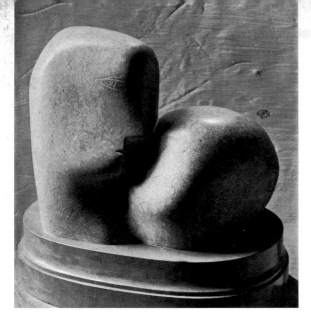

29 *Two heads, 1932*

30, 31 Sculpture with profiles,
1932

Ill. 30

complete unity of physical and mental rhythm.' One tends to forget that in the thirties, a line was often engraved in a sculpture – an outline, a nose, a wavy line, an eye, a broken circle. Often an outline takes the form of a profile in the cubist manner, engraved on a three-dimensional form, as a result of which the latter prevails, as a form, over the recollection of the reality, which is the profile. The line is, in any case, rhythmic, standing for the signature on the piece of sculpture, which, in its turn, is rhythmic in the three-dimensional manner.

Barbara Hepworth's attitude in 1932 to architecture is characteristic. When *The Studio* asked her if she regarded sculpture as an art 'to be practised separately or in conjunction with architecture', she replied as follows:

Architecture does not need sculpture for its construction, nor should the architect be dependent on sculpture for the complete realization of his idea in building. Sculpture is an additional decoration to the building and is only lovely when the architect's idea and the sculptor's are in harmony and both architect and sculptor fully realize the abstract meaning of form.

52

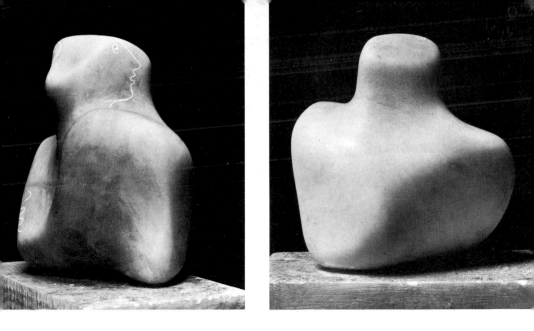

This reply of hers is not founded on the traditional Bourdelle-Eric Gill conception of architecture as the mother of the arts. The answer bears the stamp of a sculpture whose first task had had to be to rediscover itself and also that of certain examples of the architecture of the thirties which had freed itself of all ornamentation and had concentrated on a search for functional solutions that were cool, businesslike and rational.

As we have already seen in another context, modern architecture in Britain had been slow to get started and had looked to Germany for its stimuli. The opportunity for German influences to make themselves felt once again presented itself when Nazi persecution caused many gifted German architects to seek a temporary refuge in Britain; men like Gropius, Mendelsohn and Breuer. Despite the hospitality they met with in the country of their adoption, they had difficulty in obtaining important commissions, so they worked together with indigenous architects of the same persuasion, and this conferred an exceptional character on the British architecture of the time. It was only in the 1932–33 period that the outlines of true modern architecture took shape when names like Leslie Martin, Wells Coates, Colin Lucas, Maxwell Fry, Amyas Connell, Owen

Williams came into prominence. Achievements in this field acquired an even more decidedly international *cachet* thanks to two Russians, Berthold Lubetkin and Serge Chermayeff.

Ill. 35 The artists who had settled in Hampstead – where the Mall Studios of Nicholson, Hepworth, Moore, Read and Stephenson were to be found – were familiar with the modern flats which Wells Coates had built in Lawn Road, where Gropius was living and collaborating with Maxwell Fry.

The architects were not merely interested in what was happening in the plastic arts, but felt that a bond existed between them and the sculptors. This did not, however, take the form of active co-operation. Declarations such as that of Barbara Hepworth – that sculpture sought to be itself and nothing other than sculpture – can undoubtedly be traced back to abstract form in painting and sculpture. A similar absolutism ruled in architecture, which sought to be solely architecture – and so gave rise to the misunderstanding that construction

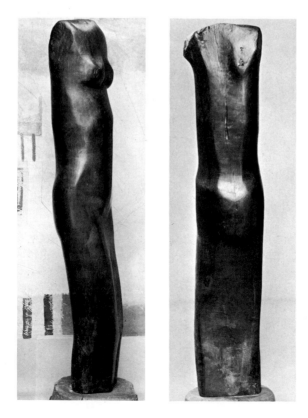

32, 33 Torso, 1932

and architecture were one and the same thing. What later, as expressed by the mediocre, was to become self-complacent dogma was at that juncture a clear parting of the ways and, as such, essential if one was to arrive at the purity these architects dreamed of. This clear parting of the ways did not at the time exclude an understanding. It was not by chance that Leslie Martin and his wife, Sadie Speight, also an architect, visited Barbara Hepworth and Ben Nicholson's Mall Studio, and that at this early stage, they purchased some of their work, forging a bond with the sculptor and painter. This was the way mutual understanding was fostered in those difficult, impecunious days of great promise. Although there was no formal organization into groups, contributions were made from several sides, and these helped to create a basis for a new, reformed awareness of style. No one has expressed the atmosphere of mutual understandings and revival better than Herbert Read in *A Nest of Gentle Artists*:[3]

> For five years I lived in friendly and intimate association with this group of artists, visiting their studios almost daily and watching the progress of their work. At the back of the studios were small gardens, and in mine I built a wooden hut, about six by four feet, and there, during the first summer, I wrote *The Green Child*. It was the happiest period in my life. I remember how when we had just moved into the studio and freshly decorated it, woodwork pale blue, walls white, Ben Nicholson came in to see the result. 'Wait a minute,' he said, and retired, coming back a few minutes later with a round cork table-mat which he had painted scarlet. He seized a ladder and nailed the scarlet disc high up on the white wall. The whole place was transformed by this accent of colour, perfectly placed. *The group worked intensely, in loose association with other artists.* [My italics]

Barbara Hepworth commented about a quarter of a century later[4] that the years 1932–33 reflected the stringent ideas of vigorous young people on architecture and art. For their opinions become more critical of the architects' weakening attitude, while there is no further mention of architects and artists working together to create environments. The equilibrium had been disturbed. One remarkable

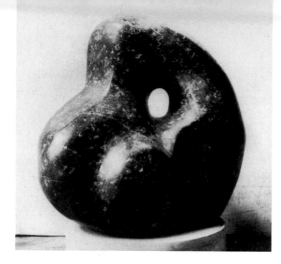

34 *Profile, 1932*

phenomenon is the way the gothic style found renewed favour – as an instinctive realization of a proper relation between the two disciplines of architecture and sculpture. She writes:

> As a rule, however, the architect has to, or seeks to, satisfy all the divergent demands, working alone, and this is an impossible task. If he fails then to accord to the other arts their just deserts, he will never create a true space, wall or surface for the painter or the sculptor. Encouragement, the inspiration of others, will be lacking. The architect could do much to improve the present state of affairs, one in which man is suffering from spiritual undernourishment.

Summarizing, one is struck by the fact that the outlook in 1932 apparently corresponded with a state of vital concentration on one's own medium, which was a source of private inspiration, but that this vision neither added up to a dogma nor represented a permanent verdict. It was merely a state of affairs. It became clear later on that something had been expected of the architects which they had failed to supply. The original understanding, present even when there was no actual co-operation, had never been intended as a rigid, immutable dogma of mutual exclusion – an exclusion, moreover, which lacks all tension and makes all understanding of the other's viewpoint superfluous. In the thirties the tension that had arisen between all the arts, architecture included, was an invisible tension, an abstract tension, salutary in effect but not destined to endure.

56

The Common Language; The Hampstead Pleiad; Unit One and Circle

During the thirties the work of these artists enjoyed the privilege of attracting more attention than usual among professional critics in the British Press. Some non-professionals, too – leading personalities in archaeology and science and a few painters who also resorted to the pen felt impelled to define the new language of form in greater detail.

One of these figures was Paul Nash, the well-known painter, who had founded 'Unit One' in 1933 and who in the following year issued the book which took the group's name for its title, and of which as mentioned earlier, Herbert Read was the editor. In his foreword Nash made it known that, despite the use of the term 'a common language' the artists belonging to 'Unit One' were 'not agreed that there is only one method of painting, sculpting or building, nor even that their art should express a common sentiment or even a conscious direction'.

All the same, they discerned a common goal which Paul Nash, contrary to his denial of the existence of some definite trend, said amounted to putting new life and impetus into a force they all believed in – the true contemporary expression – as it existed in England. 'The title then,' he wrote, 'combines the idea of unity – Unit – with that of Individuality – One.'

There were two architects among 'Unit One's' members: Wells Coates (b. 1895) and Colin Lucas (b. 1906). Wells Coates was aware of having learned more as an architect from the painters and sculptors than from the architects – with one exception, the Parthenon. He writes:

The reason for this must surely be clear: the work of artists such as those with whom I am associated in this friendly group Unit One is,

reduced to its simplest element, linear and special research work. We
are each a grouping together of many different elements, with work
and interest as a single unit.[1]

Exhibitions were an important factor. They provided an oppor-
tunity of acquainting the artists with and assessing each other's work.
They were important, too, because they acted as a challenge or a
stimulus to the critics. This sounds strange today, when there are so
many exhibitions that an art critic tends to become a computer
devoid of human reactions and merely registering facts; indeed, not
even that, but merely reducing everything to a formula. In 1940 it
could still happen that an exhibition led to reactions of an unusual
order in the Press. Even non-professional critics put forward their
views. Art criticism in the decade from 1930 to 1940 is of genuine
historical importance. It often embraced far from superficial re-
actions on the part of people of aesthetic sensibility, possessing either
a specialized or a more general knowledge and training.

Something worth while was, at all events, built up by the artists
as a group and by those writers who endeavoured to react and help a
difficult public to react to what these artists were doing. The art
criticism relating to Moore, Hepworth, Nicholson and others con-
tains some remarkable expressions of opinion. It may be regarded as
a chronicle of the aesthetic feeling of the day. But these reactions,
I feel, amount to something more than that, since in them the purely

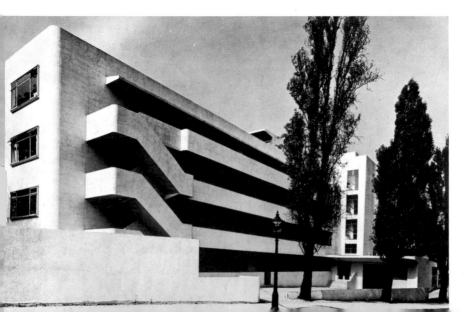

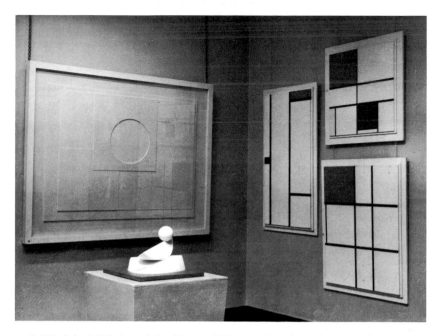

36 Work by Nicholson, Mondrian and Hepworth at the 'Abstract and Concrete' exhibition, Reid & Lefevre Gallery, 1936

aesthetic reaction was extended to embrace psychological, historical or philosophic considerations. Herbert Read and Adrian Stokes provide examples which for quality are virtually unmatched anywhere.

Before going on to consider a few of these studies of the art of the time, it is only fair to pay some attention to those who made these exhibitions possible. There was Mr Duncan Macdonald of Reid & Lefevre, who as an art dealer possessed a dangerous penchant for supporting an artist and his work, even when they did not add up to a commercial proposition – which, indeed, was the case with the *avant-garde* in London before 1940. Duncan Macdonald was, moreover, often of real help to the Nicholson *ménage*, when they were having difficulty with their finances (exacerbated by the birth in 1934 of triplets). He liked Barbara's work. Nicolete Gray should be mentioned in this connexion as well. It was she who organized the 'Abstract and Concrete' exhibition at Reid & Lefevre's gallery in *Ill. 36*

35 Wells Coates. Lawn Road Flats, Hampstead, 1934

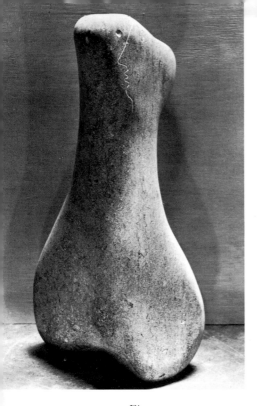

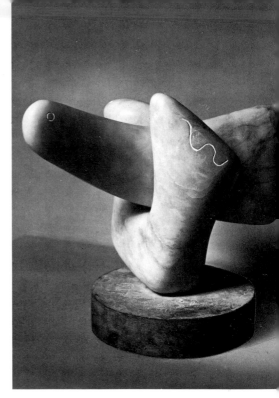

37 *Figure, 1933* 38 *Two forms, 1933*

King Street in 1936, featuring the ten artists who belonged to this group – an exhibition that has become a landmark. The interest she had shown in earlier years, as Nicolete Binyon, has already been mentioned. She wrote an unpretentious introduction to the exhibition catalogue, which stressed once again how the British abstract artists were making 'for the first time since the eighteenth century' a real contribution to international art. She mentioned, too, the existence of features which linked all this work together, remarking, 'That there is something in common in all these works is, I think, immediately apparent.' She did not, however, specify what this was.

The critics take us further. One of them, Henri Frankfort, was not a professional critic, but a professional archaeologist who made his name with his writings and studies on the art of the Near East.

Referring to an exhibition held in 1935 and writing from his knowledge of ancient art, which had furnished him with a yardstick for assessing modern art in the light of that of earlier times, he noted that Barbara Hepworth's work 'realized values which belong to the essence of sculpture and which, in fact, characterize good work of all ages'.[2]

He was aware that his assessment 'passed beyond the limits of rational analysis'. He referred to the form of Hepworth's sculptural language and possessed a rare understanding of its qualities, which he compared with Chinese carving and Egyptian work:

> It appears, then, that each carving contains, besides the base and exquisitely modelled elements upon it, a third constituent of equal importance. Even as in music, not only sounds but also silences enter into the rhythm of the composition, so matter and empty space form in their harmony these carvings. But space unlimited cannot enter into the order which is a work of art. It is the function of the oblong slab to give it definition, to delimit with precision that spatial individuality of each work as a whole.

39 *Two forms, 1933*

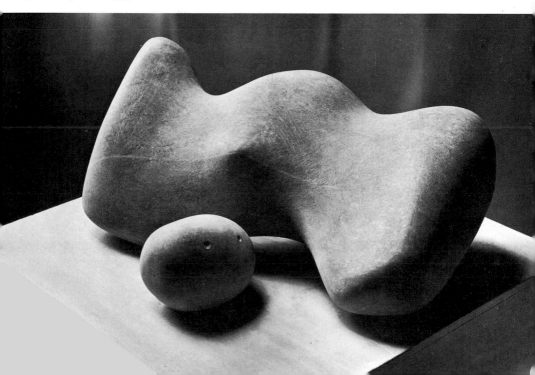

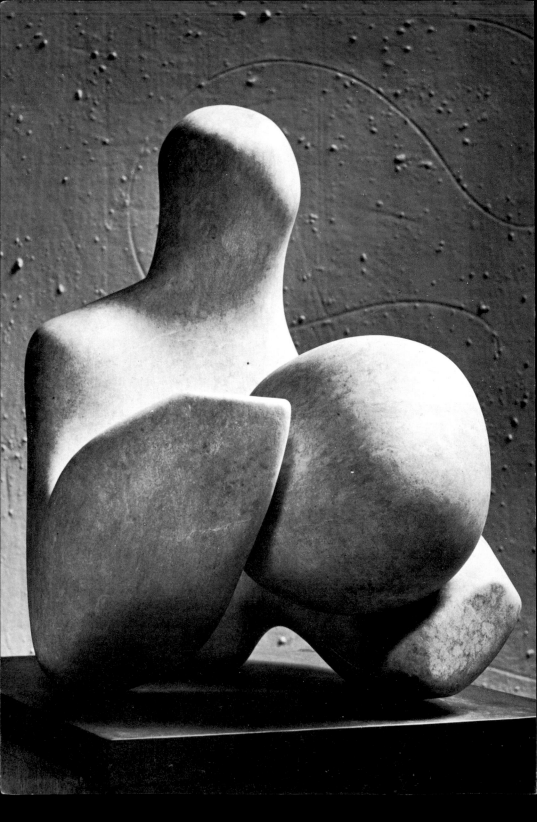

Frankfort was particularly struck by the clarity of the parts and the unit that is more than the sum of its parts. He is struck, too, by the colour:

> Moreover, the effect which is realized contains colour and texture as powerful elements, which critical reflection may attempt to separate but which were, in fact, insolubly contained in the one original creative act of artistic conception.

Frankfort was among the first to appreciate contemporary art as such with sensitive insight and to place it in an historical setting.

Another, who did something comparable, was a no less remarkable physicist, J. D. Bernal FRS. He wrote a foreword to a catalogue for an exhibition of Barbara's work which was held at Reid & Lefevre's in 1937, saying that what he wrote did not represent a piece of art criticism. His analysis helped to make clear that the responses evoked by the new work were so rich in nuances, so complex, and so much more than merely aesthetic, that one could think in terms, not of an individual but of a common language. Furthermore, he helps us to understand its symbolism. In a manner differing from Frankfort's, Bernal too arrives at the view that Hepworth's sculptures evoke antiquity, not as twentieth-century imitations of ancient art or as archaic stylizations, but purely by virtue of the quality of their form:

> The first impressions of the present exhibition suggest very strongly the art of the neolithic builders of stone monuments which, in the second millennium, stretched along the coasts from Sweden to Assam. Nor is the analogy entirely superficial.

It is a tribute to Bernal's vision in those days that he should not have mistaken the simplicity and the restricted symbolism of the neolithic for a step backwards in the direction of the well-known, realistic cave paintings which preceded it. It is thanks to more recent researches – those, for instance, of Leroy-Gourhan – that nowadays we see the realism of the cave paintings as the beginning of a decline rather than as peak achievements:

63

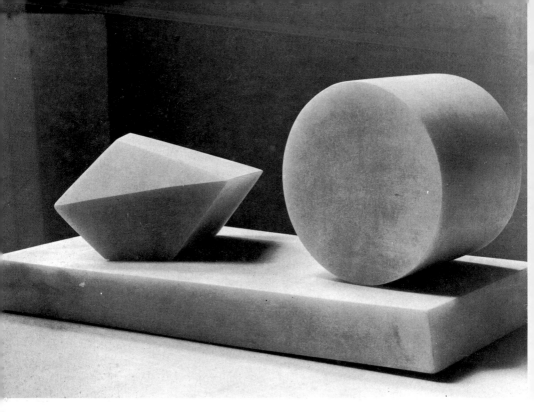

41 Two forms, 1934

In a sense Miss Hepworth's art stands in extreme relation to the representational art of the nineteenth century from which the whole of present century art has been in revolt. She has reduced her sculptures to the barest elements, but those elements correspond curiously enough so closely with those of neolithic art that it is in comparison with them that we can best describe them.

Bernal then refers to the upright stone blocks of Cornwall and Brittany: 'Another group represents stones pierced in one way or another with conical holes.' At the time Barbara had not yet got to know Cornwall. No one at that juncture – at the outbreak of the war – guessed that landscape was to play so important a role in her life and work.

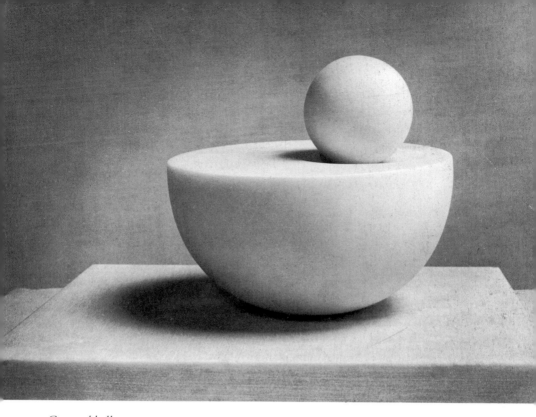

42 *Cup and ball, 1935*

It can be seen that we are far removed here from what Robert Melville has maliciously termed 'the parochial abstract'. Bernal does not, however, confine himself to seeing images of the Dolmens and the celebrated Men-an-tol in Cornwall in Hepworth's work: 'Indeed, in other ways her statues correspond to the earliest stage of Greek sculpture, recalling many Helladic figures and particularly early statues of Apollo.'

He names the new elements of her sculptural language: 'The sphere, the ellipsoid, the hollow cylinder and the hollow hemisphere. All the effects are gained either by slightly modulating these forms without breaking up their continuity, or by compositions combining two or three of them in different significant ways.'

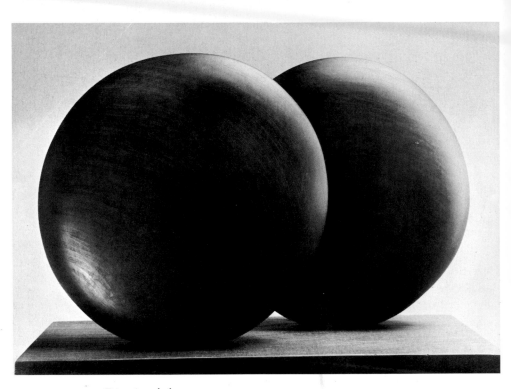

43 *Discs in echelon, 1935*

Referring to five 'Single Forms' he also speaks of a 'fourth dimension introduced into sculpture, representing by a surface the movement of a closed curve in time'. He praises Hepworth's 'extreme control' over the geometric form and the finish on the surface of the materials she uses. He is of the opinion that abstract works of this nature cannot exist in a vacuum. The resistance which they meet with, however, has meant that no answer has been found to the problem of their place in the life of the community. Bernal does, indeed, see their relation to architecture, yet he goes no further than expressing what his expectations for the future are.

Adrian Stokes, the painter and essayist, was also a member of the small group which helped to evolve and publicize the common language which developed in the art of the thirties. He differs from Frankfort, Bernal and also from Paul Nash in that he wrote more

than critical reviews of exhibitions, gradually evolving his entire psychoanalytical aesthetic in small books written in a manner which might if the term did not run the risk of seeming derogatory, be called a 'science of art'. Despite his extremely condensed style, his writings such as *Stones of Rimini*[3] and especially *Colour and Form*[4] found favour with artists too. His own experiences as an artist and his knowledge of psychoanalysis, added to his sense of the present, all played their part in this. His theories were accordingly of value to the aesthetic thought and feeling of his time. He, too, contributed to that complex of views in the thirties, which, for lack of a better term, I would call 'a common language'.

Stokes discussed Barbara Hepworth's carvings[5] on the occasion of the Lefevre exhibition in conjunction with Ben Nicholson, laying particular stress on her rediscovery of the possibilities stone offers the sculptor:

> This steadiness of shape, through many ages unconsciously expressed by visual art, in recent times had altogether been lost. To cultivate a reverence for stone thus became an aesthetic need. Miss Hepworth is one of the rare living sculptors who deliberately renew stone's essential shapes.

Stokes conferred a deeper and more subtle meaning on the rather propagandistic term 'truth to material' and on the significance of carving, adding a contemporary touch to the more historical approach of Frankfort and Bernal. About 'the true carver', he says, for instance:

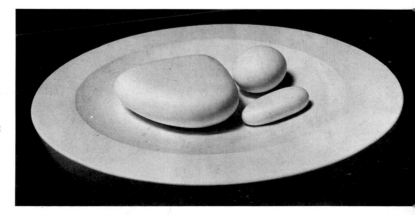

44 *Forms in hollow, 1935*

The true carver attacks his material so that it may bear a vivifying or plastic fruit. He woos the block. Not shape, not form, but stone shapes are his concern. Stone may be forced to realize almost any plastic idea but as carving it is valueless if no love, no reverence, had been paid to the stone; however great the merits of the plastic idea, the stone itself has not come to life.

He goes on to say:

As pebbles by natural forces, so forms by the true carver are rubbed: though it is sufficient for him to rub the stone in the final process only. You may see the rubbed forms from every angle of Miss Hepworth's carving. . . . These stones are inhabited with feeling, even if, in common with the majority of 'advanced' carvers, Miss Hepworth has felt not only the block, but also its potential fruit, to be always feminine. These sculptors approach the block with such gravity that more ebullient, more masculine forms evade them. None the less, after Miss Hepworth's exhibition, her contemporaries and Miss Hepworth herself, I feel, will modify their attitude.

Stokes is the only critic to discuss the male and female element in Hepworth's work, tracing the mother and child theme even in the abstract composition:

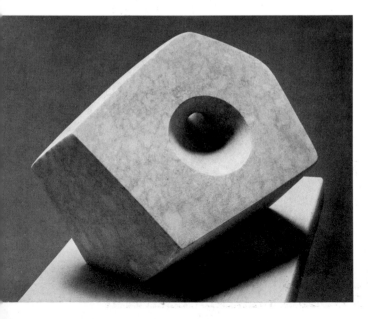

45 *Holed polyhedron,*
1936

46 *Two segments and*
sphere, 1935–36

It is not a matter of a mother and child group represented in stone. Miss Hepworth's stone *is* a mother, her huge pebble its child. A man would have made the group more pointed: no man could have treated this composition with such a pure complacence.

Ill. 40

Artists found his book *Colour and Form*[6] both fruitful and enlightening. He wrote in contemporary terms. The way in which he included colour in his observations on form and traced the latter back to its origins made the book something more than a mere accompaniment, in the shape of an essay, to what was happening in painting and sculpture. It represents a remarkable growing awareness of what was being realized in images, either sculpted or painted. When he writes: 'A new plastic freedom invaded and revived the carving

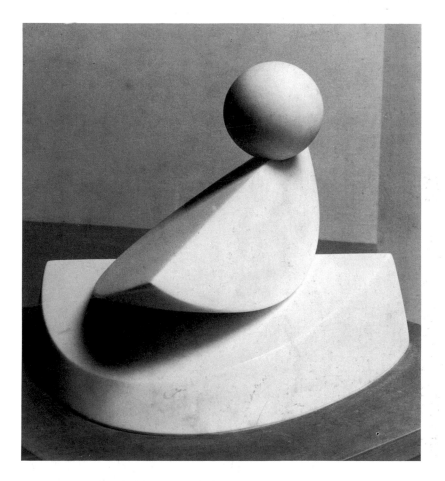

approach. This rather complicated point is to me the crux of modern European art history', these words are founded on rich experience and wide observation of the art worlds of England and Paris, their mood determined by his love for the Italian world of Giotto, Masaccio and Piero della Francesca.

At the same time Ben Nicholson, then in daily contact with Barbara Hepworth, was developing his own work, while Henry Moore was richly productive. The extent of these advances was to be seen in the works exhibited. Referring to Nicholson Adrian Stokes remarks that his circles and rectangles are not 'patterns' but:

> Much of this work is the fruit of pure *carving conception* [my italics]; indeed these paintings are developments from previous and concurrent work in the cuttings of similar designs in wood.[7]

According to Stokes, the concept of carving also involves colour.

As compared with the work done before 1930 and shortly after, a marked change now took place. The persistence of the abstract in Barbara's work – and, for a time, in Moore's too – undeniably set

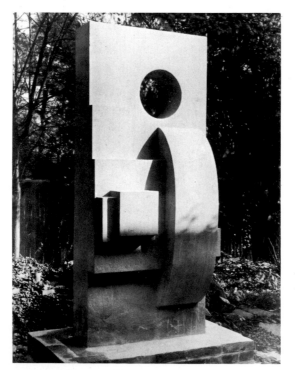

47 *Monumental stela, 1936*

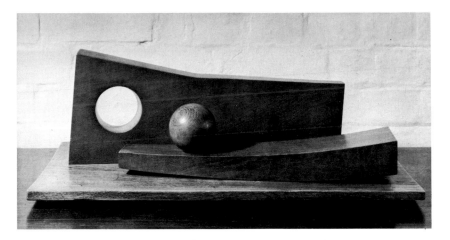

48 Ball, plane and hole, 1936

its stamp on these years, up to about 1937, years in which the emphasis lay to a far greater extent on a joint effort at fostering the spirit which inspired modern art than on mutual differences. True, Ben Nicholson and Henry Moore represented two different worlds: but it is no less certain that, working side by side, Hepworth and Nicholson influenced each other's art – it is inconceivable that they should not have done so. It is rare for two mature creative talents, with so much in common, to meet and, moreover, to meet at a decisive moment in their artistic development.

Yet no one at the time – not even the critics discussing the 'common language' thought in terms of opponents or allies. Instead artists felt a certain autonomy, an awareness that each was making his own approach to shared problems of form, colour, and line. Since cubism, sculpture's themes had been limited. Now that the narrative element still dominant in Rodin's work had been banned, figurative sculpture confined itself to one or two figures – sitting, crouching, reclining, or standing – to the mother and child theme, while more abstract sculpture showed a preference for the sphere, cylinder, circle, rectangle, cone, or for an organic stylization like that of Arp.

The forms which the constructivists – Naum Gabo and his brother, Antoine Pevsner – had developed stood quite apart from this work. In the complex of the English (insular) and the European

(continental) development of form, constructivism played a part which deserves closer attention, since both Gabo and Moholy-Nagy came to England in 1935. Gabo, who had known Barbara and Ben in Paris, where he had lived in a state of deep depression since the death of his first wife, was induced to come over to London, where he married again, this time to Miriam Israel. The Hampstead colony was reinforced by his presence. He was a convinced and thoughtful defender of a certain way of life. As such he impressed people. He was ardent in the cause of clarity, precision and purity of style, which man's future environment would have to accept in art and architecture. It is extremely interesting to consider Gabo's contacts after his arrival in England as an emigrant, in 1935, and to investigate the relationship between him and Henry Moore, Ben Nicholson, Barbara Hepworth and Herbert Read, the leading quartet in England.

As was to be expected, Gabo was received kindly, with humanity. They knew who he was. His past, in Russia, was impressive. Cut adrift, such artists as he, men of principle, had been thrown out of Russia, if not officially, then as the price of political and cultural

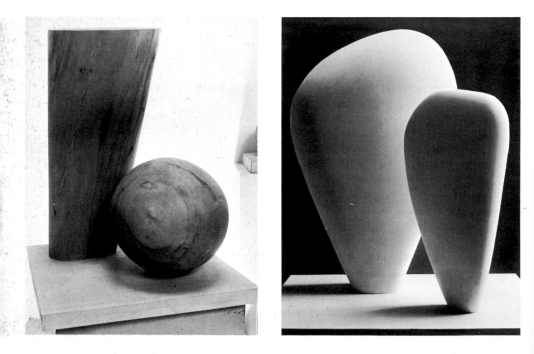

developments in that country. The poison of Hitlerism had made Germany and Austria impossible for them, and in insular England they hoped to be able to salvage their ideas – and their lives. Gabo did not merely bring work with him, he stood for a programme, that of constructivism. The English were obliged to explain him to them-selves and to decide on their attitude towards him, which Herbert Read did with his pen. As a man obsessed with an idea and, moreover, dedicated without reserve to the abstract (he called it 'the concrete'), Gabo enjoyed a certain authority. But constructivism was at the same time a way of life, not simply a theory of art. It recognized the significance of the artist's emotional attitude towards his material and this was, rightly, seen as of vital importance.

By 1935 both Moore and Hepworth were mature artists who had travelled a long way and were now devoted to, not to say enslaved by, those age-old materials, wood and stone. It was an emotional deeply rooted bond, one that could not, fortunately, be argued away, one, too, which in the modern age had proved capable of conjuring out of these familiar materials potentialities that had hitherto been undreamt of.

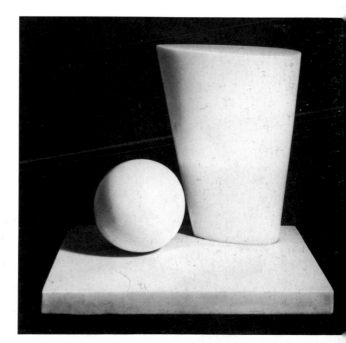

49 Two forms, 1937

50 Two forms, 1937

51 Conoid, sphere and hollow II, 1937

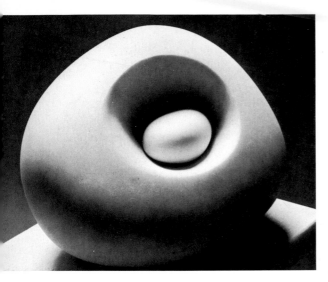

52 *Nesting stones, 1937*

Gabo, however, had completely, or almost completely, discarded the old ideas regarding volume, mass, stone, wood. He was also against the use of colour in construction. According to him the colour had to come from the materials themselves. He, in his turn, had an instinctive affinity for glass, iron, perspex, tin, steel and all manner of synthetic materials. He insisted on including time, light and space among the components out of which sculptures should be created. While not dismissing volume and mass as valueless, he had nevertheless unseated them from the throne. The old emphasis laid on volume and mass, with space as a secondary factor had been done away with. Space became a point of departure – a concept with which Hepworth, Nicholson, and others were able to concur. They had made the same discovery for themselves and were attempting to apply it. It meant much that there could be agreement on this point. But, even so, neither Moore nor Hepworth found themselves able to relinquish their relationship with wood and stone, a relationship which had proved so fruitful and which had deep roots in their mental and physical constitutions.

The consequences were legion. It was inevitable that the form Gabo gave to his works could, on the face of it, have no real influence on the English artists. In this matter they were poles apart. One would even be justified in maintaining that when Gabo made a

74

closed-form sculpture in Portland stone, he had succumbed for a moment to his English environment. His theories could, for that matter, justify an exception of this nature. But in his English environment such exceptions were too infrequent for us not to see them as resulting from temptation.

Gabo's understanding for rhythm in sculpture and in art generally must, of course, have struck a very sympathetic chord in Nicholson and Hepworth. Yet in other respects he could hardly have found in them disciples for his constructivism.

It was a different situation where the architects were concerned, as Sir Leslie Martin has explained.[8] Martin had been an early admirer of the work of Barbara Hepworth and Ben Nicholson, he and his wife being among the first to purchase their works. The Martins' appreciation extended to Gabo too. The work he had done for Diaghilev's ballet *La Chatte* made Gabo known in other London circles as well. Although unlike the present, there was little sign in those days of using the work of these sculptors in architectural projects, architects did show an intense interest in it. Actually, they

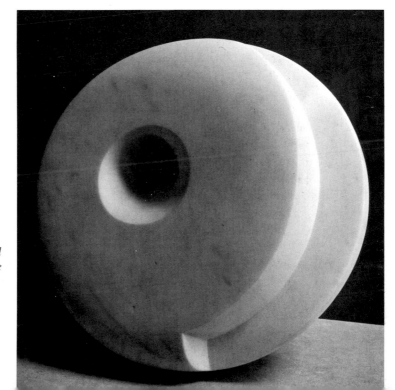

53 *Pierced hemisphere I, 1937*

were all expecting to see the creation of a living environment which would be characterized by the qualities of clarity, precision and purity. For all their differences did not these works, these artists, too display a certain homogeneity?

Sitting round the fire and talking, they arrived, as though as a matter of course, at the idea of co-operating to produce a book to be called *Circle*, on lines purer and stricter than *Unit One* in times gone by. There was a need for a joint declaration of faith.

The editors-in-chief were Leslie Martin, Gabo, and Ben Nicholson. Barbara Hepworth and Sadie Speight devoted themselves to assembling the material and to the typography. It appears that Henry Moore did not feel quite at home in this company, which can be explained by his greater tolerance of surrealism and his looser ties with the abstract, which, however, was powerfully present in his own work at this time. He did not expect much of the architects either. His ties with the others were looser. The use of strings in sculpture, for instance – a feature he had introduced in his work in 1937–38 – proved in his case to be no more than an interlude. But in the case of Barbara Hepworth – who had introduced strings into her work in 1938–39 – they were to become a lasting feature. She had studied mathematical models in Paris and London in her youth but let the idea lie dormant in her mind until she could use it emotionally, not mathematically. Later, Moore was to remark: 'When the war came I gave up this type of thing. Others, like Gabo and Barbara Hepworth, have gone on doing it. It becomes a matter of ingenuity rather than a fundamental human experience.' This opinion contains a scarcely concealed contempt for the medium which, in Moore's case (cf. his words about abstract forms), is based on living creatures.[9]

This does, indeed, explain why Moore did not occupy himself with the theme for long. Gabo, however, proceeded from an entirely different point of departure. Even before 1937 he had been engaged on experiments which he termed the 'spherical theme' and which were intended to reflect the visual image of non-cubist space. He wanted to get away from rectangularity, and from 1936 on – that is, after he had come to England – he went over to representations of

Ill. 55

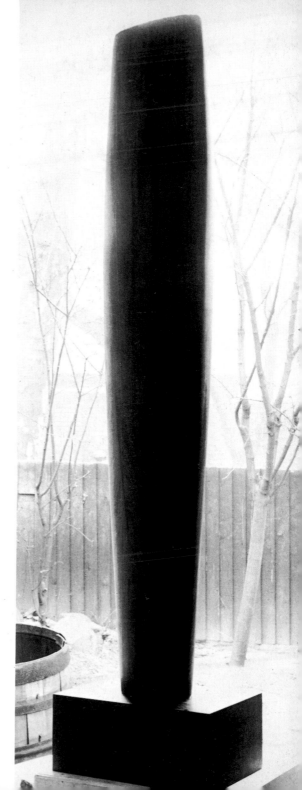

54 Single form, 1937–38

space by means of curves, which required cords, threads, and bars for the transparent linear constructions. Gaston Bachelard did not apparently get on his trail, otherwise he would have found in Gabo one of his proofs that 'life is round' – not the earth, but life.

There is obviously a fundamental difference between Gabo's and Barbara Hepworth's use of strings or materials resembling them. The difference is a logical consequence of the fact that Gabo works with *total* transparency, giving to the line in this transparency a specific structural function. In Hepworth's work transparency exists as a *contrast* to the closed wall which the use of wood or stone entails. The choice she makes of materials and her relation to them (differing from Gabo's) do not allow of absolutely linear constructions either. These occur only in her drawings, which she did not begin to produce in any quantity until the war years, in St Ives. In these the line does sometimes acquire a structural significance of its own, and it is only then that it approaches the Gabo idiom. Before she made the drawings, her wood-bronze-strings combination was fundamentally different.

Among the members of the Hampstead group, Moholy-Nagy was also an advocator of abstract art. He had made movement above all

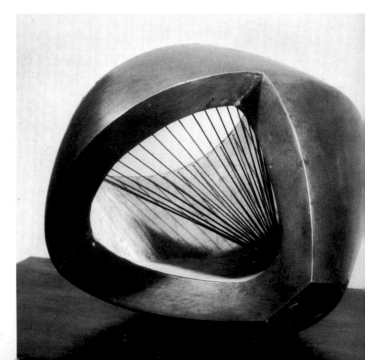

55
Sculpture with colour and strings, 1939

things the heart of his general theory and work. He was a pleasant addition to the group although he left little mark behind him in English art circles. He did win recognition, however, as a theoretician.

The company was, as it were, complete when, with war threatening, Mondrian came to settle in London in September 1938. It was a company of artists who lived in the same neighbourhood, formed a free community and spoke a common language; even so, within it the English contribution continued to be clearly distinguishable from the continental.

Nor should it be forgotten that when Mondrian arrived, 'Circle' had already come into being through the enterprise of English artists, though Gabo, it is true, played a big part in it. Mondrian's participation in 'Circle' and the consequent strengthening of personal ties played their part in ensuring that all his Hampstead friends did their best to help him – it was Nicholson who finally found him a studio. There was, however, a more fundamental reason for the general recognition he enjoyed, namely the fame of his studio in Paris and a quality of absoluteness present both in his work and himself. Barbara was also attracted by his personal elegance and dignity, his affability and harmony of mind, qualities which sometimes reminded her of her father.

I do not believe that Mondrian's sojourn in Hampstead was of any significance, where *his* work is concerned. He was merely in transit, his protracted stay being due to the exigencies of wartime. He imported both himself and his work, in unaltered form, from Paris, and his Hampstead studio was immediately transformed into a true likeness of the studio in the rue du Départ.

As to any influence in the reverse direction, Winifred Dacre (Nicholson's first wife, in whose company Mondrian had left France for London) in particular and, in 1933 and 1934, Nicholson and Barbara Hepworth as well, had brought powerful impressions of neo-plasticism back with them from Paris. Mondrian was not imitated – indeed, circles and curves played no part in his idiom. However, Mondrian's conception of space, colour and form had already proved so fruitful a source for the experiments of others that there was little left for him to change by the time he arrived in

Hampstead, in 1938. But mere contact with him had an exhilarating effect. As a rule, views are not altered by discussion, though such discussions can have a clarifying effect.

The reminiscences which Charles Harrison collected and introduced for *Studio International* (December 1966) under the title of 'Mondrian in London' are confined almost entirely to conjuring up from the past this artist's presence, his behaviour, his contacts and his environment. But it was due to his stay in London that a number of his English friends purchased Mondrians for their collections. This stay ended in September 1940, as he had always dreamed it would, with his departure for New York.

If we concede that by 1938 there could no longer be any question of his exerting a real, a direct influence on other artists, it seems likely that English artists like Moore, Nicholson and Hepworth may have offered an unconscious resistance to Mondrian's absolutist theories. He cannot have approved of the role which the human figure repeatedly plays in Barbara's work, and objects in Nicholson's, nor can the circles and rectangles, which they saw as spatial elements, have been acceptable to him. They, on their part, must have felt impelled to cling to the remains of 'object-relationships' and seen no objection to certain 'subversive movements' in their work penetrating it from outside. There was, after all, no question of failing to give intrinsic purity its due. No artist in the English ranks became a neo-plasticist, certainly not Barbara Hepworth. The emotional relationship to the materials used and the nature of his visual reactions to the world around him, rooted in his physical and mental constitution, once again proved to be the vital factors in the artist's work. Thus the Pleiad of Hampstead spoke a common language – which did not, however, mean that discussion and disagreement were ruled out. They understood each other, because they had decided on their terminology as applied to their media and to such concepts as line, surface, space, form. But this defines the limits of their common language – it did not amount to more.

The problem of a common language where Barbara Hepworth and Ben Nicholson were concerned was rendered distinct and unusual by reason of their association in private life and their work

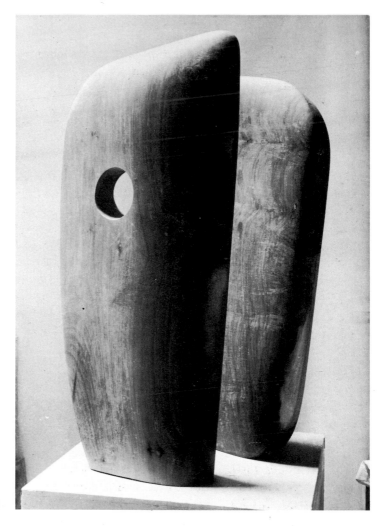

56 *Forms in
echelon, 1938*

within the Hampstead community. Such a question as what Barbara
owed to Brancusi and Arp is simply the normal one about the
significance of an influence. Bearing in mind her early history, it
is possible in Hepworth's case to defend the view that she was only
susceptible to those things and persons which succeeded in making
contact with, and evoking a response from, what was already present
in her mind. A heightened form of communication, which seldom
caused her to deviate from the course she had already set herself.

Jean Arp's influence on her was restricted from the outset by his indifference to material; a conception of form in pure white material held no attraction for her. But his free abstraction and his relation to nature did indeed mean much to her. It was, in fact, a romantic abstraction and it made her more aware of her own relation to landscape.

Barbara's life with Ben Nicholson set in train a far more intense process than any visit to the studio of, say, Braque, Miró, Arp or Picasso could do. It was as much a case of mutual 'give' as of mutual 'take', and the process was unconscious. Giving and taking became an inextricable complex of seeing, feeling, doing and consciously making, quite transcending 'influence' in the ordinary sense. It is even more difficult to analyse where the two artists are working in different media. When Barbara was married to John Skeaping, the two of them were working in the same media; yet their personalities differed so widely that they would not have had much to give each other later. An exchange of an entirely different order came about when she married Ben Nicholson. Whereas, generally speaking, Hepworth experienced everything in forms, to Nicholson the line and the plane alone mattered; he transferred everything to a world which tended to withdraw from the three-dimensional world, or which moved with great subtlety in space via the medium of reliefs, though not three-dimensionally. Their relation to their material differed.

If we look carefully at the work Barbara and Ben produced between 1931 and 1933, we shall see a change beginning to take place. In the ensuing period, from 1933 to 1938, there is a marked increase in the intensity of the purely abstract work. In her case, in the fullness of the taut volume in space, sometimes accompanied by the complication of a spatial tension in the relationship between the forms of a volume and a second or third volume. In his case there is no spatial expansion whatever, but great simplification, sometimes greater rigidity and a subtle evolution in the relationship between circles and rectangles.

Artists who found difficulty in selling a work for £40 or £50 often supplemented their income by obtaining commissions to

design advertisement posters or to make textile designs. Thus one will come across abstract motifs by Keith Murray, Norman Webb, Paul Nash and others, which were a welcome move away from the frightful little fauns, flowers, Derby Days on printed cotton, still in fashion around the year 1925.

The Edinburgh Weavers were particularly successful in finding good artists. Barbara Hepworth made a few designs – handblock prints based on geometrical motifs, including *Pillar* – and Ben Nicholson was responsible for various Poulk Prints and designs for the Edinburgh Weavers, including a motif making use of letters and figures, another with boats and animals, others abstract, vertical and horizontal. It was by this roundabout route that the artists gained access to the modern interior, that the scope of their work was extended until it came to form part of the architects' interior designs. *The Flatbook*,[10] in which J. L. Martin and Sadie Speight proffered a selection of the items which were available, basing their

58 *Photograph taken by Barbara Hepworth of her son Paul, aged 12 years*

choice on fairly severe principles, provides a good example of this trend. Their premise was that 'the planning and living accommodation, either in the house or flat, is undergoing at the present time a considerable revolution'. *Kitsch* was to be out.

Few paintings are to be seen in the rooms, while of sculptures there is no question. The style favoured is evident from the names of the artists (with samples of their work) which crop up here and there in the book: Piper, Hepworth, Jackson, Nicholson, Juan Gris. In these circles the importance of industrial design – a field in which Herbert Read played an active role – had been grasped early on. Nevertheless, the infiltration, one which could have had so beneficial an effect, remained confined to these efforts.

A study of the limited number of drawings Hepworth produced in these years is rewarding. Like the sculptures of the 1937–39 period, they are rectilinear. The objects they represent are crystalline forms, sometimes seen from above, sometimes from the side, and precisely drawn, clear, pure and severe. The term 'crystal line', though a tentative one, is fully justified. The geometry of the crystal, the laws it obeys, its clarity – all satisfy the requirements as to form which the anti-surrealists demanded during these years. Crystals were almost symbols of the ideal they pursued. Derived from nature, the drawn crystal did not seem in the first instance to be a product of the imagination. Neither did the circle, the sphere or the cone. They are the forms or elements by which the creative personality expresses its own world, its own rhythm. These structures are altered by the creative act. Why, then, should we not allow that the imagination is able to convey the crystal from the realm of nature into that of the mind?

However this may be, in these years Barbara Hepworth drew crystals whose structure was highly unusual and illogical. Their creative quality lay in the way in which they deviated from nature, in the work of the imagination, which conceived illogical surfaces of colour, complicated internal structures, here and there with colour in them. Their fascination resides in the combination of the delicate with the exact and the complicated. Nothing has been left to chance, it would seem, everything is governed by laws. But these

laws are far removed from the overt laws of nature; they are the laws of the artist's own inner rhythm, nothing less. The imagination has had a far greater share in this than these cool, fragile structures would suggest at a first glance.

The 'crystal' has, since the advent of cubism, been taken as a symbol of the highest conceivable form, attracting certain artists – among them Lipchitz and Paul Klee – during a phase in which abstract art was well to the fore. But it was in the hands of Barbara Hepworth above all that the crystal developed into a highly objective and yet, at the same time, personal expression of spatial feeling. This needed the utmost concentration, and here maybe the war played a vital role. For it took her to the remote south-west coast of England, on the shores of the Atlantic, where the conditions were ideal. This episode in her career, marked by the poetry of the crystal, proved to be one of extreme importance.

In this Cornish retreat of St Ives she was joined by a few other Hampstead artists who sought refuge from the mounting turmoil of the outside world.

59 Photograph taken by Barbara Hepworth of the triplets; Simon, Rachel and Sarah Nicholson, 1937

Exodus to Cornwall

It has happened more than once in the twentieth century: a fairly small group of artists live and work together in fruitful contact; a common language evolves, which each artist speaks after his own fashion. Something of the kind had happened after Picasso and Braque had found each other, during the first, probing days of cubism – their child. A number of other artists then followed suit prior to 1914. Came the first world war, and all these forces were dispersed. After the Armistice, when the survivors returned from the front, the old ties had disappeared forever; each went his own way. This same war had drawn the protesting dadaists together in Zürich, only for them to break up when it ended. In Paris, surrealism provided a new field of conflict. In London the outbreak of war in 1914 had a disastrous effect on the vorticist movement, still in the early stages of its development. In 1939 one could at least claim that a fortunate concatenation of artistic achievements had already produced important results, even if the departure, when the threat of war increased, of Gropius, Moholy-Nagy, Breuer, Mendelsohn and Mondrian signified a loss. The Hampstead Pleiad came to an end.

Barbara Hepworth and Ben Nicholson with their three children and a few essential items from the studio and the home, set out for St Ives in a cheap, hastily acquired little car to seek what they hoped would prove a safer home for the triplets. There Adrian Stokes had a house, Little Park Owles, in Carbis Bay, later the property of the painter Peter Lanyon. Stokes offered the entire family hospitality. Ben got the studio ready and a difficult period, lasting for some months, began – the difficulties increasing when Naum Gabo and his wife arrived too. Gabo felt ill at ease in St Ives. There was an attempt to persuade Mondrian to come down as well, but he adamantly refused. This little fishing port and resort was no place,

he felt, for him, who was used to life in a big city. He was, in any case, now able to realize his original plan of going on to New York. Bernard Leach, the potter, was among those living in St Ives, and the physicist Bernal had gone down there on secret war work.

Barbara started a nursery school, which meant that her creative life as an artist was immediately reduced to a minimum. After four months with Adrian Stokes, she and Ben found a small house; and in 1942 they moved into a roomy house with its own garden, Chy-an-Kerris, from which they had a view of the sea.

Life in their small community was difficult and tiring, the home making great demands. Yet it was a full life. James Sweeney sent consignments of books from America. Apart from the books themselves, this also meant a much-prized contact with the outside world, which wartime conditions had reduced to a minimum. The important international contacts had come to an end. Now, amid the grandeur of the Atlantic scenery of the Cornish peninsula, Barbara's drawing got its chance. Most of the time she would draw

60 *Drawing for sculpture, 1941*

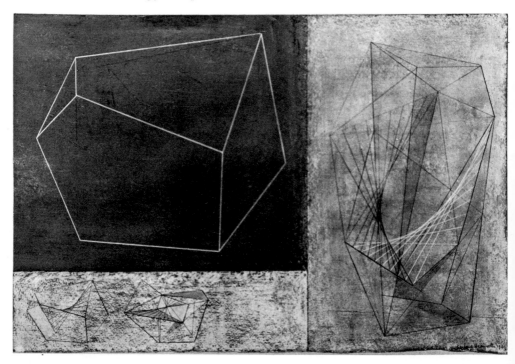

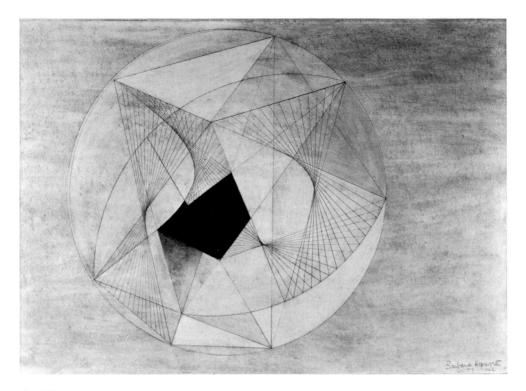

61 *Circle, 1942*

at night, when the day's work was done. Her drawings proved to be a continuation of the great drive in abstract sculpture that her London days had seen.

To begin with, the leading motif of Hepworth's drawings was the 'crystal'. In her sculpture, there had been some forms resembling crystals in 1934, but these had not been transparent. The interior forms, however, which were linear in the Gabo manner (though Gabo never closed them up and in his work their function was different) did appear, simplified in some degree, in the sculptures incorporating strings.

Ills. 60, 61

It is not easy to put one's finger on the difference between the late London work (1937–39) and the early St Ives work (1940–43). Nevertheless, the difference is there, and I shall attempt to explain the nature of it. In London the holes were still fairly small in relation to

the volume and the mass. Sometimes they were a complete penetration, sometimes merely a hollow; there were many spherical or hemispherical forms. After 1938, however, Hepworth broke the forms right open, introducing cords and colour. The circles and

Ills. 62–64 spheres became fewer, the number of ovals increased. In 1943 there was even a question of a spiral movement. The colour she used in her sculptures represents part of her total conception of form. Cubism had, as we know, already experimented with colour. Zadkine used it pictorially; Archipenko took it further, to what he himself called a 'pictorial-sculptural fusion' (amalgamation of the pictorial and sculptural). Arp made various reliefs using colour. Laurens tried to use it to harness the play of light on the surface and came close to the truth when he saw it as a means of excluding the direct effect of natural lighting. He believed he was conferring on the sculpture its own light – in much the same way as the Greeks had thought to do, according to Lipchitz.

In Barbara Hepworth's use of it, colour acquired a function in relation to the form, not to the material, to which it bore only an indirect relation. She did not suppress the material by her use of colour but used it partly to reinforce the impression made by the natural colour of the material and partly to add, as it were, a further dimension to the form. She had been experimenting with this since 1937, the year which saw the publication of Stokes's book *Colour and Form*. Colour, as she uses it, is, in any case, exclusively concerned with a problem of form; it has nothing to do with any pictorial effect. By its partial use her forms become more evocative than form alone would be. It arouses associations with nature and light. 'The colour in the concavities plunges me into the depth of water, caves, of shadows deeper than the carved concavities themselves.'

Living so much with forms, she put into her work emotions drawn from nature, which were neither mystical nor romantic but based on her actual observation and experience of the Cornish landscape. I could not term this awareness of colour and its associations abstract or metaphysical. It belongs to the landscape generally. To form and material, colour is added, as a third component, to extend the range of her evocations.

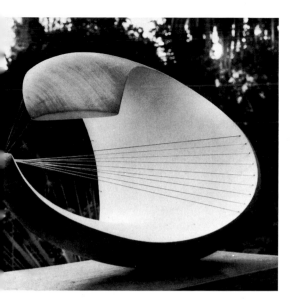

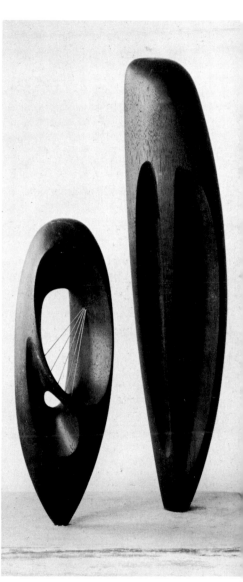

62 *Wave, 1943–44*

63 *Sculpture with colour (oval form)*
pale blue and red, 1943

64 *Two figures, 1943*

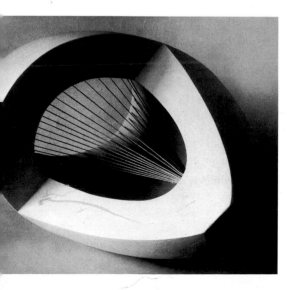

Colour, then, was concerned with something of which she became increasingly conscious: a feeling for landscape. It had lent to her childhood a deep undertone of quiet, continuous observation and emotion. Twice it had come to her as a hymn; in the ecstatic early years in Tuscany, and once again, later on, at Saint-Rémy, in Provence.

Hymns of this kind never return in the same form, and when landscape captured her imagination for the fourth time in her life, in Cornwall, she described it lyrically, but her awareness of it was both humane and realistic. She had ripened and was now conscious of the constant influence nature exerted on her life as a sculptor.

65 *Landscape sculpture, 1944*

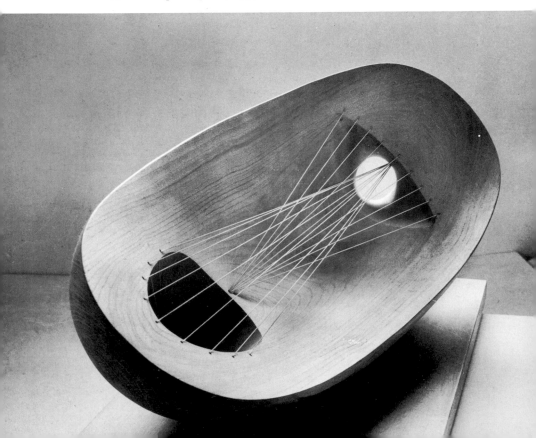

Feeling for Landscape

No other country in our civilization has, from the eighteenth until deep into the twentieth century, obliged its artists to come to terms with landscape and seascape to the extent that England has. Even today critics have tried by means of irony, scorn and a too literary approach to rid themselves of the characteristically English problem of the artist's link with the landscape. They have tried in vain. In a barbed introduction to *The English Eye*[1] Bryan Robertson and Robert Melville stimulate the artists and themselves by questioning such concepts as 'the ideal of locality', 'roots in a particular land-scape', 'references to rocks and the sea and the weather in Cornwall' and by speaking of 'parochial abstracts'. 'The landscape convention in English art' is, indeed, a characteristic of that art, which, while it can be a healthy one, has its unhealthy aspect, romantic and sentimental.

Given the situation in the eighteenth century, the watercolour landscape was both a sound and logical social and aesthetic pheno-menon, a sign of an empirical interest in a region. Later, it declined into an insipid hobby, sometimes not without charm.

The light-hearted critics of *The English Eye* say of Barbara Hepworth's sculpture that:

> . . . it has geological references as well as an affinity with the ancient menhirs and quoits. . . . but this sculptor has a broader range than is realized abroad, and the present use of abstract, non-associative colour in English sculpture was most radically deployed by Hepworth twenty-five years ago when she used strong colour to add a new dimension to her stone and wood carvings. This innovation was ignored by the English. . . . She has been affected by the country but also kept it in its place, quite an achievement considering the potency of that landscape. . . .

93

Here, the matter has, fortunately, been reduced to its proper proportions. It merits further explanation. For Cornwall plays a considerable, even a symbolic role in modern English art and literature. For Barbara Hepworth the process actually began in Yorkshire, and Cornwall is the second and last English phase of a basic topographical emotion which is no longer a matter of geography but one of the mind and creation. Neither is it any longer a matter of feeling for landscape in the narrow sense but one of the relation of the creative individual to nature.

Here, too, it is impossible to avoid laying the main stress on the English character. Not even the nature-loving romantics in Germany and France show the same constancy and range in their feeling for nature in art, literature, music, architecture, landscape and garden architecture as the British; it is these qualities that give their work a character which is almost unique in the story of twentieth-century sculpture. In English poetry close contact with the countryside has often produced great work, far transcending its local character. It is very difficult to discover anything analogous in sculpture; yet

66 Sculpture with colour (Eos), 1946 67 Elegy II, 1946

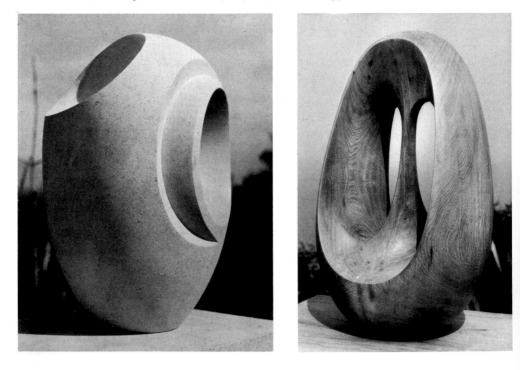

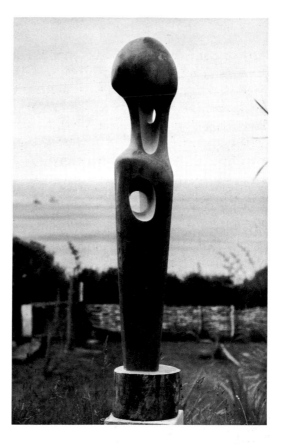

68 Single form (Dryad),
1945–46

painting, no less than poetry, has drawn strength from half-conscious instincts awakened by living in the country and experiencing nature's moods. Among European artists, John Constable provides the classic example of how significant a wholly provincial relationship to one's immediate environment and its inhabitants and a sincere affection for a region can become, when the genuineness of that affection goes hand in hand with a strong sense of reality and a controlled imagination. The romantic poets projected their own lyrical mood on to nature, either implicitly or explicitly; this cannot be said of Constable. On the contrary, he tried to be objective and empirical and went no further than that, being neither a writer nor a philosopher. Wordsworth being both, was capable of expanding his nature poetry into a poetical philosophy. Herbert Read has analysed this

95

lucidly in his book on Wordsworth,[2] in which he makes an essential distinction between the poet and his contemporary romantics:

> For Wordsworth, however, Nature had her own life, which was independent of ours, though a part of the same Godhead. Man and Nature, Man and the external world are geared together and in unison complete the motive principle of the universe. *They act and react upon each other*, so as to produce an infinite complexity of pain and pleasure.

This was a process of maturing. The common, immediate enjoyment of nature, through intuition and feeling, in which the intellect plays only a subsidiary, even negligible part, was transcended by the realization of the duality; nature and mind. The interchange is preserved: the eye continues to see, the ear to hear, the body to feel, all sense are alert, the emotions alive, but the mind does not dissolve in them. Instead it asserts itself, maintains its authority, while the contradictions are bound together by the technique of poetry.

The technique of poetry and that of sculpture are too disparate, of course, to be assigned a common denominator. However, an important work of sculpture makes us aware of the artist's attitude to nature just as the poem makes us aware of the poet's. The tools of poetry and sculpture may differ but not the creative force which puts those tools to use.

Seeing Wordsworth through Read's eyes we became aware of a relationship between his thinking and the feeling for nature Barbara Hepworth evolved for the purposes of her sculpture. This feeling for nature is not romantic, not heroic. It is innocent of subjective lyricism and its objectivity is not tied to any locality. Clearly, it is an interpretation of form, a form, moreover, that seems to flow like the sea. Here again it should be stressed that form is not to be seen in this context as opposed to content. Nor is form one with content. The form *is* the content, always. Emotions have contributed to its creation and a feeling for landscape has contributed to these emotions. But once they have become form, they cease to be nature and are of a different order. As an interpretation of nature in terms of form, sculpture is elementary. That is to say, however splendid Cornwall

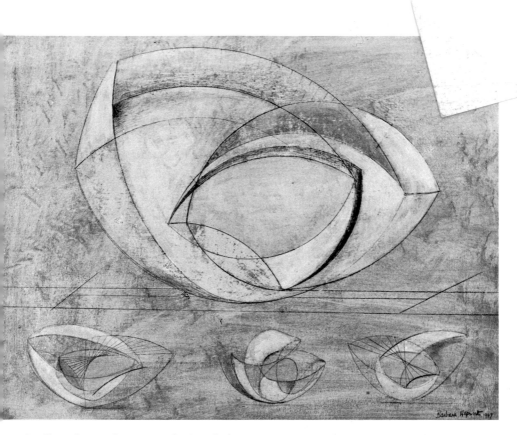

69 *Curved stone forms on pink ground, 1947*

may be and even though the evocative names of local places form
the titles of her works, in the sculptural process, it is man, not the
landscape, who triumphs. From the strange reciprocity, the exchange
between the sculptor's inner and outer world, a sculpture emerges in
which man and his emotions have gone to work on the elements of
nature and transformed them.

'Sculpture', Barbara Hepworth has said, 'is a three-dimensional
projection of primitive feeling: touch, texture, size and scale, hard-
ness and warmth, evocation and compulsion to move, live and love.'
And of landscape: 'Landscape is strong – it has bones and flesh and
skin and hair. It has age and history and a principle behind its
evolution.'

97

I would not go so far as to say that landscape and nature form the point of departure in Barbara Hepworth's sculpture. Neither is this point of departure man. 'Man and landscape' comes nearer to the truth, even though it is not the best definition. Man and landscape, experienced emotionally, are essential elements in the sculptural process, yet it is the creative power, both at the beginning and at the end, that determines what the results are to be.

The sculptor often mentions 'body experience' as the centre of creation. 'I rarely draw what I see – I draw what I feel in my body.' Again, 'It is within our bodies to feel and to be, and in making a sculpture we do, in fact, make a talisman that enables us to enter our *architecture* [my italics] and look at our painting as fully poised human beings.'[3]

The artist also says: 'The pierced hole allows bodily entry and re-entry. The spiral takes hold of one's hand and arm. . . .'

In this way the sculptural process is seen as a process of opposed forces in man, destructive and constructive combined with 'an affirmative statement of our will to live'. This is why the sculptor so often lays emphasis on life's vitality and continuity, why the *rhythm of life* is so important to the fashioning of sculpture; a rhythm which makes itself felt in the body and which is perceptible *outside* the body as another rhythm in space (i.e. the landscape) and the people moving about in it.

These people and their movements – walking, standing, lying down – are observed in the context of their existence, as the latter is reflected in them. They are observed in relation to their environment and the artist senses how their movements are influenced by that environment. Landscape and people are subjected in this way to observation, measured unconsciously in terms of the artist's own rhythm. The body is said to be passive in its receptivity. Yet only relatively passive, for it has decided in advance what it is going to receive. It can only absorb this if receptivity, readiness to receive, is already present. It takes impressions in only if it is capable of sur-render, and this surrender is so active and intense a reaction – not to everything indiscriminately but to what it has selected – that the passivity with which it receives is a highly relative quantity.

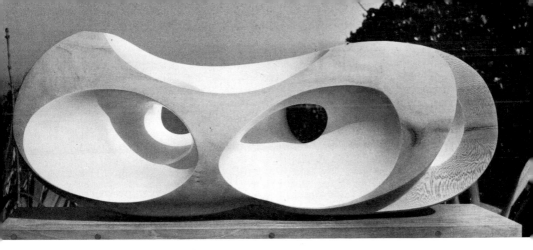

70, 71 Pendour, 1947

Thus the observation of what takes place in space, beyond the confines of the body, is of value only if it finally turns inwards, if it returns to the body in the form of a newly acquired rhythmic sensation, composed now of the two rhythms, a sensation which, being now a composite rhythm, is already the beginning of form.

Only in this way can we understand how, for Hepworth the sculptor, the object observed can be the 'others', the outside world, while at the same time being the artist herself. Thus, in the end, the highly important feeling for landscape (as an object) is transmuted into the process of sculpting an inner, central and independent feeling which cannot be distinguished (as a feeling) from the form in which it manifests itself. As Hepworth has put it: 'From the sculptor's point of view one can either be the spectator of the object or the object itself.'[4]

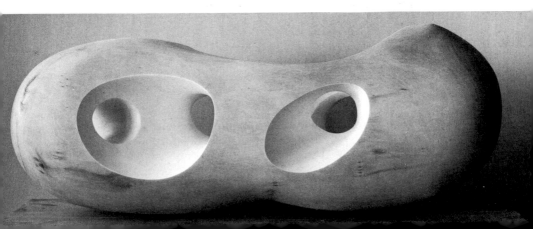

At the beginning of these observations I remarked that this re-currence down the centuries of a conscious confrontation with nature is a characteristically English phenomenon. Where the twentieth century is concerned, Barbara Hepworth represents the spatial reaction in sculpture of this feeling for nature and, as such, she is exceptional; for before this the poets and the painters had what was virtually a monopoly in the field. As Herbert Read says in his *Philosophy of Modern Art*:[5] 'What distinguishes all the romantic painters, from both the Realists and Classicists, is their preoccupation with landscape.' He distinguishes 'a native tradition, northern, allied to the tradition which stretched right across Scandinavia, Russia, northern China' from 'an imported tradition, the Mediterranean one'. In this tradition, he says, nature is merely décor, a 'background to human activities'. On the grounds of this distinction, Read sees the predominance of landscape as 'the expression of an innate Northern necessity and not as a romantic category'.

Confining ourselves for the moment to the feeling for nature, we may certainly assert that in the Early Renaissance, in the work of Masolino and Masaccio, Ucello and Piero della Francesca, nature was

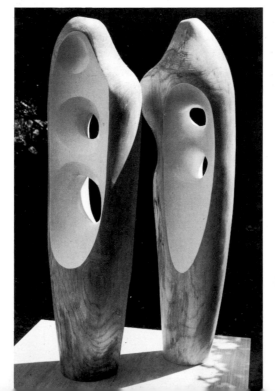

72 Two figures, 1947–48

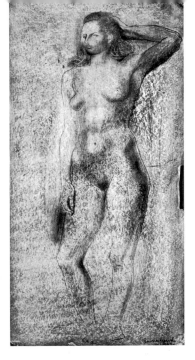

73 Column, 1947

more than a mere background to a depiction of human activity. In the works of these Italians, the relation between the people, standing, moving, gesturing, and their setting, be it a town, garden, a mountain landscape, interior or exterior architecture, is so perfectly balanced, so beautiful, each element making an equal contribution to the whole, that we can understand why when, in the twenties, they stood for the first time in the Brancacci Chapel in Florence or before Piero della Francesca's works in Arezzo both Henry Moore and Barbara Hepworth must have felt an intuitive, half-conscious admiration for precisely this delicate relation between the figures and their no less significant surroundings. It was, if you like, a typically English reaction, a typically English recognition of this harmonious southern Mediterranean solution to the problem of figure and environment.

Barbara Hepworth's feeling for landscape is indeed *not* romantic, and what is typically or fundamentally English we do not know; we can clarify it historically and psychologically, but cannot prove it. What has been clarified has not on that account been proved. There is always an indefinable element – which cannot be explained in

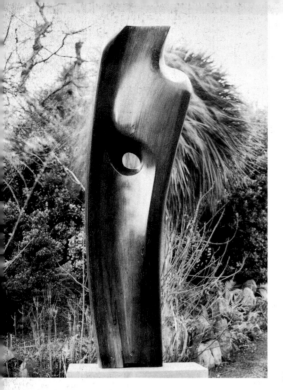

74 Rhythmic form, 1949

terms of English landscape and garden architecture in the sense in which we are speaking of them here – yet which can nevertheless be made more comprehensible.

In his *Studies in Landscape Design*[6] G. A. Jellicoe has shown in striking fashion that the influence of landscape painting on landscape design is an historical fact, but that in our time the sculptors too are contributing. It is important to have the following documentary evidence when stating not only that the sculptor with a talent for the abstract in terms of space has realized what elements of landscape have signified in her own development, but also that a great landscape architect like Jellicoe is always conscious of the inspiration this type of sculpture has meant in his own work.

We shall see the influence of the sculptor in the design of the hills at Harwell, and it is of interest that in her work a sculptor like Barbara Hepworth is never removed from her environment. It is not surprising that her work can serve as a source of inspiration in the modelling of

75 Bicentric form, 1949

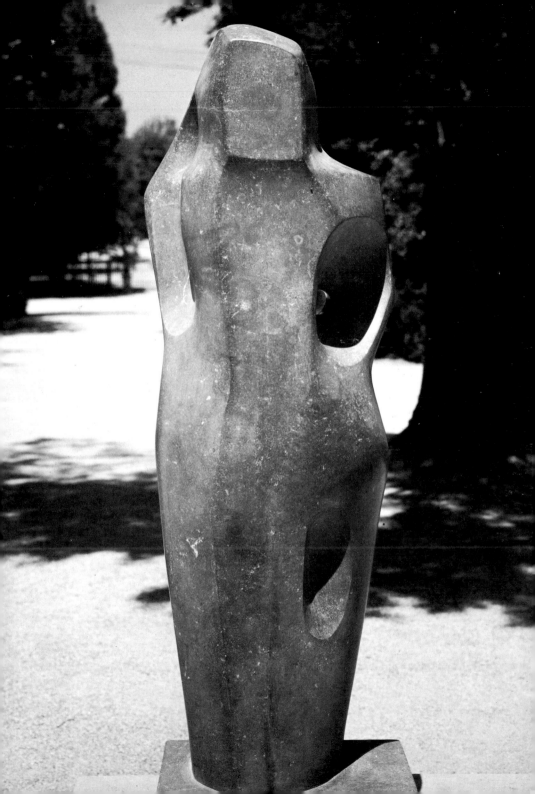

land forms, when we read the following example of her own appreciation of space in landscape. . . . This effect upon human beings is the ultimate objective of all landscape design, whether rural or urban.

Jellicoe also refers to Paul Klee as being an inexhaustible source of invention in a field which the landscape architect can also make his own.

If we relate this to what Adrian Stokes has written regarding the significance of the environment to the psychological and artistic aspects of man's creativity, we shall arrive at one of the most important moments of coherence in the spatial achieved in England in our time.

One would want, of course, to see evidence of what has just been said about landscape in the sculptures themselves. But it can only be seen there indirectly, for these sculptures are never an imitation of natural forms nor an evocation of geographical fact.

Essential changes came about in the form of Hepworth's sculptures once the spheres and circles decreased in number and the ovals increased. This occurred in 1943. It is not merely that ovals arrive on the scene, but the holes in the masses become larger and more frequent too; they double, treble in number. Forms even acquire two centres instead of one.

This, of course, is not without its significance. The vitality which was expressed or symbolized in the centrality of the circle shifts towards the oval, in which centrality is abandoned in favour of two centres, entrances to the closed form, which thereby acquires the character of a connective form.

The result is a more complicated interior form. Of necessity, the function of the strings becomes considerably more important. In 1943 she was still making forms (without strings) with a complex of holes which formed connected arches within. In the same year forms also appeared with separate holes but with criss-cross groups of strings which link them together. Further advances were made along *Ill. 62* these lines, each year bringing new surprises. In 1944 the waves came into being, and in the drawings as well. Here the hole has mastered

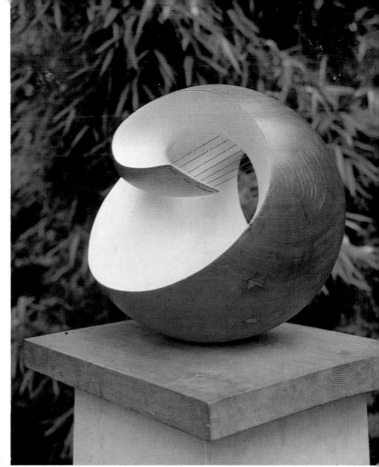

76 Pelagos, 1946

the interior and even broken it open to such an extent that it loses the character of a hole. We can see the same phenomenon in the drawings. The result is a more powerful expression of movement and light, so that mobility is now developed clearly in the spiral (1944–46), a particularly important aspect. This has a considerable bearing on the totality of form and hole. The hole is no longer an aggressive attack on the closed form but acquires a dominant significance in harmony with the total mass. It is as if the spiral concept binds the two components (the open and the closed) together in one movement. There are countless variants; the combination of the twofold hole and the use of pale, matt blues and yellows confer a

Ill. 76

Ills. 71, 72

105

remarkable character on the works produced in the period 1946–48, with signs of change becoming apparent in the last year. These sculptures have now indeed become apparitions rising up out of human characteristics and the landscape.

All rectangularity has given way to flowing movement, the one element merging smoothly into the other. A harmony is achieved which nevertheless contains within it elements of contradiction and discord. The complexity resulting from there being more than one way of entry; the continual dissociation from any tendency towards centricity; the labyrinthine nature of the arches which appear inside the work – these are not signs of peace, but of tension.

Once again we may cite Wordsworth, where he is concerned with a related structural situation in *The Prelude*. The quotation calls for no comment.

77 *The hands and the arm, 1948*

78 *Hands operating, 1949*

> Dust as we are, the immortal spirit grows
> Like harmony in music; there is dark
> Inscrutable workmanship that reconciles
> Discordant elements, makes them cling together
> In one society.

More than ever before the process of form has become the process of our inner life too, in association with life in general.

The titles Hepworth applies to her works continue to resemble those used during the thirties: 'two figures', 'oval sculpture', 'landscape sculpture', 'single form' (the addition to which of 'Dryad' is due to a Cornish influence); yet titles such as 'elegy', 'eos', 'pendour', 'pelagos', 'eidos', with their mythical resonance, introduce an attitude of mind – mood would be too weak a word, for everything invariably becomes form independent of mere mood.

In both the drawings and sculptures there is, however, a tendency towards a temporary – yet so far only partial – return to the human figure. In the drawings the nude is the source, while, in 1948 the series of figures in hospital uniform comes into being as a result of

the artist's being allowed to attend operations and make drawings of what she saw. Her daughter had to have an operation at the Princess Elizabeth Orthopaedic Hospital in Exeter, and since one of the surgeons there was a personal friend, it was possible for Barbara Hepworth to be present where normally no artist is allowed. It is the

Ills. 77, 78 studies of hands and their attitudes in this series which strike us most forcibly, with the respect they show for the work these hands are doing and with their feeling for beauty. The simplicity, severity even, of the clothing and the significant grouping of the figures, as on a stage, give this 'intermezzo' a style all its own, which may have something to do with recollections of the artist's days in Italy, and of the art, for example, of Giotto.

Ills. 74, 75 In sculptures, too, such as *Bicentric form*, *Cosdon head*, *Rhythmic form*, all dating from 1949, the human image begins to exert a pressure on the abstract element, one which it can hardly bear with. It is as though the 'discordant elements' which Wordsworth had in mind in the passage quoted above are seeking reconciliation in the elements drawn from architecture, human beings and landscape . . . without arriving at a satisfying solution.

79 *Three reclining figures (Prussian blue), 1951*

Venice and Greece

In June 1950 Barbara Hepworth went to Venice at the invitation of the British Council, to represent British sculpture at the Biennale. The artist's solitary stay in the city proved a source of new observations. She was seeing Venice for the first time and she has described the experience as a 'dynamic interplay between the volume of the mass and the volume of space'. It is from her account of her experiences there that G. A. Jellicoe quotes in elaborating his theory regarding the relationship between landscape and architecture and (plastic) art.[1] She reacted visually and at the same time with an intelligence which saw everything in terms of sculpture – to the very essence of her existence. In 1951 she was invited to submit sculptures for the Festival of Britain. This confronted her with the same problem she had met with in 1946, in the London County Council competition for Waterloo Bridge: how to determine the place and nature of sculpture in the urban scene, where it will be surrounded by large buildings and wide spaces continually filled with masses of people on the move. Neither she nor the other five sculptors who were asked to contribute were actually commissioned.

The *Bicentric form* of 1949 and the *Contrapuntal Forms* of 1950, *Ill. 75* made for the Arts Council were still completely governed by a conception of form which tended to assign to the human figure too important a role in abstract work. In the *Turning Forms* of 1950 she retrieved herself and in the ensuing 1951–52 period a growing tautness is discernible, a lyrical introduction to the climax repre- *Ill. 85* sented by the *Pastorale* of 1953. Here, once again, we have the block of marble in all its purity. It has two openings. From it emanates a rural peace, warranting its title. Everything of the thirties is in it, and in the linear features and the surface engraving there is the same mellifluence as in the melody of the flutes in Debussy's music.

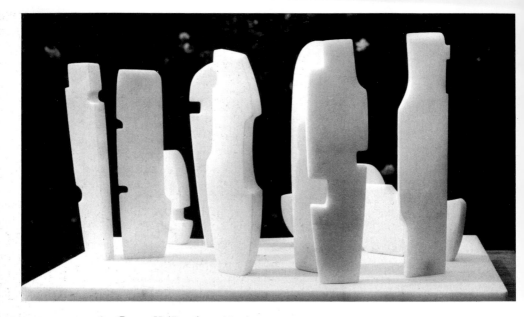

80 Group II (People waiting), 1952

In 1951 a change took place in her domestic life. Her marriage to Ben Nicholson was dissolved. The reasons do not concern us here, but just as in the early months of 1931 their life together had been of exceptional importance to the work of both, creatively and aesthetically, so the drama of this parting twenty years later, too, had a significance which justifies its mention. For it marked the end of a period which had seen a constant, direct exchange of critical opinions, an end which – though the exchange was to be briefly revived shortly afterwards – was indeed final.

It was as though the Fates were pursuing the sculptor as in a Greek drama. In 1953 her first child, Paul, born of her marriage with John Skeaping, was killed in an air crash above Siam. He had been a designer of aeroplanes, later becoming a pilot. In 1954 she made a journey to Greece in an attempt to reconcile herself with destiny. Her experiences on this occasion covered a broader field than those of 1950, when she had gone to Venice, and were probably intenser too. Greece certainly failed to take away her grief, yet with its special light, its landscape and its reminders of the oldest Greek art, it

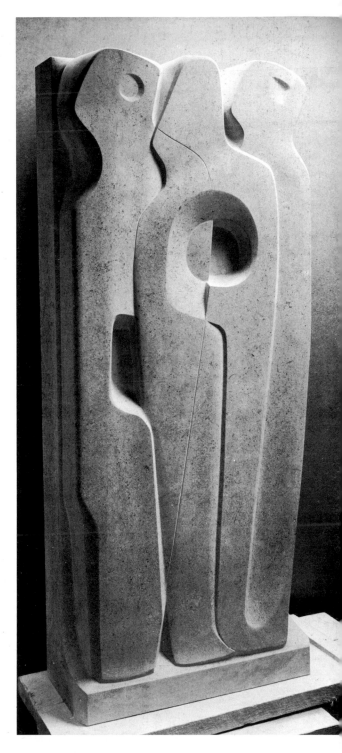

81 *Interlocking forms, 1950*

82 *Vertical forms, 1951*

broadened her horizons, opened wide the heavens of space and brought her back to the true roots of her existence, which lay in her sculpture; brought her back to testing it out yet again and on a grand scale.

The trip to Venice had been a first step towards being entirely on her own. The second step – one which brought with it a powerful upsurge of her art – was the trip to Greece.

She had a sketch-book with her and in it, besides rough sketches, she made notes: brief, concise impressions, visual and aural, all of them rapidly absorbed into the rich experience of her life as a sculptor. Her impressions of light and colour were of an astonishing subtlety. The feeling for landscape became unified, an amalgamation of shapes, structures, colours, light and – sounds. The word 'rhythmic' recurs several times: 'Mycenae – rhythmic movement of mountains. The Royal Tombs – a vast ellipse (pit) of stones on stones. Majestic landscape, hills purple and pink, blue and some deep red – the lower margin of hills rhythmic with olives; the upper hills rhythmic with folds from left to right.'

Over the Acropolis; the spaces between the columns – the depth of fluting to touch – the breadth, weight and volume – the magnificence of a single marble and all-pervading philosophic proportion and space!

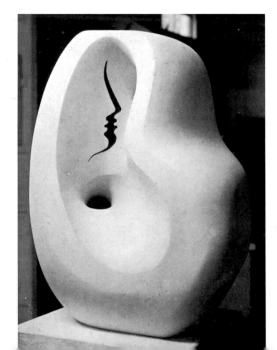

83 Rock form (Penwith), 1951

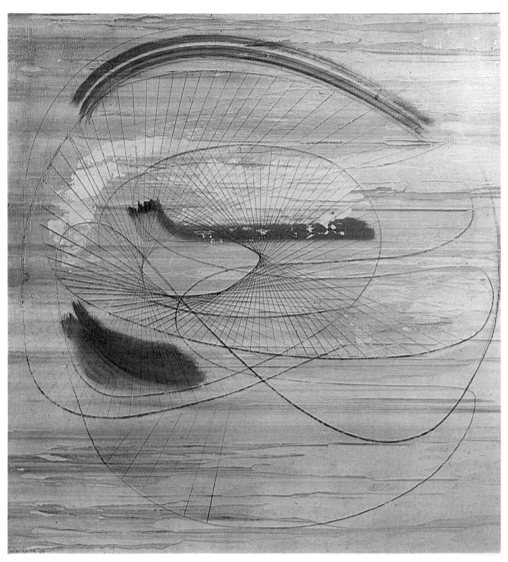

84 Curved form (Orpheus), 1956

But it was Delphi which made the deepest impression on her:

> Standing alone in the stadium, alone below Olympus, I felt at ease both
> physically and spiritually. This experience of being part of Mount

Olympus, part of the plain of Itea and totally alone, did perhaps justify my existence. To describe the day would be to dissipate the visual memory. Instead I hold it secretly to sustain me.

Ten years later, in 'Greek Diary' she declared: 'It is deeply part of my work.'[2]

In the period between Venice and Greece her drawings became fewer. As Alan Bowness has written: 'In the mid-1950's drawing becomes a less important activity again.'[3]

Ill. 84 The impressions of the Greece trip, as she noted them down, were remarkably full of colour and sound, but it was not until 1956 that the effect became apparent. A drawing such as *Orpheus* of that year is, as it were, an apotheosis of transparency, light and movement. It is an evocation of space quite unlike any previous drawing, because the form, even when it had been broken open, had always been definite. But now the form has become indefinite; the line reveals the gesture, the totality of colour and line conjures up space without defining form, because space has now become pregnant with forms.

A new phase had set in and the prelude was full of new possibilities, ever advancing, retreating and reappearing.

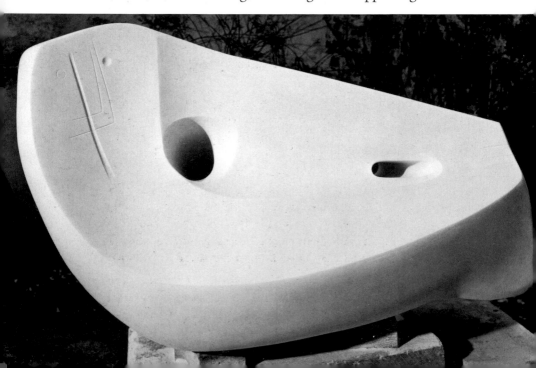

The Big Scale

A certain lyricism, emotionalism, now accelerating, now decelerating, took over repeatedly between the visits of Venice and Greece.

The years 1951–52 were still marked by thin, elongated verticals: *Image, Churinga, Young Girl.* In the following years they continued, though on a more limited scale: *Antiphon* (1953), *Vertical form* (1955–56). The later verticals were no longer so thin, so transparent. The early ones had been more lyrical, elegiac, flowing, open, defenceless and retiring. The next year, on the Greek trip, it was with a presentiment of new creative power that she looked towards the future: 'I looked forward to 1955 – a year of quiet abstract carving – a year of dedication,' she wrote.

Ill. 86

Ills. 87, 91

In 1955, indeed, the heavy pieces of African tree trunks arrived in the garden of her Trewyn Studio in St Ives, filling the place with their 'savage quality of smell', their enormous size and weight – they were between forty-two and forty-eight inches in diameter and weighed two to four tons a piece. Recovered after an illness, she was full of new and excited plans for working on this mysterious, dark and ancient material from Nigeria. She believed these trunks to be as much as fifteen hundred years old.

Carving this wood filled her with renewed energy. 'The great logs', she wrote in a letter to me of February 1955, 'have set me off on a new phase of work. Already one of the largest logs is taking shape – a great cave is appearing within it and I have tunnelled right through the 48 inches and daylight gleams within it. It is terribly exciting to have such enormous breadth and depth. When I have finished perhaps I shall be able to get inside it. Now I want to carve them all at once.' And gradually the smell of them, which had been 'overpowering' to begin with, became 'more gentle and amenable'.

Her being encompassed fierce passion, an affirmation, which led

85 *Pastorale, 1953*

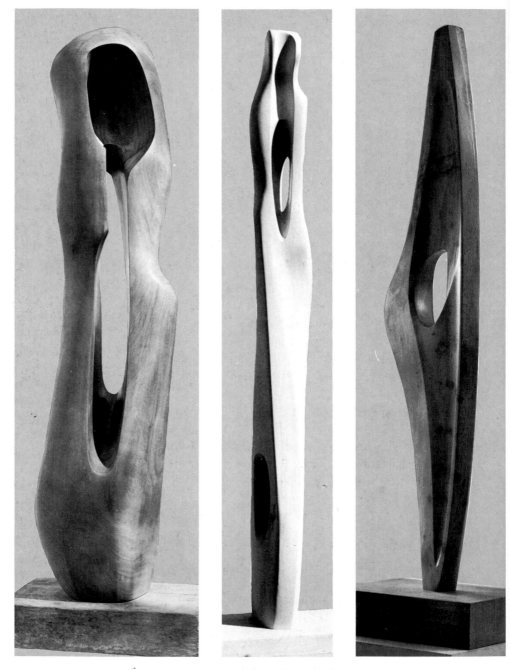

86 *Figure (Churinga), 1952* 87 *Single form (Antiphon), 1953* 88 *Phoenix, 1954*

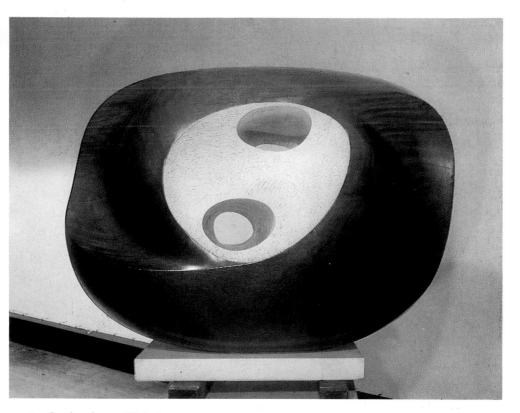

89 Oval sculpture (Delos), 1955

to new formulations of her ideas on sculpture. Engaged on these almost animal wood sculptures with their sonorous boom, she wrote: 'Sculpture, to me, is primitive, religious, passionate, and magical – always, always affirmative.'

The Greek titles she chose for these works, such as *Phira, Corinthos, Delphi, Delos,* reveal the mood in which she was working. Indeed, these were works dedicated to Greece. *Ill. 92*
 Ills. 89, 93

Larger in scale than she was accustomed to, they became a synthesis of the earlier work, in which the new elements bring the open and the closed form into perfect relationship, reconciling the tension in the form (especially in the curves) and the surprising combination of the warm and ominous darkness of the wood with the lucent colour of the interior. Here there is both the composite and the

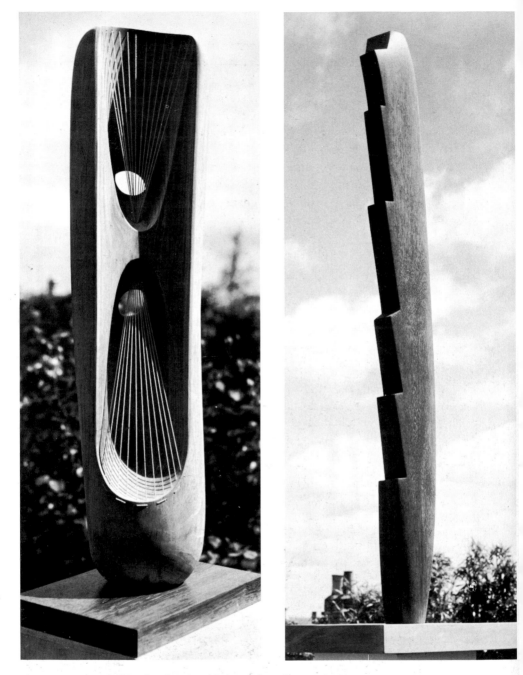

90 *Wood and strings (Solitary figure)*, 1952

91 *Vertical form*, 1955–56

simple. As regards scale, too, her style achieves a quality in these works which it would be difficult to improve upon.

In the course of the succeeding years the urge to work on a bigger scale grew. Hepworth is exceptional among sculptors in that she does not work from a small model whose dimensions are then magnified. In her view every enlargement alters the character of the work and compels one to alter the form.

She insists on remaining uncommitted in negotiating with architects who request a model, and one of her conditions is that it must be understood from the outset that changes may be introduced once the full-scale work is undertaken. 'Man,' she declares, 'is only six foot tall and our whole vision changes according to height and perhaps in depth, and it is a physical reaction which tells on all our spiritual perceptions.'

92 *Corinthos, 1954–55*

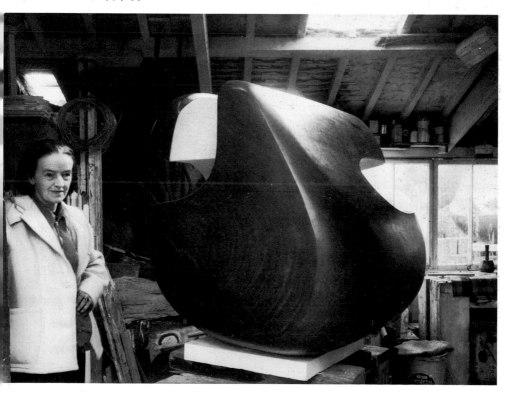

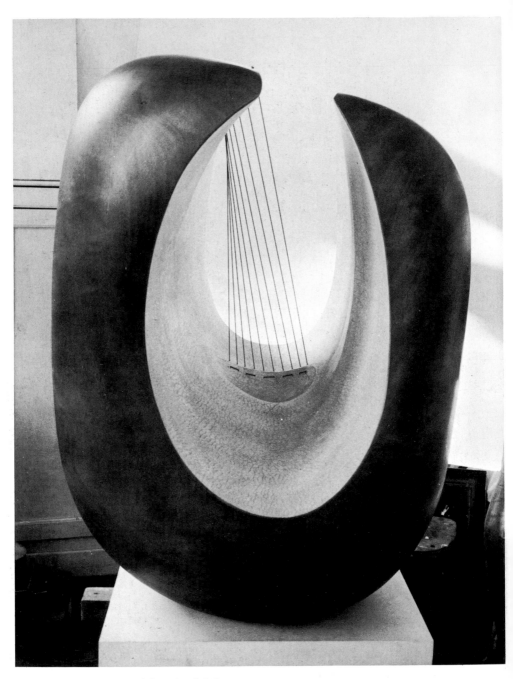

93 *Curved form (Delphi), 1955*

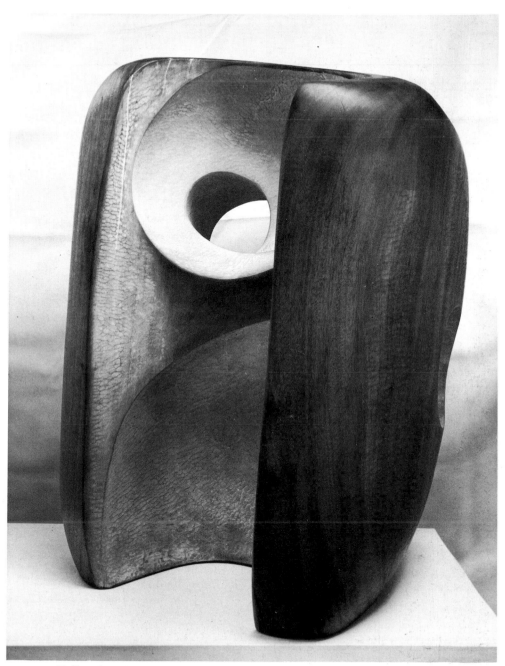

94 *Hollow form (Penwith), 1955*

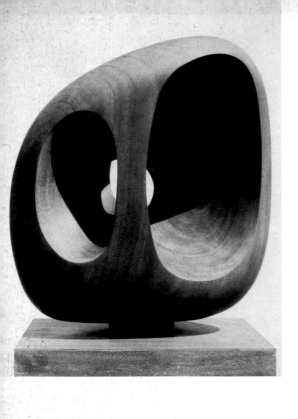

95 Icon, 1957
96 Head (Elegy), 1952
97 Marble form (Coré), 1955–56

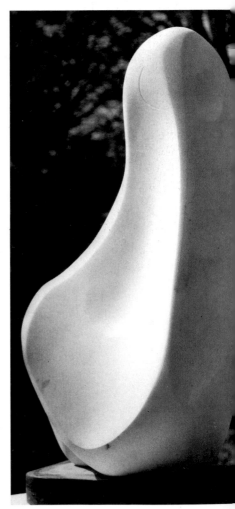

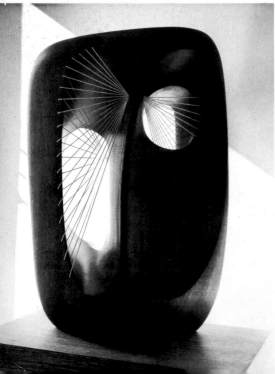

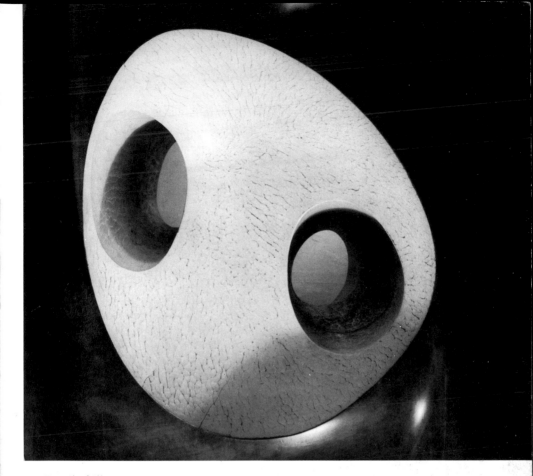

98 Detail of Ill. 89

The years 1955 was special in another respect, too, for it was in this year that she had the opportunity to design the décor and costumes for Michael Tippett's three-act opera *The Midsummer* *Ill. 99* *Marriage* to be performed at the Royal Opera House, Covent Garden. In 1951 she had designed the costumes and décor for Sophocles' *Electra* at the Old Vic in collaboration with Michel St Denis. Now her great sensitivity to human beings in motion and the influence environments have on the way they walk and stand was called upon to meet a new challenge, to which she gave herself

completely. 'I have been swallowed up', she reported, 'by the opera, 18 nights and 17 days never seeing daylight, sleeping at Paddington and working in the theatre all day and travelling between the two by underground. Horrible. But a splendid "first night" when the colour and light of the sets truly blended with the splendid music'. It exhausted her, but it taught her a great deal. Working in a team of about four hundred people gave her every opportunity to observe the effect of space, light and colour on human beings from close quarters.

It had a mixed reception from the critics. A review in *Art News & Review*[1] gives a good impression of the décor's significance:

> The main set is a large tri-lithic gateway, sculpturally conceived and architecturally planned to give space for the action in the plane of reality. It makes passing reference to the austerity of Gordon Craig and to the coloured rectangles of Mondrian. The Magic Wood and the cryptic lotus flower represent the spiritual world. The details of

99 Ritual dances. Décor for 'The Midsummer Marriage' by Michael Tippett, 1955

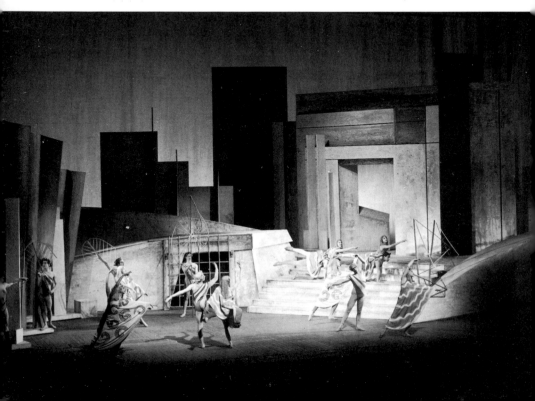

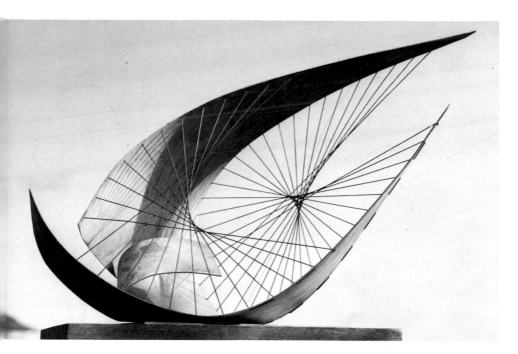

100 Stringed figure (Curlew), 1956

the nets and grills are true Hepworth, and bring space into the sculptural plan. The costumes are treated in mass rather than individually. The colour range of blues of the women's costumes creates a chorus rather than decorates individuals. It is a courageous production and the most outstanding set at Covent Garden since *Salome*.

She had been working on it as early as 1954. It meant a new discipline, in which she laid stress both on movement and on the significance of the gesture. If there is anything she regrets it is our age's inability to profit sufficiently from the discoveries of contemporary abstract art, when producing operas and plays. It does so now and again, and the ballet, particularly since Diaghilev, has demonstrated the possibilities. Yet the trend has never developed, just as in architecture innovations which could be of great value to the community have always remained rare exceptions only, examples to be recorded in historical studies and pointed out to specialists and the initiated.

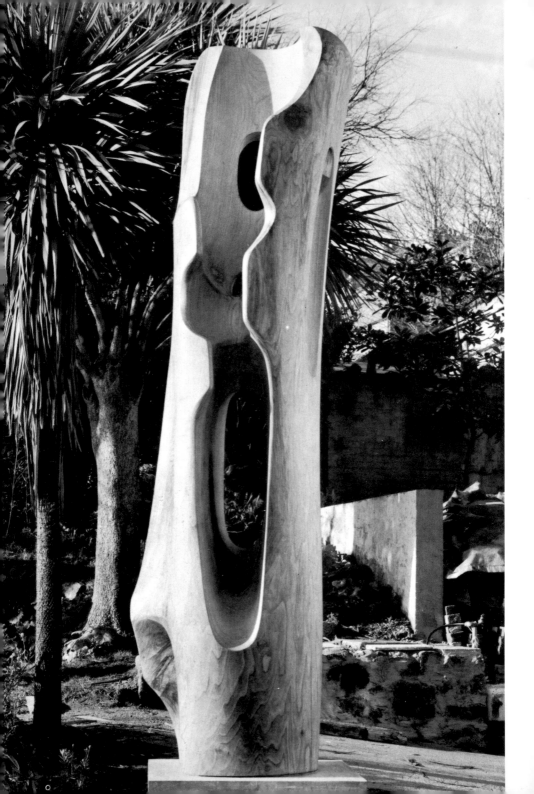

The Bronzes

In 1936 it must have seemed inconceivable that Barbara Hepworth would ever work in bronze. The revolt against modelling in clay was both an historical revolt and one involving artistic and moral principles; it concerned what followed after the modelling – the casting in bronze. Twenty years later it could be said that the battle had been won, views had matured and the younger generations had no ambition to revive Rodin – what they wanted to do was to broaden their means of expression by using other techniques. Truth to material, as has been said, was more than a technique, it was part of a way of life.

The generation of Reg Butler, who had been familiar with working in iron from childhood onwards, of Chadwick, Armitage, Paolozzi, Caro, introduced other values. Butler's award-winning

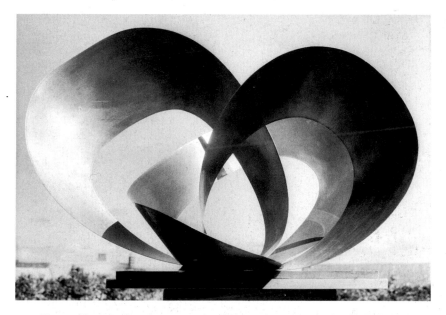

101 Figure (Requiem), 1957 *102 Forms in movement (Galliard), 1956*

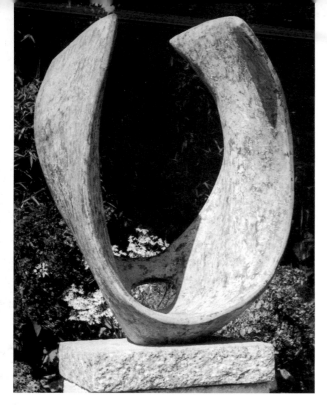

103 *Curved form
(Trevalgan), 1956*

Monument to the Unknown Political Prisoner riveted attention on iron and bronze, always seen in relation to the psychological and aesthetic areas of experiences which could find a means of expression in such materials and such a technique. Herbert Read does not exactly say so but the names he quotes in his *Concise History of Modern Sculpture*[1] allow one to conclude that the choice of materials in sculpture must be dependent on whether the artist is, or is not, subjected to some degree to the 'shadow' in the unconscious, which term Read derives from Jung. The surrealists, the vitalists, do not, indeed, succeed with Brancusi's and Hepworth's rigorous discipline of material and form nor with that of the constructivists. Yet it can hardly be maintained that this 'shadow' element is lacking in Hepworth's work, though in that work it is held in check.

The development reflected in her work during the 1950–57 period was none other than a coming to terms with the active shadow elements in her personal life. Then, too, there was the process of

128

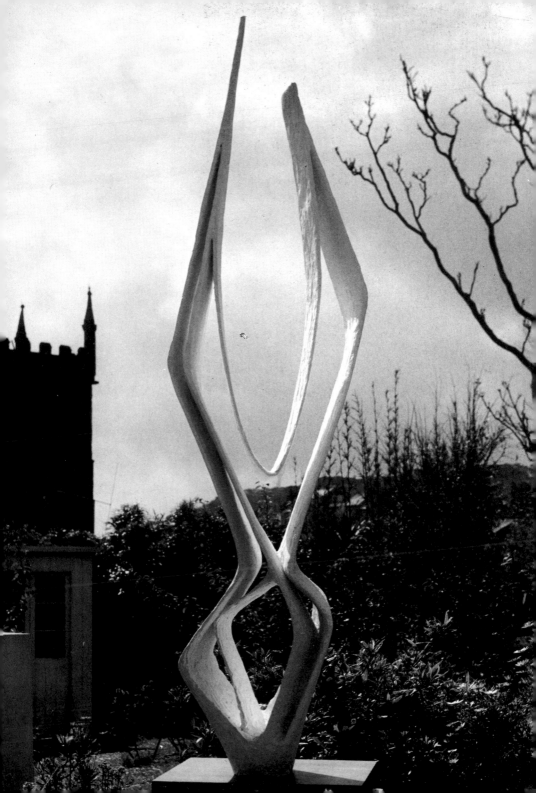

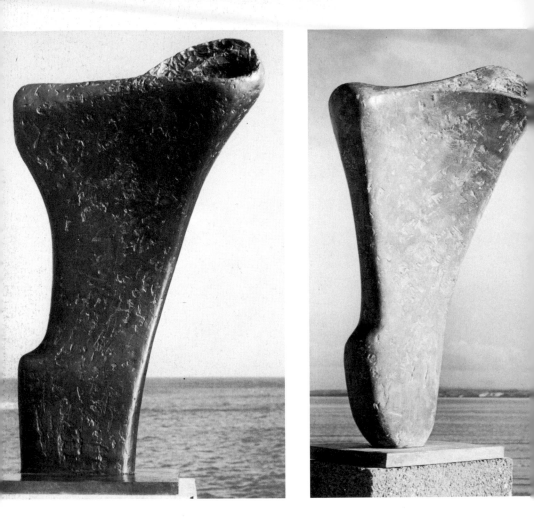

ageing, of gradual apprehension of the past. The strength of her style has lain in the nobility with which this has been objectified in the construction of the forms, which, in my view rightly, rejects any reference to events in the artist's private life. A distance has been created between the artist and such events, which are nevertheless presented in her work. The building up of form in her work has always amounted to a victory over life's various destructive threats and assaults. The same year which saw the creation of the large sculptures which Greece had inspired, *Delos* and the others, shortly

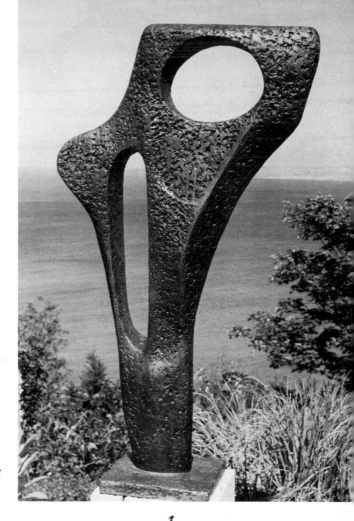

105 *Torso I (Ulysses), 1958*

106 *Torso II (Torcello), 1958*

107 *Figure (Archaean), 1959*

afterwards produced her first experiments with metals, with iron and bronze carved in hard plaster. It would appear today as having been a concession to the methods Butler had introduced. Actually, however, it was, it seems to me, in part a matter of sensitivity to what the younger generation was doing. Although she did not share the views of Butler and his fellow-artists, she pondered the possibilities which iron and bronze had to offer to her. It rescued her from the dangers inherent in accepting the 'truth to material' as the sole determinant of sculpture's significance.

108 *(pp. 132–33) Trewyn garden with 'Figure for landscape' in foreground*

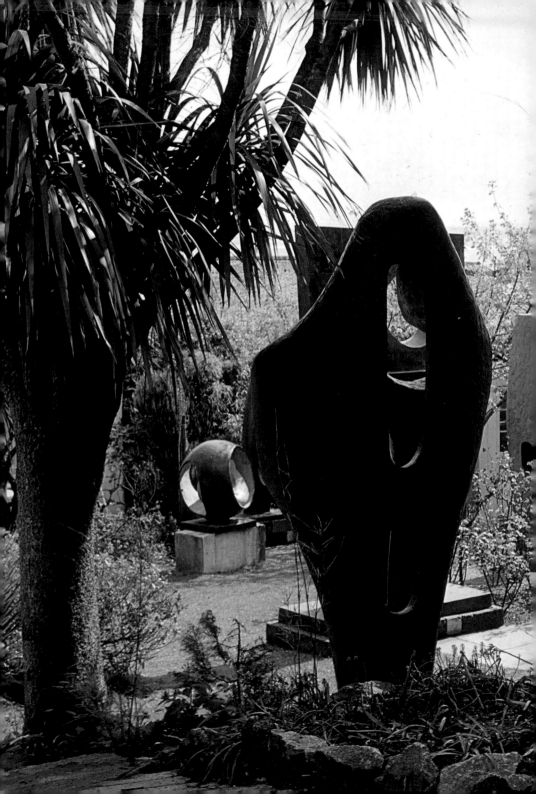

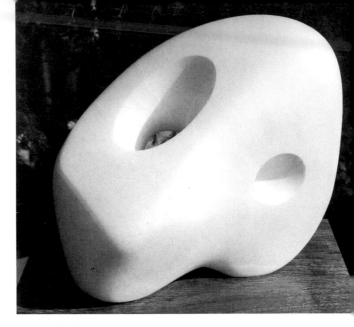

109 *Landscape figure,*
1959

110 *Head (Icon), 1959*

111 *Small form (Trink),*
1959

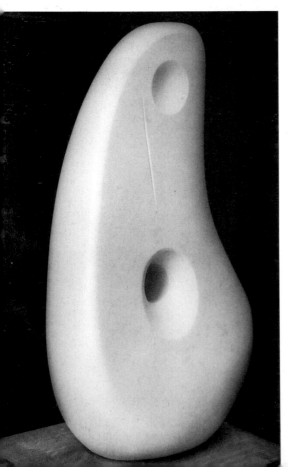

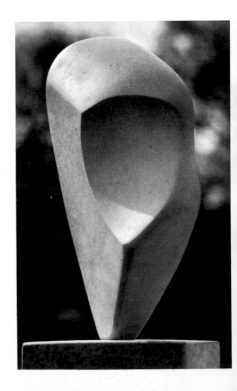

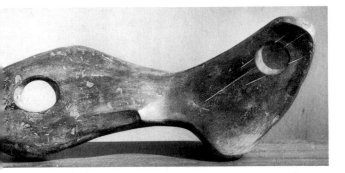

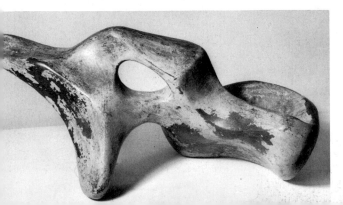

112 *Forms (West Penwith), 1958*

113 *Reclining figure (Trenona), 1958*

114 *Reclining form (Trewyn), 1959*

But she would not be the artist she has become if here, too, she had not sought for a technique related to carving, which conferred on the bronze – via the plaster and after the surface had been finished - a character all its own, making it something more than a way of reproducing a model.

Another and more important factor was that these bronzes were produced simultaneously with the wood and stone carvings and at a moment in her life when she was ready for work of this kind.

The drawings of this period confirm the process. Alan Bowness was right to attempt for the first time to trace the connexion between the drawings and the sculptures.[2] When after the journey to Greece a hitherto unknown freedom and mobility became evident in the drawings, especially in their colour, this seemed at first to be inexplicable. Inexplicable to those who held fast to the stringent recipe

115 *Curved form with inner form (Anima), 1959*

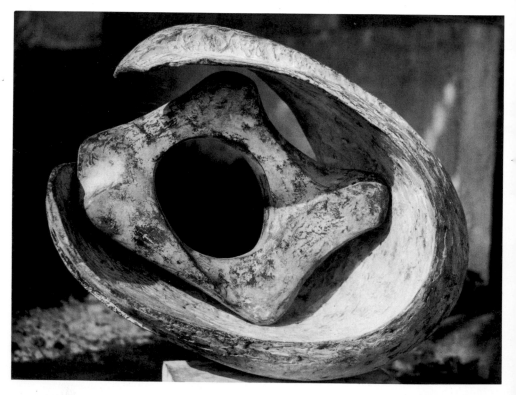

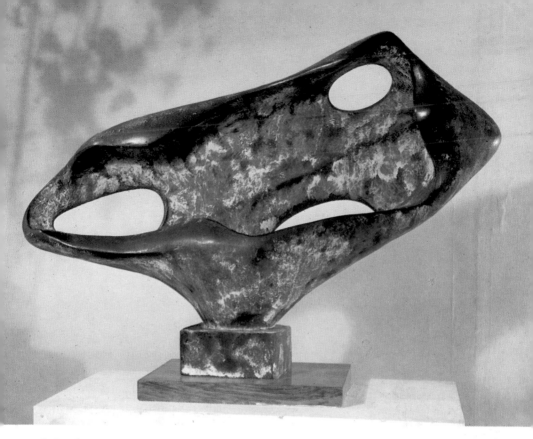

116 Sea form (Porthmeor), 1958

used for the carvings. But the artist later supplied the answer herself – in her bronzes, which, as forms, have indeed been enticed out of the material. This does not of course apply to the bronzes which assumed forms that had been conceived earlier on, when she was working in other materials. Although these castings, too, were subjected to a special treatment, they nevertheless fall into a different category.

Working on a large scale where bronzes are concerned poses its own problems and invariably involves a special effort and technique. Hepworth's work had previously exceeded her normal scale in some commissions, for instance the sculpture for the Royal Festival Hall

done in 1953, but now she had to grapple with volume and mass.

Ill. 117 Seen from a distance *Meridian*, done for the State House in London in 1958, is graphic in character, yet at close quarters the effect is three-dimensional. That is to say it has three-dimensional lineation which seems conceivable and capable of execution only in bronze. It was beautifully cast by Susse Frères, in Paris. The originality of this work lay in the fact that the large scale of the open lines was related to the architecture of the building, one which a closed structure of the same dimensions would have lacked, for a closed form would have seemed small or, in any case, not big enough. The open structure, on the other hand, does away with all suggestion of competition between the sculpture and the building itself as to character and size.

Ill. 121 Three years later, in 1962, she made *Winged Figure* for a side façade of John Lewis's London store in Oxford Street. Erected above eye-level, it is like a shield strung with harp strings which create a play of shadows in the morning and evening light. Here, too, the original touch lies in the open structure of the aluminium figure, which does not emphasize the extent of the long façade and which also succeeds in preserving its own truth although related to the whole.

The bronzes form three groups. One group comprises the closed, strictly geometrical concept, with polished surface. Another comprises the open interior, taken to great lengths, and from this second group the bronzes intended for architectural commissions stemmed.

Ill. 104 Thus *Cantate Domino* came about via the *Gloria* of 1958, in the form of a complete opening-out of the related motif, in which the right and left sides incline towards each other at the top, without actually

Ill. 84 touching. See, too, *Orpheus* of 1956. In the maquette of *Meridian* the movement of lines turns back into itself, sealing itself off.

The third group comprises the organic, abstract bronzes, closed or half-open, like shells, and receptive, with the same delicate female

Ill. 116 elements which can be seen in *Porthmeor*. All these works have a lyrical, sometimes almost tragic or elegiac undertone (see, for

Ills. 105, 106 instance, *Ulysses* and *Torcello*) which had hitherto naturally been rare in her work.

138

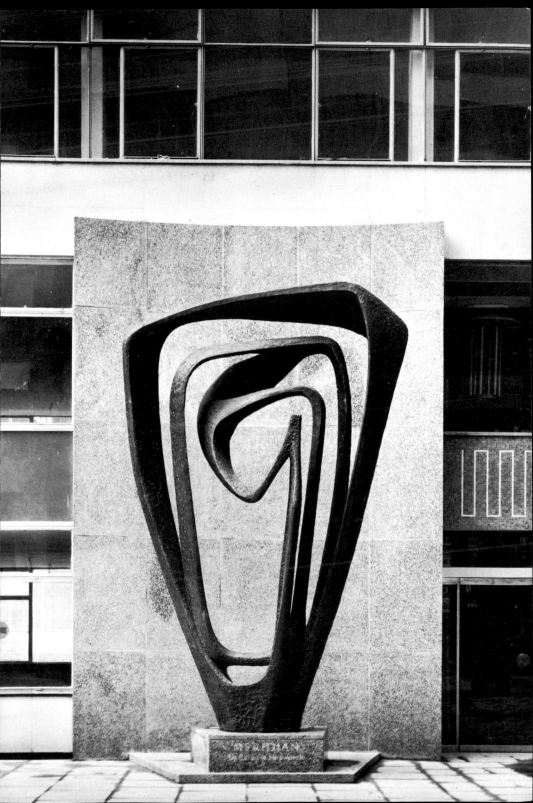

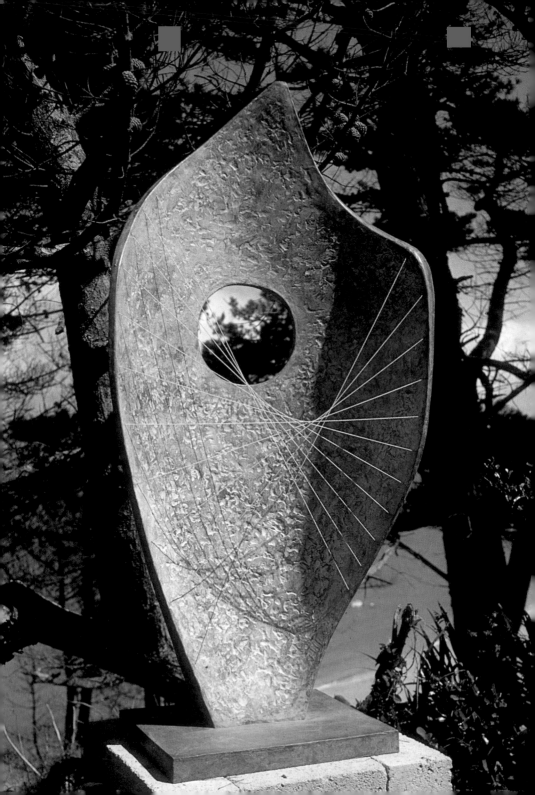

Thus the years 1958–59 were full of potential, with a wider range of materials and an expansion in the number of themes, partly springing from the past, partly new. After the perfectly controlled beginning with the Greek sculptures, done in African wood in 1957, the introduction of a new rhythm was clearly evident in the following year, a rhythm less perfect at times, on account of the influence dark, human undertones had on the absoluteness of the form. Freer, some have said, when thinking of the geometry and the crystals of the past, the results of abiding by the rules. A different sort of freedom, however, when one considers that rules are also involved in obeying forces of another order, the forces of body and soul.

These bronzes heralded the latest phase in her work – a phase in which international recognition has at last brought her commissions, prizes, distinctions. They do not interfere with the solitary, creative life she had been leading, at work in her Trewyn Studio at St Ives.

118, 119 Curved form (Bryher II), 1961 (and detail)

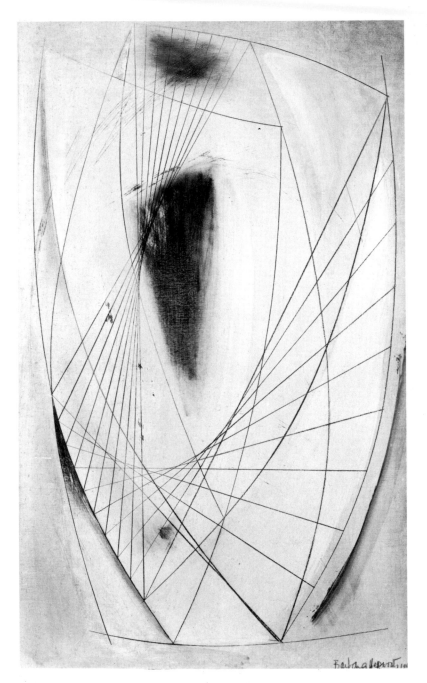

120 *Turning form (blue on a pink ground), 1960*

121 *Winged figure, 1962*

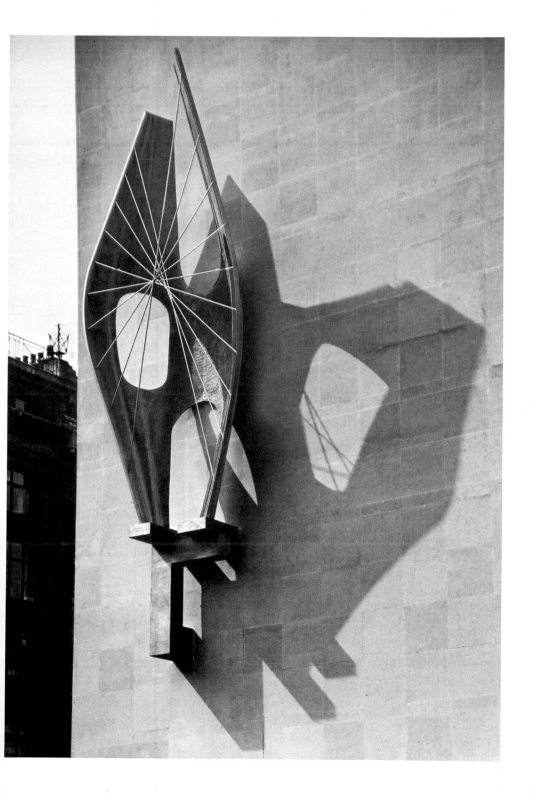

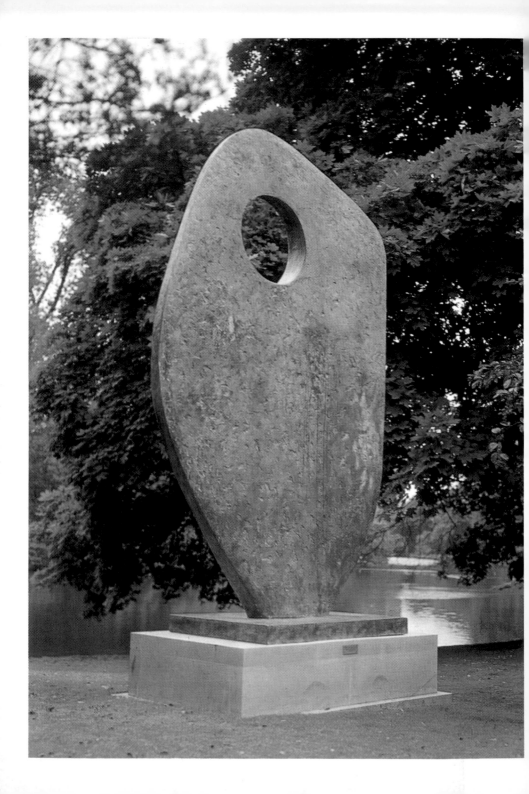

The Nineteen-Sixties

Hepworth's working and living quarters at St Ives became an enclave. Step by step she purchased small houses and land surrounding her studio to have room to create the large works and to erect those that had been finished. The original plot, formed by the garden, surrounded by high walls and with the seagulls sweeping across with their plaintive cries, has continued to be the centre; the living and dining quarters have remained the same for years. But now everything is surrounded by her work. In the garden, between trees and shrubs, stand the sculptures, in bronze, in stone, in marble. Each hour *Ill. 108* of the day has its chosen piece, its favourite. Nowhere else does the abstract sculpture of this century seem to thrive better, to appear more real, than here – half inside, half outside the Trewyn Studio. For what is to be found outside is merely an extension of what is inside. And the light from the tall sky, filtering through the sub-tropical plants, the palms, the reeds, the roses, casts its moving shadows there, blossoms there at its brightest and tenderest. The light dwells in the sculptures, like the bird in its nest, and later in the day it can transform what seemed lifeless patches into the miracle of an arch, a hollow, an opening, through which it can flow.

So far it has become no serviceable yardstick for the art historian but remains something purely subjective, and reprehensible into the bargain – yet the manner in which natural light, so merciless, so indifferent to man, plays with forms is always the most exacting test of quality they have to undergo. A piece of sculpture has never yet been made beautiful, improved, by the flattering fall of light upon it. Light is not in itself benign. Forms receive it, and out of this something nameable and unnameable, measurable and immeasurable, is born which delights those who see it. But it is man, the sculptor, the architect, which brings this about, who acts as the intermediary.

145

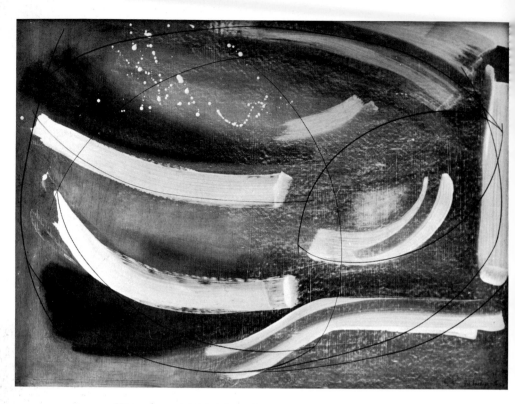

123 Wave forms (Atlantic), 1964

A great part of Hepworth's work has come into being down in Cornwall, with the Atlantic always near by. I have no intention of making yet another contribution to the romantic mythology of Cornwall. In the final analysis, it is the elements with which the artist is concerned, the outer and the inner. Yet the grandeur of the long, powerful breakers of the Atlantic, so utterly different from the bourgeois thrust of the short North Sea waves, is but a romantic fairy-tale – unless accompanied by the creative reaction to them which takes place within the mind and emotions of the artist. Such a *Ill. 123* drawing as *Wave forms (Atlantic)*, is inconceivable without Hepworth's delicate reaction to seascape and landscape.

146

124 Figure (Sunion), 1960

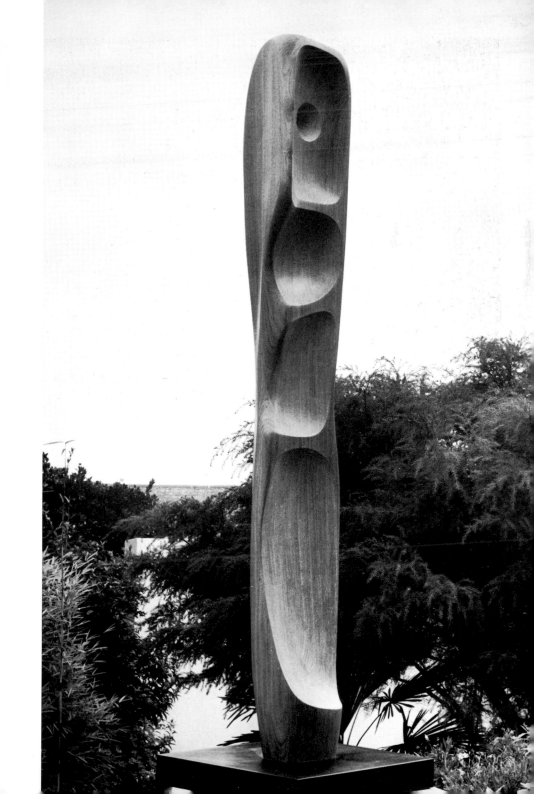

Her production since 1959 presents a highly composite picture. So far the ultra-sensitivity to the human and lyrical feeling of the preceding years had been repressed. The abstraction, expressing itself once again in a severe tautness, relates both to the thirties and the 1953–58 period. The process of creation was bound to take account of the force exerted by the past, and her victory over this results not in any relinquishing of linear features but in a new dialogue. Her repertory of forms is extended. Her experience with 'big-scale' work can be put to good use, and again and again small sculptures appear, performing the indispensable and happy function

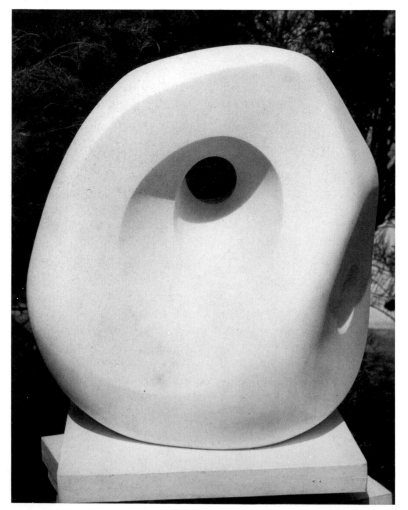

125 *Icon II, 1960*

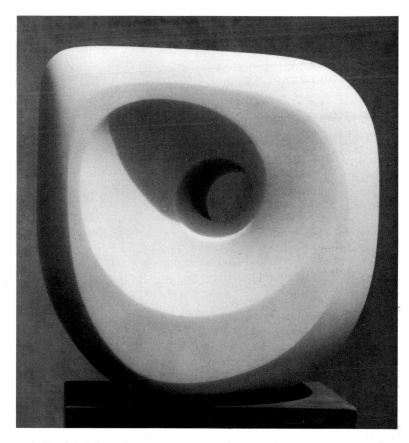

126 *Head (Mykonos), 1959*

of a counterweight. Small groups, composed of two or three units, become more frequent than hitherto. The very direct and strict geometry of the 1934–38 period does not recur. In the sculptures done from 1936 onwards the rectilinearity of the few drawings she made up to about 1941 is almost entirely absent. A fairly large sculpture in blue ancaster stone but destroyed during the war, formed an exception. The combination of the open circle and the rhythm of squares and rectangles contained the elements of the common language of the thirties and especially those of Ben Nicholson's work. In sculpture it remained unique. It was pure form and therefore Hepworth.

Ill. 47

149

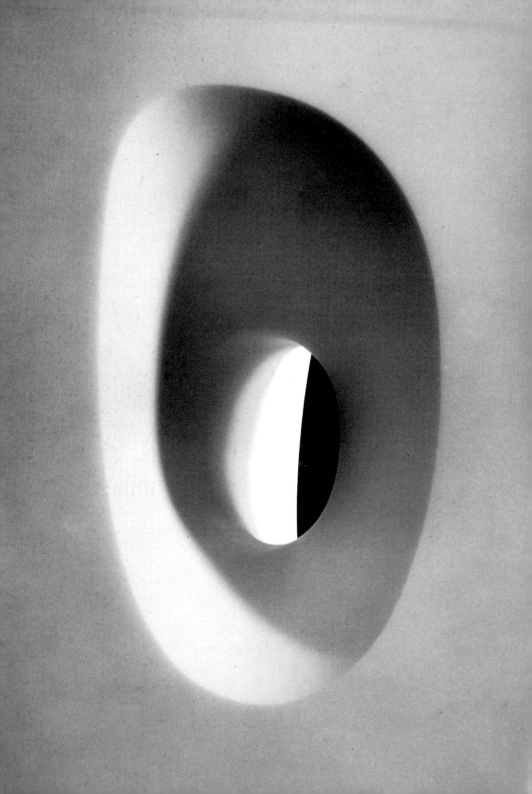

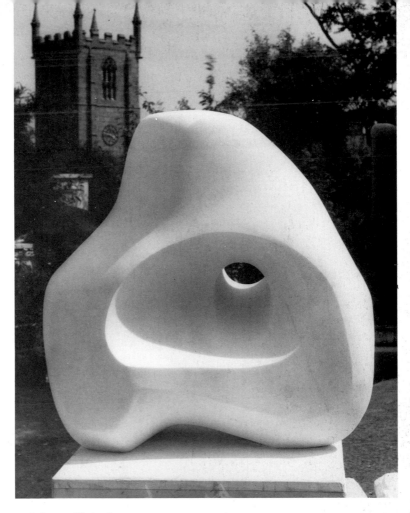

128 Image II, 1960

The years 1947, 1952 and 1953 produced the drawings with vertical, elongated rectangles superimposed one on the other. These are remarkable abstracts in which the human form is easily recognizable, although the consistent rectangularity has rendered them wholly abstract. In the sculptures this resulted in a number of groups of alabaster figures which, however, make a fundamentally different impression owing to the absence of the numerous rectangular components out of which they are built up in the drawings and

127 Totem, 1961–62 (detail)

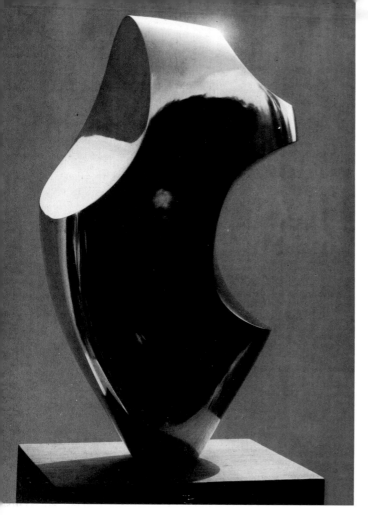

129 *Figure (Chûn), 1960*

which determine the contours there. As sculptures they represent a black, unarticulated volume, rather flowing in outline. The value of these groups appears to differ from that of the drawings, lying, as it does, in the relationship between their component parts.

Ill. 129 *Figure Chûn*, of 1960, in polished bronze, has an affinity with earlier torsos and with the taut curves of some of the figures in the groups. It is, like *Serene Head* (1959), precisely determined in Cycladic curves and lacking all the organic naturalness that character-

Ill. 116 izes *Sea Form, Porthmeor* (1958).

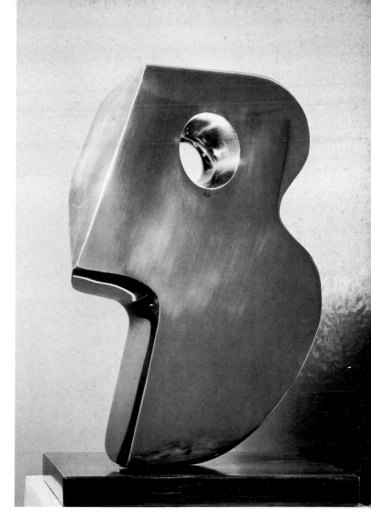

130 *Trophy (Flight), 1965*

The reappearance after 1936, 1947 and 1952–53 of rectilinearity, the rectangle with the circle (as a line, hollow or boring), is a logical consequence of the magnetic field. Discs, arranged parallel to each other, or surfaces arranged at right-angles to each other, open up new possibilities of transforming the space in between into intermediate or anti-forms (see the remark on the Parthenon columns and the spaces between them, p. 112).

The year 1966 was especially rich in relatively small, three- or four-part compositions made up of rectangles: *Three Squares and*

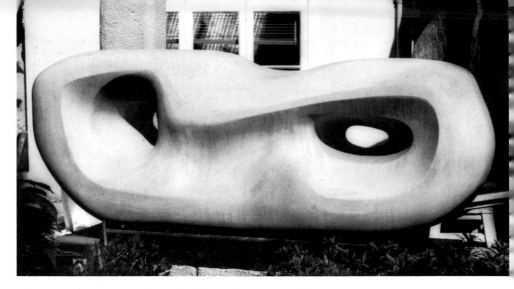

131, 132 Curved reclining form (Rosewall), 1960–62

Ills. 162, 163 *Circles, Three Forms (Two Circles), One Eye Maquette, Four Squares (Four Circles), Six Forms in Echelon.* Some of them were maquettes for big-scale sculptures, others precious, unique works to which the use of alabaster give an air of costliness. Compared with what had gone before, the piling-up of the parts, the refinement of their relationship to one another, and the rectangular arrangement emphasize their three-dimensional character. They have, moreover, a simple architectural quality, which leads almost automatically to their development on a larger scale.

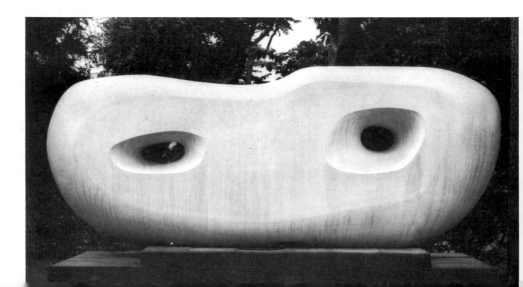

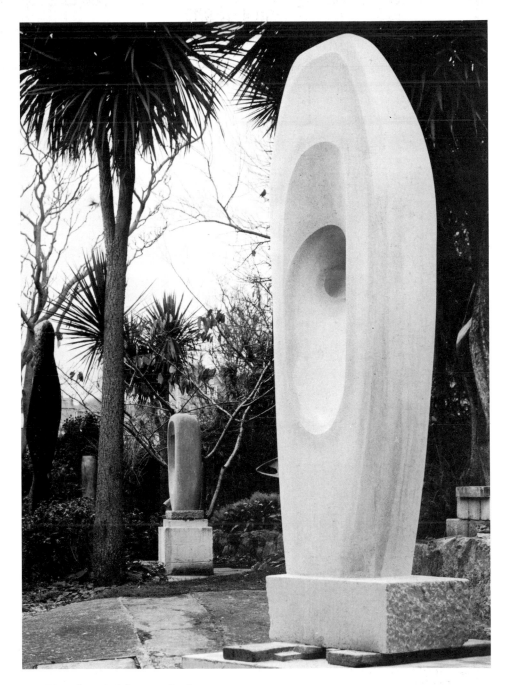

133 *Pierced vertical form, 1962–63*

134 *(p. 156) Figure for landscape, 1960*

135 *(p. 157) Rock form (Porthcurno), 1964*

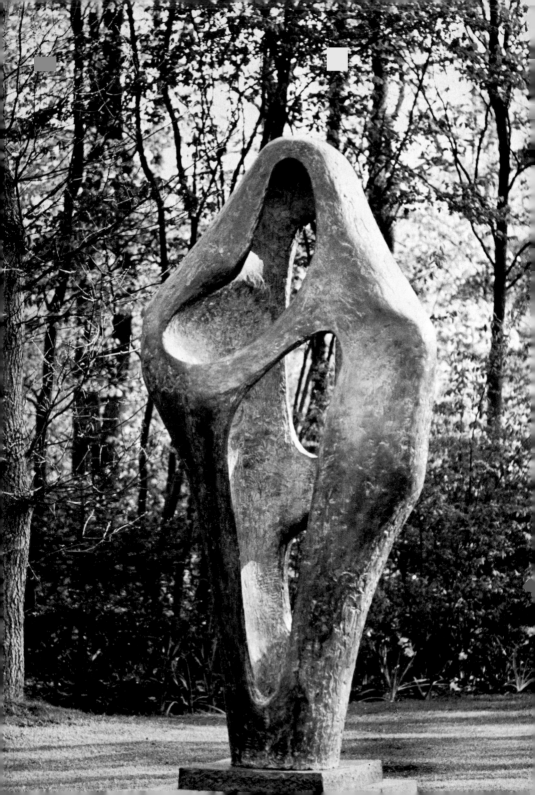

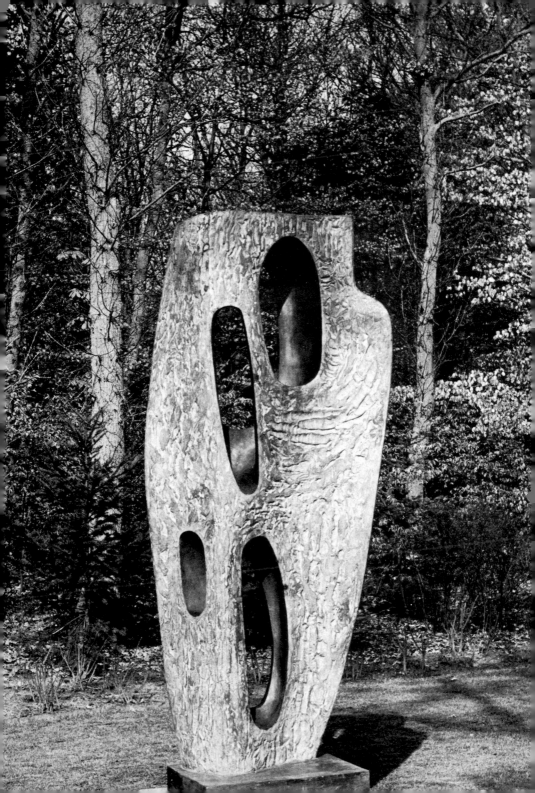

In the tension between the small sculptures, some of which are closely interrelated, and the large-scale projects designed for landscape setting, is manifest an interaction between large and small which proves highly fruitful.

The simple rectangles and circles, of large dimensions and placed on a pedestal, may indeed bear a relationship, as regards composition, to earlier, pre-1940 works; qualitatively they are none the less three-dimensional in effect. They are totally form, by virtue not only of the gentle arching of their surfaces, but of the strength that resides in their circular cavities. It is as though the function of the hole, which formerly had seemed to be a breaking-through to the outside, has been reversed; as though space itself had made these

136 Sphere with inner form, 1963

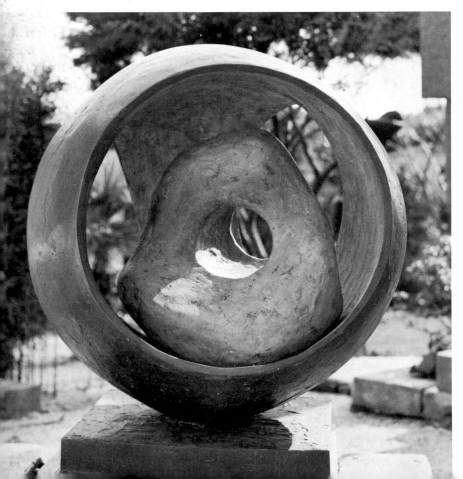

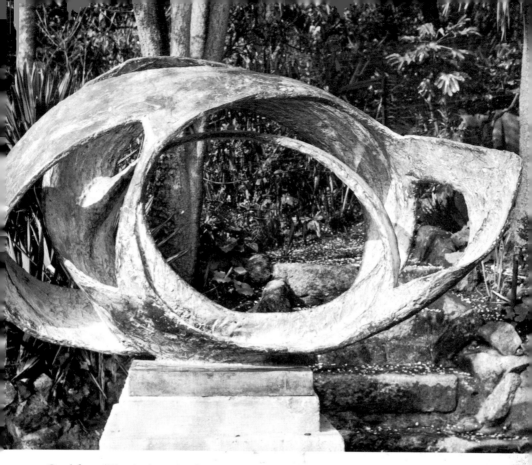

137 Oval form (Trezion), 1962–63

holes, working on the material from the outside, the hole simply sliding into place. The approach is now from the spatial angle, whereas formerly it had been the mass, nearly all either spiral or oblique, that had been the criterion. Seen in relation to the architecture of the late Dutch architect Rietveld at Otterlo, where the Pavilion of Sculpture he had designed for an exhibition at Sonsbeek in Arnhem has been re-erected in the Sculpture Park, these compositions are a revelation. Rietveld's origins in the Stijl movement (Mondrian, Van der Leck, Van Doesburg) were never so evident as when the large Hepworth sculpture was placed in position – separate

138 *Square forms with circles, 1963*

139 *Square forms, 1962*

from his pavilion, yet in a carefully calculated relation to it. The open architecture, which consists of vertical and horizontal sliding surfaces, has a rhythm of its own. The gentle curves of the sculpture, the strength of its simple structure, and the dimensions of the holes, generate a different rhythm, resulting in a dialogue spoken by two different characters in an allied language.

Seen in relation to the changing rhythms of the wall structure in Rietveld's pavilion and the natural scenery outside, the two circle-shaped holes in Hepworth's sculpture acquire a highly individual *Ill. 140* function and significance. As a result, we have here one of those rare examples, in the period of functional architecture and the ensuing years, of sculpture and architecture enriching each other. It makes us realize once again how many opportunities have been missed so far during the twentieth century, opportunities for the architect to find the artists with whom he could have realized the rich potential in our time of architecture and the abstract plastic arts.

140 *(pp. 162–63) Rietveld Pavilion, Rijksmuseum Kröller-Müller, May 1965*

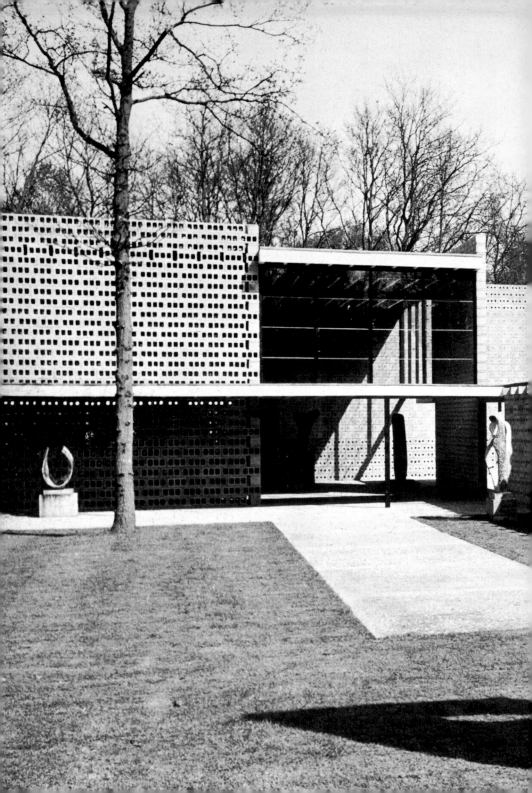

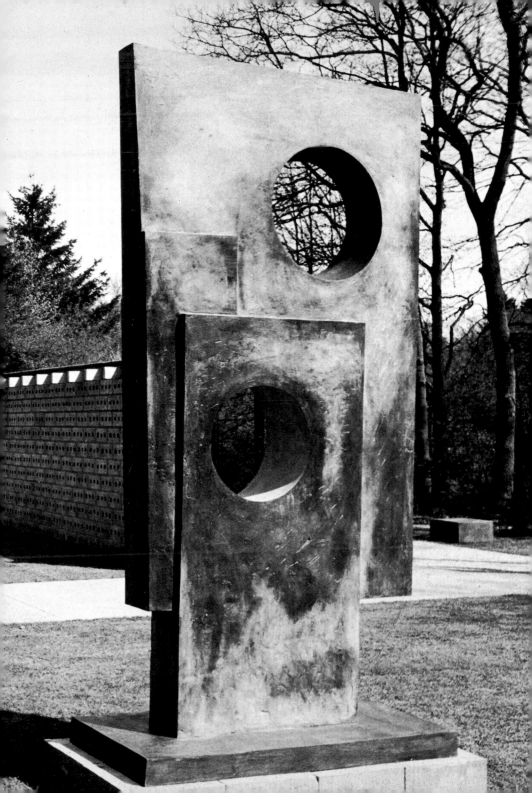

Another example of a big-scale work related to an existing building – by its design and not merely by its siting – was the Dag Hammarskjöld Memorial on the East River in New York, next to the United Nations Building.

Ill. 142

'Single Form' themes have occurred in all Hepworth's phases, from 1934 onwards. They were not always as simple as in the 1935–37 period, with the sloping surface at the top. It was of the upright stones of the neolithic that Bernal was reminded when he saw the early exhibitions of Hepworth's work. He might have quoted the Old Testament in which Jews like Jacob raise a neolithic stone as a memorial on the spot where, sleeping, they had received their heavenly visions. The *Dryad* of the 1945–46 period was already less simple; in 1953 there was an *Antiphon* resembling the tall, slim figure of a girl. The later years brought verticals which came closer to what was ultimately to find form in the *Memorial*, the large, simple bronze shield, with its single spatial eye. In earlier versions on a small scale (for example in *Single Form*, 1961, in walnut) it had remained a circular valley.

Ill. 68

Ill. 87

Ill. 122

Ill. 141

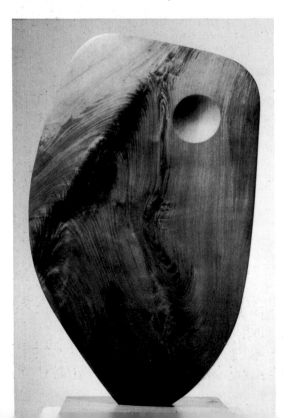

141 *Single form (September), 1961*

142 *Single form, 1962–63*

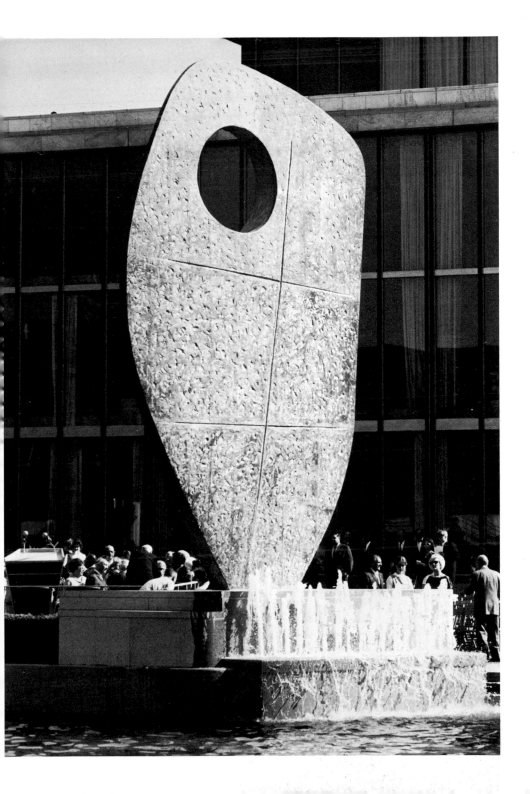

I do not know at what stage the valley became an eye, but the decision to make the change must have sprung once again from the desire to pierce through the material. This arched form with no centre was given an acentric open circle which sets up a tension with all the edges, a tension that is resolved by the perfect clarity of the circular cavity. It is as though it has developed out of the ancient wisdom of China, as though it has grown out of images.

The work was not originally conceived as a memorial, for Dag Hammarskjöld had, before his premature death, discussed with her the matter of a sculpture to be erected near the United Nations Headquarters building. He was an admirer, who had become a friend once her work had penetrated as far as New York. It seemed that when he died in the tragic air crash in Africa during the troubles in the Congo, the idea of this sculpture died with him. His successor, U Thant, however, together with others, succeeded in reviving the idea, and the work was accordingly commissioned from her as a memorial to an outstanding man. She made several journeys back and forth in order to fix as precisely as possible where the sculpture should be set up.

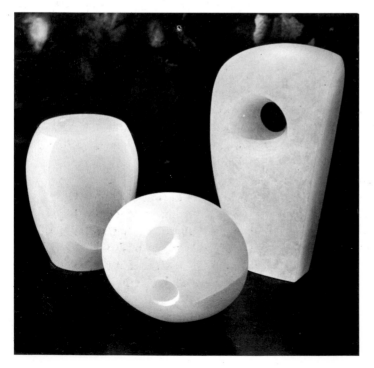

143 Three forms (Porthmeor), 1963

144 *Night sky*
(Porthmeor), 1964

In the drawings of recent years – last on exhibition at Gimpel Fils, London, in the summer of 1966 – changes have taken place as broad as those seen in the sculptures. There is a new flowering, perceptible in the altered – or rather the adjusted – relation of colour to line.

Between 1940 and 1956 (the year in which the *Orpheus* drawing *Ill. 84* was done) the colour is bounded by the line. Since it is the line in her drawings which conjures up the form, the function of the colour is to reinforce the form via the line; it can then sometimes be a means of emphasizing movement. It seldom achieves greater autonomy than in *Porthmeor*. Earlier, the colour was often transparent, hardly *Ill. 144* material at all, but in recent years it has become more positive, fiercer, more obviously material. Ignoring the lines, we see that the colour divides up the surface into two or three fields, which emerge.

167

145 *Three monoliths, 1964*

In *Construction II* the vertical and horizontal lines are like transparent
Ill. 148 crosses in a landscape. We are conscious of a symbolic mood accentu-
ated by the night-blue in the colouring.

In this latter period the colour has gained in importance in the
colour/line ratio; a harmony has been achieved, free from mutual
dependence. Each acquires its own structure, taking account of the
other only where the aesthetics of the drawing are involved. The
symbolic mood is undoubtedly unconscious. The dark undertones
of the colour, reminiscent of the vague yet ineluctable dawning of
the light or of its last glimmer, have not been willed, not appre-
hended; they have simply come into being, like a deep, dark, yet
shining feeling of pain and joy. Owing, probably, to an unconscious
intention to suppress every association or symbolic interpretation,
these drawings have been given the laconic title of *Constructions*.

168

146 *Marble with colour (Crete), 1964*

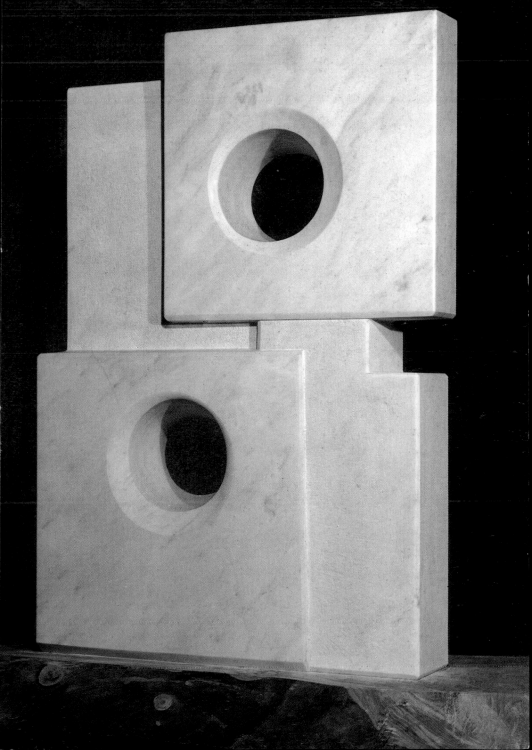

147 Construction I, 1965

Nevertheless, absurd though it may sound at first to English ears, they remind one of the art of Caspar David Friedrich – his drawings in particular – and of Otto Philip Runge, the colour theorist. There the desire for the symbol had been conscious, the feeling for landscape rooted in romanticism – as among the English romantic painters and poets (Wordsworth excepted). That this work of Hepworth's should evoke memories of Runge, Friedrich and the Nazarenes will seem less preposterous if one recalls the emergence of certain signs of abstract art in their day. Kurt Badt has mentioned this in his *Raumphantasica und Raumillusionen. Wesen der Plastik.*[1]

Among the artistic tendencies of the nineteenth century there is also a tendency towards abstraction, an ever-growing alienation from individual objective reality. . . . In the romantic painters, Caspar David Freidrich and Otto Philip Runge as well as the Nazarenes, it is manifested in the emptying of physical phenomena, the weakening of everything individual to an exiguous formal role and its reduction to the status of a partial representation of some general determinate. These are the consequences of an unbridled intensification of emotionalism which set out to make real the extremes of the possible.

148 *Construction II, 1966*

Further support for this view of mine will be found in the words of Robert Rosenblum, in *Art and Literature*.[2] Rosenblum sees features in Friedrich's art which, internationally interpreted, could lead to a reconstruction of the very foundations of modern art, 'For in the history of art', he writes, 'no less than in the history of music, literature and philosophy, German Romanticism establishes restless conditions of continuous pertinence to the dynamics of 19th and 20th century painting.'

Friedrich avoided making direct use of the Christian themes of the past. He brought a sensitivity, new in his century, to the latent forces in nature which had previously been represented in religious or specifically Christian themes. Rosenblum traces a line through Friedrich to Van Gogh, Hodler, Munch, and ending with Mondrian:

149 Forms in echelon on an orange ground, 1963

150 *Genesis III, 1966*

The austere, hierarchic structures of the Dutchman's trees, church façades and seascapes, the very themes which had most attracted Friedrich himself, restate, in 20th-century terms, a comparably passionate effort to disclose nature's abiding mysteries that would ultimately result in Mondrian's case, in a pictorial vocabulary even more lean, ascetic and impalpable than Friedrich's own.

Where Hepworth is concerned, it would be going too far to add her name to Mondrian's in Rosenblum's exposition – on the grounds of the drawings of recent years. There can be no doubt that in principle she shared Mondrian's ideas as regards the 'plasticity of relationships and proportions', but her sensitivity, and relation, to nature – ever

a positive sensitivity – prevented her from attempting absolute suppression and destruction of form. Just as Wordsworth stood apart from the other poets in his relation to, and vision of, nature, so Hepworth in her art remains – where feeling for landscape is concerned – innocent of any projection of the self on to the landscape such as we undoubtedly find in Friedrich's work. What Hepworth's work does possess is a curious component which is at one and the same time symbolic and abstract; in it, in fact, the natural and the human have become metaphorical.

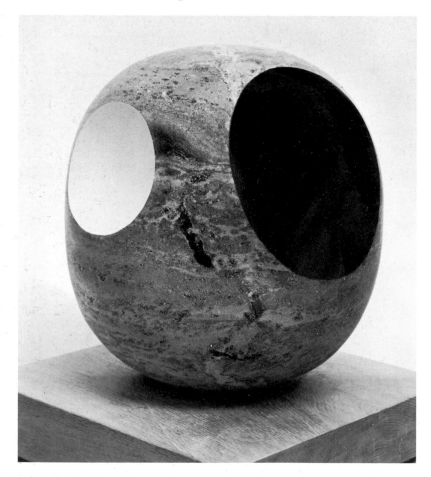

151 Sphere with colour (grey and white), 1965

152 Two ancestral figures, 1965

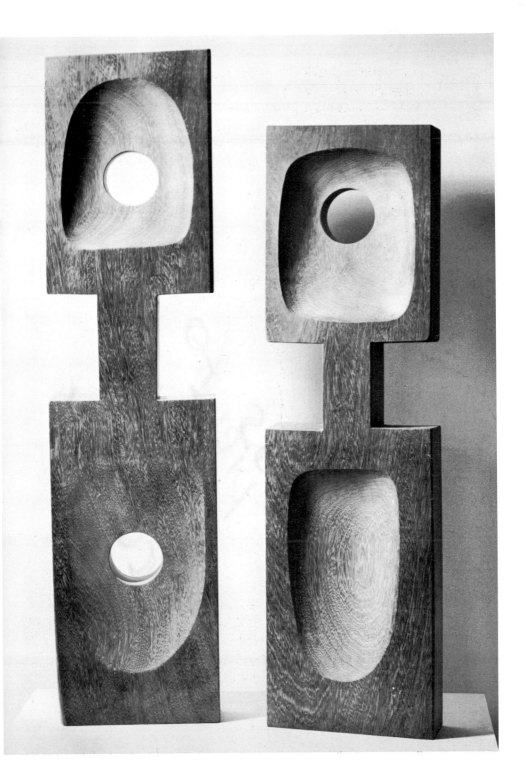

With this we arrive at the fundamental question which will principally determine her place in the entire repertory of twentieth-century sculpture: to what extent is her work really a re-presentation in our century of the equipoise of classical times, as Paul Hodin claims with such deep conviction in his book on Hepworth? In the sense of that great continuity which is so dear to England, the idea inherent in her work often comes sufficiently close to the mainstream of romantic ideas to permit us to doubt her classicism; yet, never quite close enough to associate it with romanticism in the broad sense. That her generation should have rebelled against the English romanticism of the late pre-Raphaelite flowering is an entirely different matter. Just as it is necessary to consider Wordsworth distinct from the romantics surrounding him, so Barbara Hepworth, too, should be assessed on her own merits as regards her attitude to nature (man and landscape), and as a twentieth-century abstract artist.

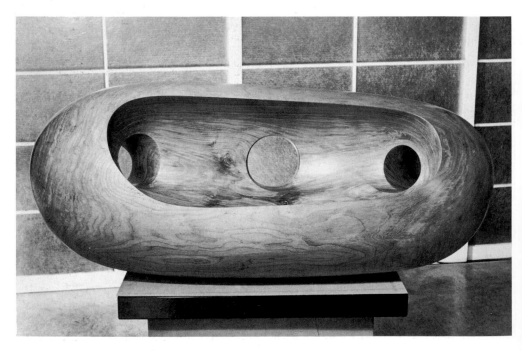

153 *River form, 1965*

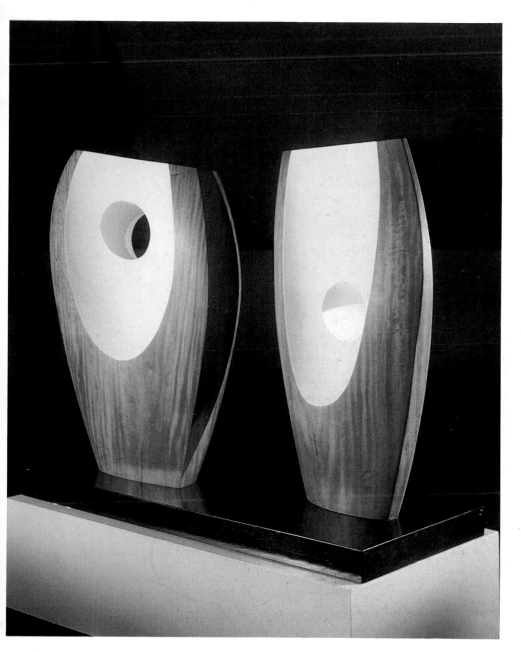

154 *Two forms with white (Greek), 1963*

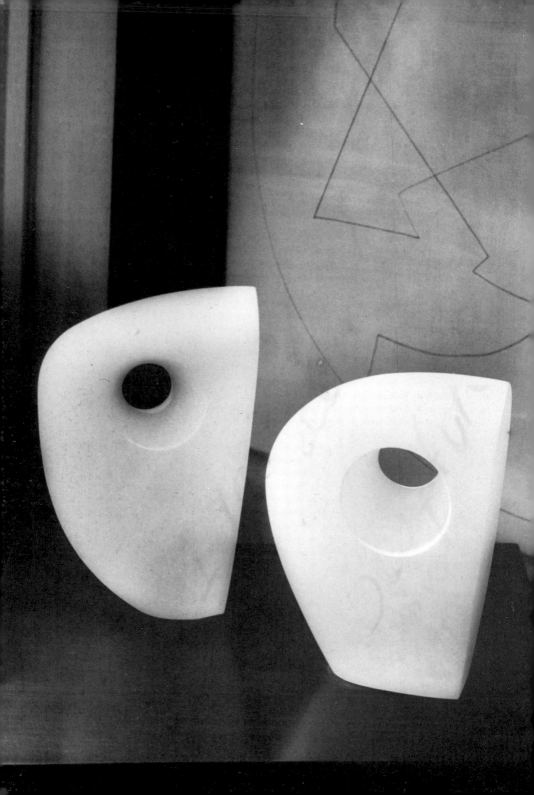

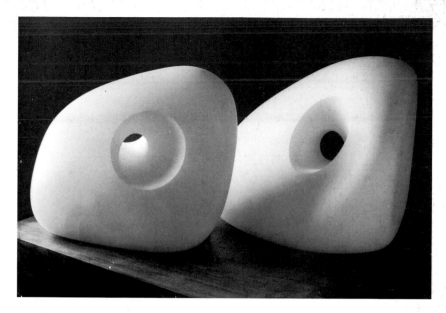

156 *Two forms pierced, 1961–62*

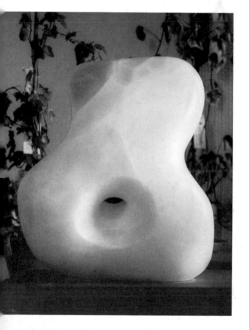

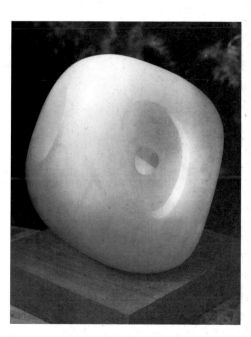

157 *Figure (Merryn), 1962*

158 *Small form (Amulet), 1960*

155 *Two forms (two circles), 1963*

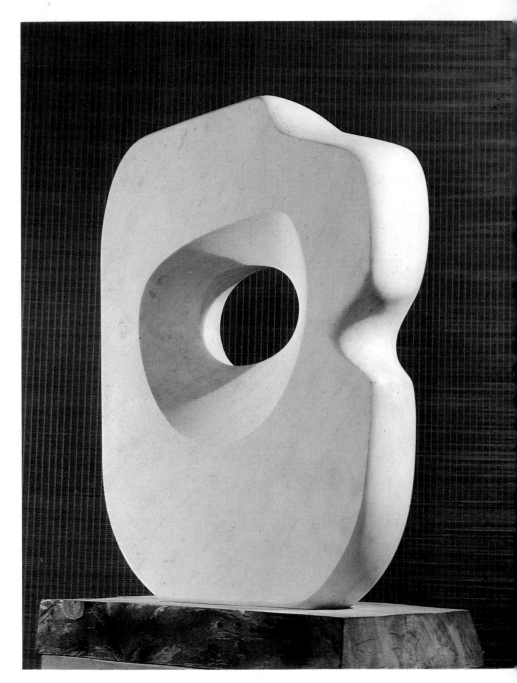

159 *Pierced form, 1963–64*

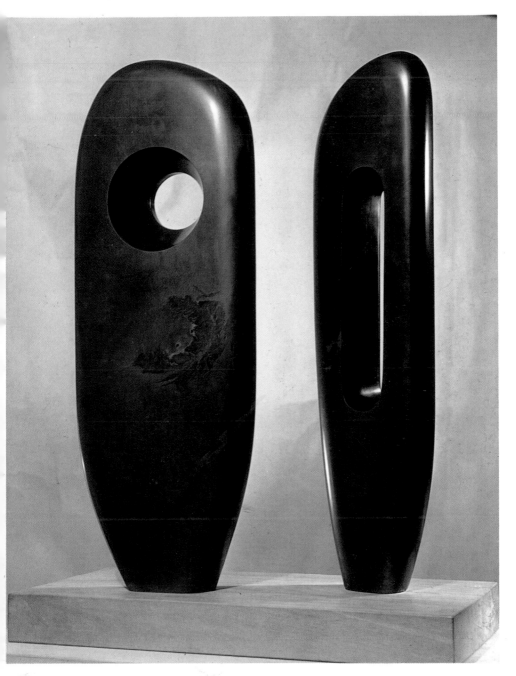

160 *Two figures (Menhirs), 1964*

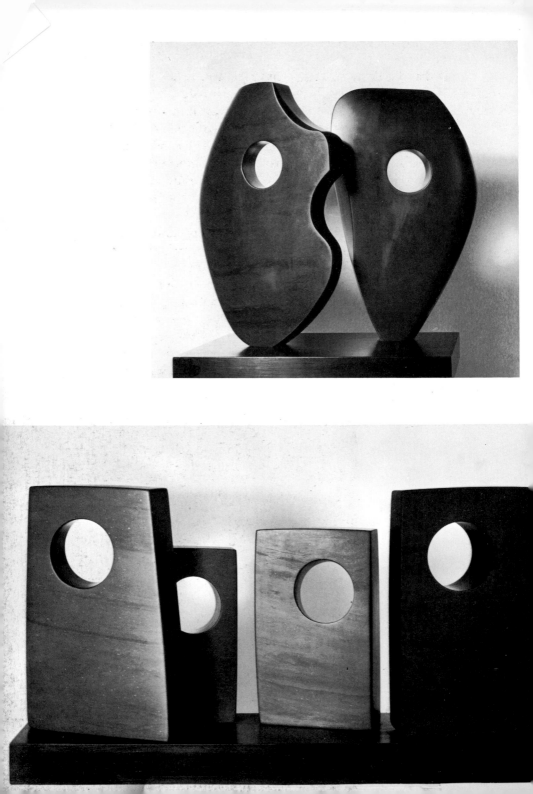

It is a fact that the element of self-control, control of her passions, emotions, feelings, work, is an attempt on Hepworth's part to exclude all *laisser aller*. Her natural inclination was anti-naturalistic, geometric, abstract, which explains her affinity with the world of Mondrian. Yet at the same time this anti-naturalism is contradicted by an exceptional sensitivity to nature and the elements, which could indeed have led her into modern romanticism, if that control, that abstraction, that urge towards clarification and contemplation had not been present and dominant.

Hepworth only discusses the problem as it affects an abstract and figurative drawing. She is aware that 'the whole process' – of abstract drawing – 'is opposite to that of drawing from life'. And she goes on: 'With the model before one . . . one chooses those forms which seem to be structurally essential to the abstract equivalent, relevant to the composition and material in which one wishes to convey the idea.' Mondrian would have rejected this last proposition in his theory of neo-plasticism, although before and during his cubist period he himself followed something approaching the method Hepworth has described.

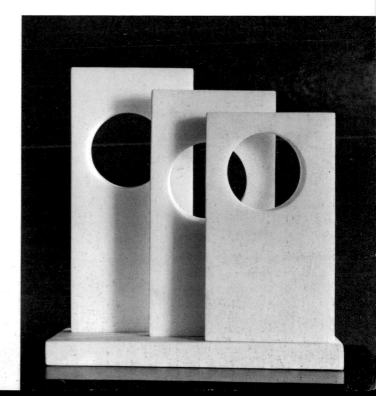

161 *Two forms (Gemini II), 1966*

162 *Four rectangles with four oblique circles, 1966*

163 *Three uprights with circles (Mykonos), 1966*

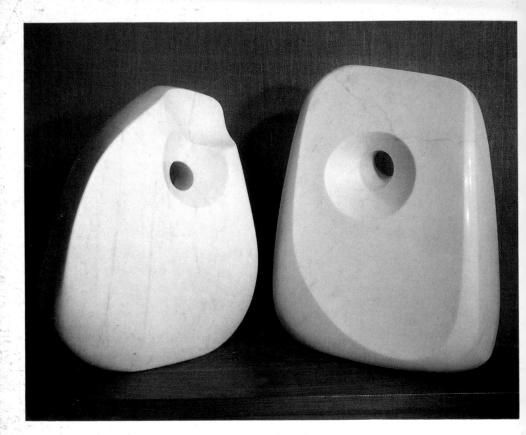

164 *Contrapuntal forms (Mycenae), 1965*

The antithesis between figurative and abstract drawing has, after all, deep roots in her unconscious. I cannot agree with Alan Bowness when he says that the figurative and abstract influence one another in her work. The influence is all from one side – the abstract side. The intimate relationship between the two is not a marriage. It is a symbiosis; the one lives on the other. In the depths of her being there exists this conflict between nature and spirit, between feeling for landscape and abstract emotion. By holding fast to her material she has held fast to nature. She did not resolve the conflict by subjecting form to the abstraction, but she did discover a style which could

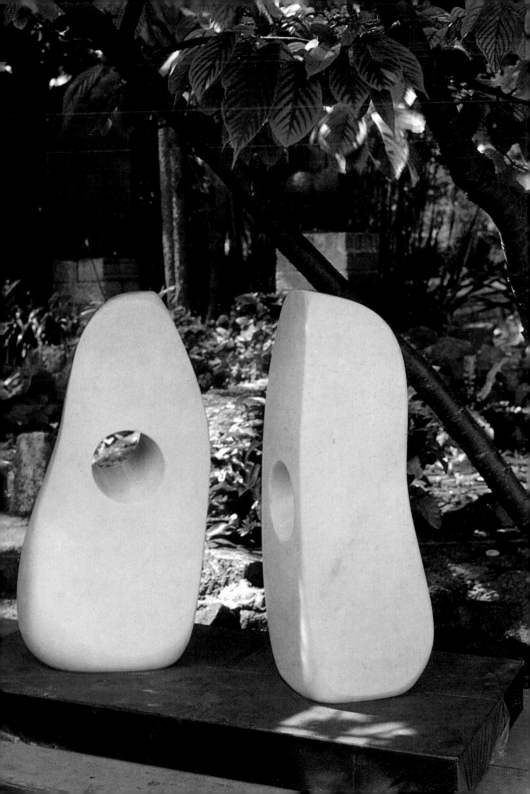

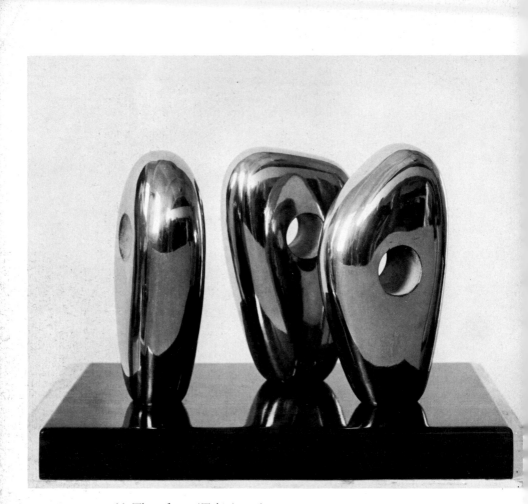

166 *Three forms (Tokio), 1967*

accommodate nature-material-form. The harmony in her work is
not a classical harmony, but a spiritual (not a natural) accord between
the abstract and her feeling for nature. In the drawings there is never
any true amalgamation of line with colour: instead, the two corres-
pond, are in ratio with one another. It is a case of the comparable
behaviour of two elements appearing simultaneously. This compara-
tive method of seeing and experiencing, the measuring of a unit
against its environment and vice versa, or of two or more units, the

186

167 *Marble rectangle with four circles, 1966*

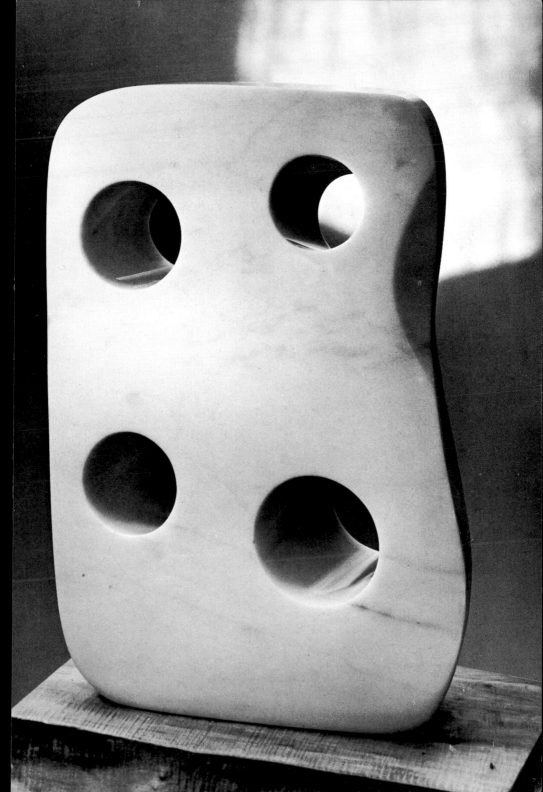

splitting up of one centre into two – this is the real well-spring of her creative imagination, which is able as a result to arrive at a metaphor. Now and again nature attempts to increase its influence, but this is invariably followed by its suppression, to make room for tensions which occur in the abstract.

Barbara Hepworth has not accepted the consequences, as Mondrian did, of suppressing and overcoming the natural in every form, and this has created new problems. Here, for the dogmatists, lies her, apostasy. Yet it is here, too, that the living sequence of her achievement is to be found, her own true value, her positive contribution to twentieth-century sculpture. For out of the profound contradictions and antitheses which keep our age in a state of tension, which keep it alive, she has conjured up works in space which continue the dialogue between space-in-landscape and space-in-sculpture, between natural forms and creative man, in a form whereby its complexity becomes simplicity, its turmoil peace.

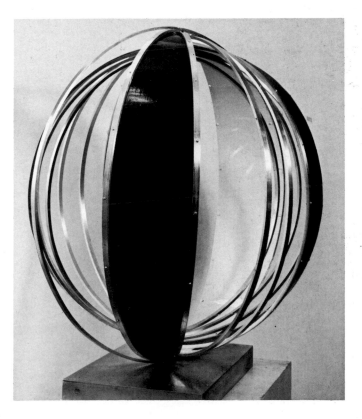

168 *Construction (Crucifixion), 1966*

169 *Sphere with inside and outside colour, 1967*

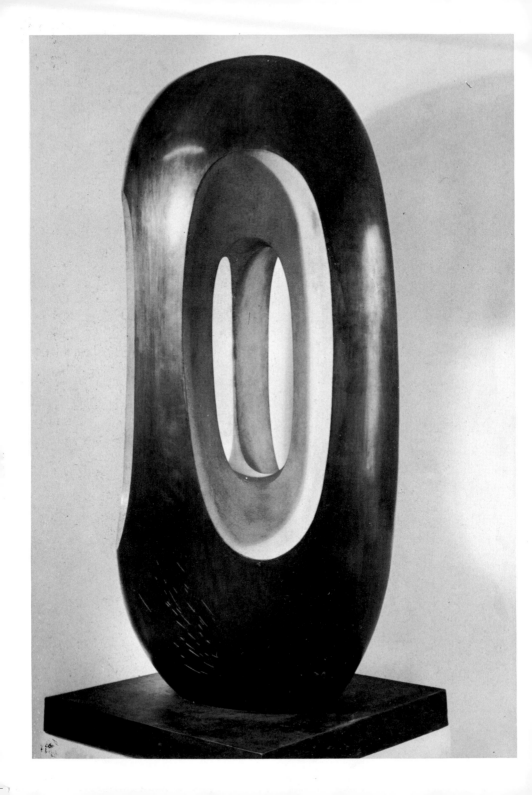

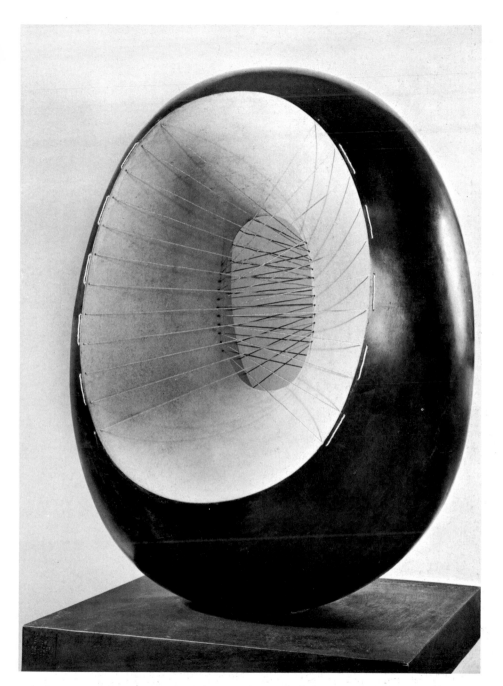

171 *Spring, 1966*

170 *Elegy III, 1966*

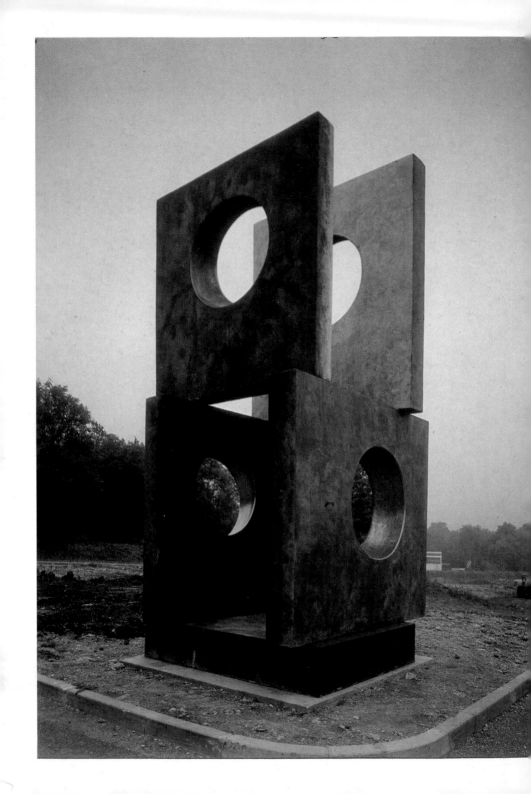

The Exit

As the years passed, Barbara's mobility was progressively restricted by ill-health. Her physical condition had become the basis of a discipline; the rhythm of her technique was a fundamental element of her work. She accepted the challenge and found new resources of energy which lasted until the end. Her works had already grown to a monumental size as she matured in the period after 1960, and her materials, including bronze, continued to make more than routine demands. She had trained devoted assistants but was unyielding about the limits that there should be to their work. She never ceased to devise schemes whereby she could keep a check on their activities, even when she could hardly leave her sickbed. She did not give in.

During her long and fruitful years at St Ives, the bay, the sea, the ancient rocky landscape and the strange overgrown garden had become more than sites; they were intimate possessions. At the same time she always felt a need to keep in touch with life in London. She loved the train journey to and from Paddington Station, mostly by night, in all its details. During the years when she was one of the Trustees of the Tate Gallery (from 1965 onwards), she continued to regard her journeys as an indispensable link with London, even when travelling became painful.

The final visit I paid her in 1975, a few weeks before her dramatic death in a studio fire, was the first to have a dark undertone. Particularly towards evening, an increasingly sombre mood pervaded the room. She confessed that her health had made visits to London impossible, and that this affected her more than she would or could explain. It was apparent that her mysterious life force, her gift of living so intensely in the present, had deserted her. Suddenly she was living in the past in a way that I had not seen in her before. She yielded unrestrainedly to unreal longings, their origins locked away in memories, and tried to

193

172 Four-square (walk through), 1966

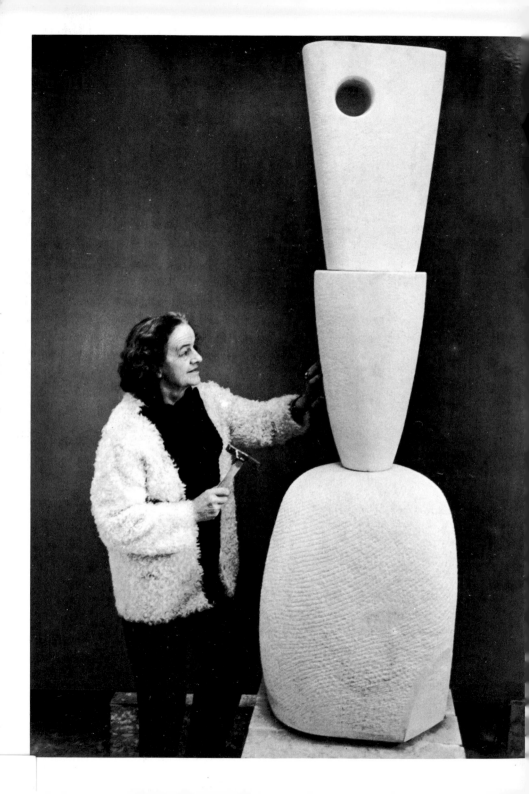

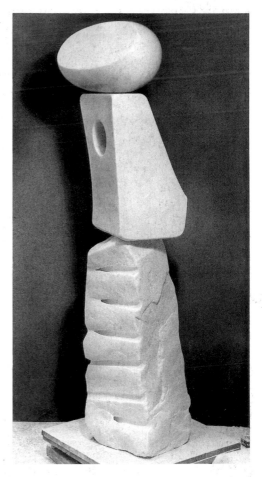

173 *Three forms vertical (offering), 1967*

174 *Three part vertical, 1971*

imagine them as having a future. I can of course consider the output of those seven years (1968–75) purely in itself, but it is hard all the same to disregard that hidden struggle against the fatal process that was threatening her creative powers.

The elements characterizing the 'images' of the work of those final seven years pass before my mind's eye, and I list them without in any way grading them: the tension in the form; the structures; the verticality which remained dominant ('reclining figures' had always been few in number, in contrast to Henry Moore's work); the vigour in the stacking of elements; the ever-varying, constantly renewed experience

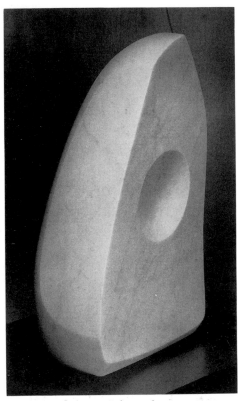

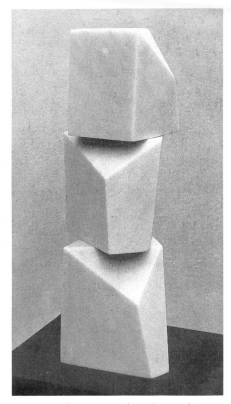

175 *Solitary form, 1971* 176 *Small one, two, three (vertical), 1975*

of piercing volume, with the piercing itself more than anything else the hallmark of her spatial sense and sensations; the resumption of group compositions after a long interval; the dual character of her surfaces, firstly as the enclosing element of three-dimensional spatial forms and secondly as 'surface as such', accentuated in some manner (linear inscription, 'scratches', low relief, colour).

In retrospect these features make one aware not only of the continuity and flow in her work, but above all of the intensity of her re-examination of past experience, culminating in a strong sensation of inner change. In reflecting on the brief series of important events in Barbara's later years, rather than provide explanations I prefer to relate such thoughts to particular moments in her life. By moments I not only

196

mean the rapid succession of elements of time but the strange depths, the space-time fusion, that can be revealed in a sudden flash of insight, if the moment is charged with ecstasy or sheer concentration.

Events such as the end of her marriage to Ben Nicholson in 1951, or the death of her pilot son Paul in 1953, went on to weigh on her destiny. To disappear supposes a possible return; in her mind doors never closed. An episode that took place in 1951 is curiously significant in this connection. She was closely involved, that year, with the Old Vic theatre company, designing, among other things, sets and costumes for Sophocles' *Electra*. All developed well, except one thing: it seemed a mere detail, but proved to have deeper roots in her spirit. Years later (1970, in her *Pictorial Autobiography*) she gave a detailed account of that curious difference of opinion with the management. They wanted

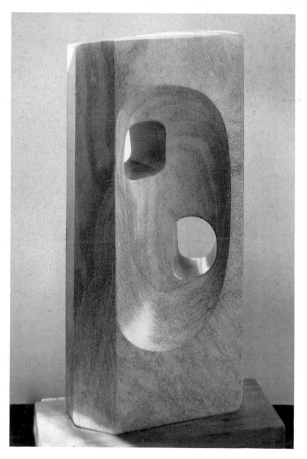

177 *Rock face, 1973*

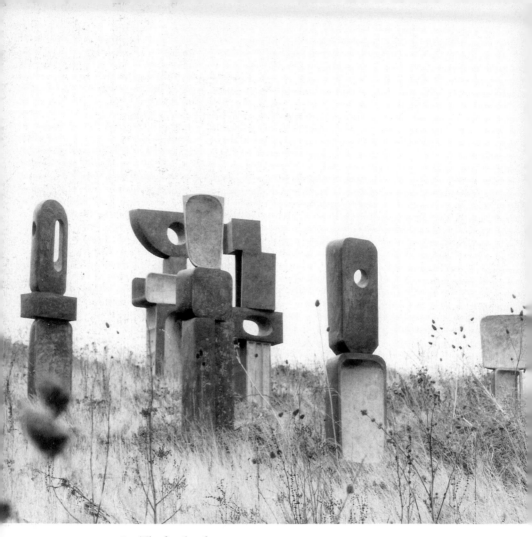

178 *The family of man, 1970*

scenery to conceal the actors as they went on or off stage. Barbara disagreed, more passionately than anyone would have expected. Every door breaks and closes a space. Space had to be open, 'with light and dark or colour – no door . . . a door would stick and the openings might make it stick'.[1] This apparently minor episode was characteristic of her sense of space. A door requires a wall, and the argument was about cutting off space: she wanted space to be indeterminate and free, so that

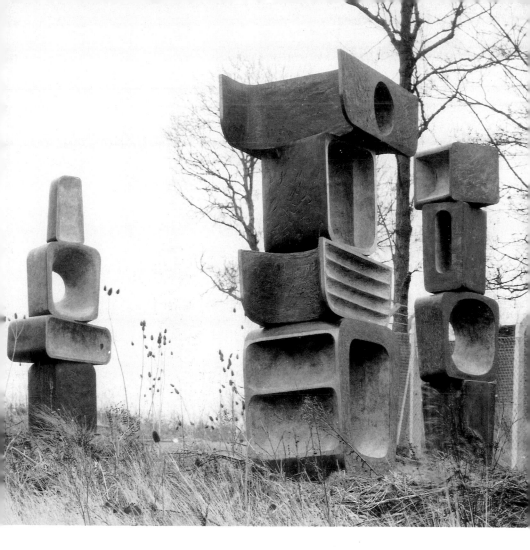

the figure occupying it – in this case the actor, but otherwise every stone, tree or human being in a landscape or in any site – had its own solitary significance. There is a link here with the emotion that first impelled her to open the volume of a sculptural form with a tunnel that gave onto infinite space.

The problem of autonomous sculpture is still with us, though in a different way (as with Richard Serra in particular), and the question to

199

what extent 'the site' may dominate or be dominated has remained a source of ambiguity.

Barbara's conception of space, as I see it now, is indeed to be found in the openings (the no-door, the door-*angst*) towards the infinity of emptiness. It is also present in some drawings. One remarkable achievement was the image of a *Construction* which took its final form, still as a drawing, in 1966. Two drawings reproduced in an earlier chapter were done in 1965 and 1966. They are rectilinear, with one *Ills. 147, 148* circle inserted as a flat disc (1965) and a second one (1966) fully open and creating a greater sense of transparency through its subtle colour. The quality of line and colour, the sublime rectilinearity, are akin to several delicate drawings concerned with more surface treatment. One exam- *Ill. 145* ple is *Three monoliths* of 1964; the number 3 plays a major role in much of her work. Others are *Square forms* (undated but drawn in 1963-64) *Ill. 168* and *Crucifixion*, executed as a 'construction' in coloured bronze in 1966. All are derived from geometrical thinking of great precision, but not at the expense of humanity, emotion and aesthetic feeling.

Considered together as a sequence, the titles here deter us from over-emphasizing the inevitable impression of symbolism that the drawings convey. Barbara's self-control was so intense that she would never have indulged in abstract self-expression: she sought, and attained, a maximum of openness. It is however – as often in the lightly coloured patches in her drawings – an openness towards an indeter- minate space. The discolourations were inspired by sentiments as flow- ing as music or water.

As she admitted in conversation with Alan Bowness, she thought of the title *Crucifixion* at the outset, not in the course of making the work.[2] She referred vaguely to a state of being seriously ill. Why should one not conjecture that some part was played by two events that continued to affect her profoundly until her death? One was her divorce from Ben Nicholson, outwardly but never inwardly accepted as a fact. The other was the discovery of the symptoms of her illness, although its progress was successfully arrested. The abstract realization of the idea of the *Crucifixion,* with a slight gesture in the direction of Mondrian, seems to be the effect of suppressing a powerful inner grief (which isolates), and of an increasing transparency, evoking the world behind the mirror.

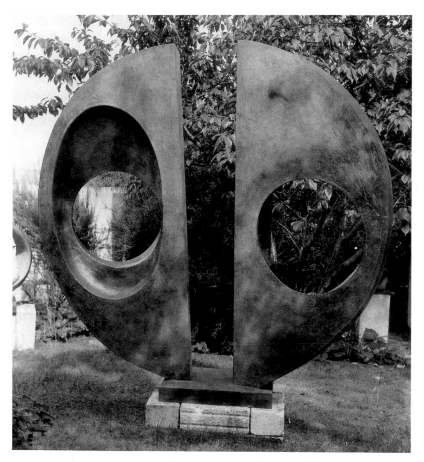

179 *Two forms (divided circle), 1970*

Herbert Read's introduction to Barbara Hepworth's *Carvings and Drawings,* published in 1952, is followed by a passage by Barbara concerning the period between 1936 and 1946 and undoubtedly written in 1951:

From the sculptor's point of view one can either be the spectator of the object or the object itself. For a few years I became the object. I was the figure in the landscape and every sculpture contained to a greater or lesser

180 *Barbara Hepworth, 1972*

181 *Trewyn Studio, St Ives,*
1959 (now the Barbara
Hepworth Museum)

degree the ever-changing forms and contours embodying my own re-
sponse to a given position in that landscape. . . . There is no landscape
without the human figure: it is impossible for me to contemplate prehis-
tory in abstraction. A sculpture might, and sculptures do, reside in empti-
ness but nothing happens until the living human encounters the image.[3]

Rereading these lines in 1986, I find it immensely illuminating to bear
in mind the experiences of the younger generation around 1960, when
the Minimal and Conceptual sculptors discovered emptiness and re-
worked the spatial experience of prehistory.

The talks Barbara had with Alan Bowness in 1970 revealed continui-
ty, but also the adjustments made since 1951:

I'm not exactly the sculpture in the landscape any more. I think of the
works as objects which rise out of the land or the sea, mysteriously.[4]

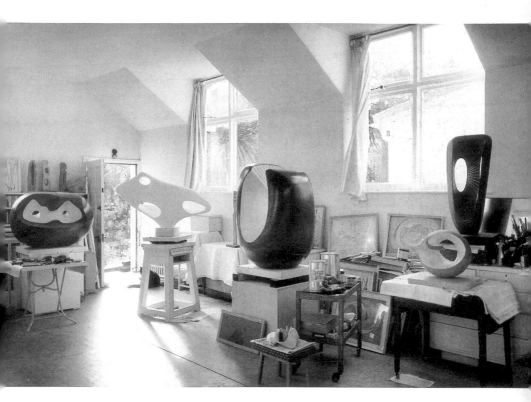

In a general sense, she had found the way through, mentally, sensitively and spiritually, as she had already done in her sculpture, proceeding again and again from the closed volume outwards. In this context we must consider the two large groups which heightened the rhythm of her work in the seven years before her death: *The family of man* (1970) *Ill. 178* and *Conversation with magic stones* (1973). The former developed as a *Ill. 1* 'family' of nine bronze figures, individually made to represent *Ancestors*, *Parents* or *Children* and culminating in *Ultimate form*. The voice and the words spoken in 1951 were evoked once again – the abstract, the human figure, the landscape of prehistory, the emptiness – and were now reinforced by the broader and more objective spatial image of 1970: 'objects which rise out of the land' and the 'I' which is 'not exactly the sculpture in the landscape any more'. The exit was accomplished.

Text References

INTRODUCTION (pp. 7-9)
1 *Self-Portrait*, London, 1939, p. 274.
2 'Nine Swallows, No Summer', *Architectural Review*, No. 545, London, 1942, p. 109.

CHAPTER ONE (pp. 11-15)
1 Philip James, *Henry Moore on Sculpture*, London, 1966, p. 31.
2 See M. Meunier in *La Revue du Louvre*, No. 3, 1965, p. 6.

CHAPTER TWO (pp. 17-22)
1 David Lewis, *Constantin Brancusi*, London, 1957, p. 43.
2 *Ibid.*, p. 11.
3 In the *Little Review*, London, Autumn, 1921.

CHAPTER FOUR (pp. 27-44)
1 *Epstein*, London, 1963, p. 12 with illustration.
2 *Architectural Review*, London, 1942, p. 109.
3 See J.P. Hodin, *Barbara Hepworth, Life and Work*, London, 1961. Item 35.
4 Herbert Read, *Barbara Hepworth, Carvings & Drawings*, London, 1952.
5 Donald Hall, *Henry Moore, The Life and Work of a Great Sculptor*, London, 1966.
6 Gaston Bachelard, *La terre et les Reveries du Repos*, Paris, 1948.

CHAPTER FIVE (pp. 45-56)
1 F.E. Halliday, *Indifferent Honest*, London, 1960, pp. 122-24.
2 *Barbara Hepworth – Drawings from a Sculptor's Landscape*, London, 1966, p. 17.
3 Originally published in *Apollo*, London, September 1962. Reprinted in the catalogue for the exhibition 'Art in Britain 1930-40 centered around Axis, Circle, Unit One', Marlborough Fine Art Ltd, London, 1965.
4 J.P. Hodin, pp. 22-23.

CHAPTER SIX (pp. 57-86)
1 *Unit One*, p. 109.
2 *Axis*, July 1935, p. 14.
3 London, 1937.
4 London, 1937.
5 *The Spectator*, 3 November 1933.
6 *Op. cit.*

7 *Op. cit.*, p. 143.
8 Herbert Read and Leslie Martin, *Gabo*, London, 1957.
9 On the use of strings, for Moore see Philip James, *op. cit.*, p. 209; for Hepworth see J.P. Hodin, p. 19.
10 William Heinemann, London, 1939.

CHAPTER EIGHT (pp. 93-108)
1 Catalogue to the exhibition 'The English Eye', Marlborough Fine Art Ltd, New York, 1965.
2 *Wordsworth*, London, 1930; revised edition 1965, pp. 126-27.
3 *Barbara Hepworth – Drawings from a Sculptor's Landscape*, p. 13.
4 Herbert Read, *Barbara Hepworth, Carvings & Drawings*, Ch. 4.
5 Faber and Faber, London, 1964, p. 80.
6 G.A. Jellicoe, *Studies in Landscape Design*, Vol. II, London, 1966, p. 5.

CHAPTER NINE (pp. 109-114)
1 G.A. Jellicoe, *op. cit.*
2 Printed in *J.P. Hodin European Critic*. (Essays by various hands published as a tribute on his sixtieth birthday.) London, 1965.
3 Introduction to *Barbara Hepworth – Drawings from a Sculptor's Landscape*, p. 23.

CHAPTER TEN (pp. 115-125)
1 London, 5 February 1955.

CHAPTER ELEVEN (pp. 127-141)
1 *A Concise History of Modern Sculpture*, London, 1966.
2 Alan Bowness, Introduction to *Barbara Hepworth – Drawings from a Sculptor's Landscape*.

CHAPTER TWELVE (pp. 145-189)
1 Cologne, 1963.
2 No. 10, 1966, p. 134.

EPILOGUE (pp. 193-203)
1 Barbara Hepworth, *Pictorial Autobiography*, p. 60.
2 Alan Bowness, *The Complete Sculpture*, pp. 13-14.
3 Herbert Read, *Barbara Hepworth, Carvings & Drawings*, text facing plate 60.
4 Alan Bowness, *op. cit.* (note 2), p. 14.

Selective Bibliography

This list is confined to all monographs devoted to the artist, and to general surveys which include items of documentary or critical interest published since 1960. A detailed bibliography of works published prior to this date is given in J.P. Hodin's *Barbara Hepworth, Life and Work*, London, 1961.

MONOGRAPHS

WILLIAM GIBSON, *Barbara Hepworth*, Faber and Faber, London, 1946.

HERBERT READ, *Barbara Hepworth, Carvings & Drawings*. Introduction by Herbert Read, notes by the artist. Lund Humphries Ltd, London, 1952.

A.M. HAMMACHER, *Barbara Hepworth*, A. Zwemmer, London 1958. Original Dutch edition, Europase Beeldhouwkunst, Allert de Lange, Amsterdam, 1958.

J.P. HODIN, *Barbara Hepworth, Life and Work*, Lund Humphries Ltd, London, 1961. Original French and German editions, Edition du Griffon, Neuchatel, Switzerland, 1961.

MICHAEL SHEPHERD, *Barbara Hepworth*. Introduction by Michael Shepherd, statement by the artist, edited by Jasia Reichardt. Methuen & Co. Ltd, London, 1963.

ALAN BOWNESS, *Barbara Hepworth – Drawings from a Sculptor's Landscape*, Cory, Adams & Mackay Ltd, London, 1966.

BARBARA HEPWORTH, *Barbara Hepworth – A Pictorial Autobiography*, Adams and Dart, Bath, 1970. Extended edition, Moonraker Press, Bradford-on-Avon, 1978. Re-printed by Tate Gallery Publications, 1985.

ALAN BOWNESS, *The Complete Sculpture of Barbara Hepworth, 1960–69*, Lund Humphries, London, 1971.

MARGARET GARDINER, *Barbara Hepworth, A Memoir*, The Salamander Press, Edinburgh, 1982.

DAVID FRASER JENKINS, *Barbara Hepworth, A guide to the Tate Gallery collection at London and St Ives, Cornwall*, Tate Gallery Publications, 1982. Preface by Alan Bowness.

OTHER BOOKS, CATALOGUES, ETC.

EDOUARD RODITI, *Dialogues on Art*, Secker & Warburg, London, 1960, pp. 90–103.

DAVID THOMPSON, *Recent British Sculpture*. Introduction to the catalogue of the exhibition organized by The British Council for Canada, New Zealand and Australia 1961–63. Cat. 33–37 sculpture, 38–44 drawings.

BRYAN ROBERTSON, *Sculpture 1961*. Introduction to the catalogue of the exhibition organized by the Welsh Committee of the Arts Council of Great Britain, 1961. Short biography. Cat. 16–23.

ALAN BOWNESS, *Barbara Hepworth*. Introduction to the catalogue of the exhibition of photographs of sculpture and drawings with some original bronzes arranged by The British Council, 1961.

HERBERT READ, *A Letter to a Young Painter*, Thames and Hudson, London, 1962. 'To Barbara Hepworth', pp. 120–28.

MERVYN LEVY, 'Barbara Hepworth – Impulse and Rhythm'. *The Studio Magazine*, September 1962, Vol. 164, No. 833, pp. 84–91.

BRYAN ROBERTSON, *Barbara Hepworth, Sculpture 1952–62*. Introduction to the catalogue of the retrospective exhibition at the Whitechapel Art Gallery, London, May–June 1962.

HERBERT READ, *A Concise History of Modern Sculpture*, Thames and Hudson, London, 1964, pp. 112, 192–96, 202, 204, 219.

WARREN FORMA, *Five British Sculptors, Work & Talk*, Grossman, New York, 1964.

HERBERT READ, *Comtemporary British Art*, Penguin Books Ltd, London, revised edition 1964, pp. 19, 25, 28, 39–41.

J.P. HODIN, *Barbara Hepworth*. Foreword to the catalogue of the exhibition of sculpture and drawings organized by The British Council, touring Scandinavia 1964–65.

BRYAN ROBERTSON, JOHN RUSSELL, LORD SNOWDON, *Private View*, Thomas Nelson & Sons Ltd, London, 1965, pp. 6, 42–45, 74, 97, 143, 146, 156, 158, 204, 245, 254, 294.

ALAN BOWNESS, *Modern Sculpture*, Studio Vista Ltd, London, 1965.

WALTER KERN (editor), *J.P. Hodin European Critic*. (Essays by various hands published as a tribute on his sixtieth birthday.) Cory, Adams & Mackay Ltd, London, 1965, pp. 2,

100, 126. 'Greek Diary' by Barbara Hepworth, pp. 19–24.

IAN KEMP (editor), *Michael Tippett*. A symposium on his sixtieth birthday. Faber and Faber, London, 1965. 'Tribute & Reminiscence' by Barbara Hepworth, pp. 58–59.

J.P. HODIN, 'Barbara Hepworth and the Mediterranean Spirit', *Marmo*, 3 February 1965, pp. 59–65.

HERBERT READ, *Art in Britain 1930–40*. Introduction to the catalogue of the exhibition at Marlborough Fine Art Ltd, London, March–April 1965, pp. 5, 7–9. Notes and documentation by Jasia Reichardt, pp. 10, 11.

JOHN FITZMAURICE MILLS, 'Barbara Hepworth – at the Rietveld Pavilion, Kröller–Müller Museum'. *The Connoisseur*, July 1965, pp. 242–43.

J.P. HODIN, 'The Avant–Garde of English Sculpture and the Liberation from the Liberators'. *Quadrum*, No. 18, 1965, pp. 55–70.

MERVYN LEVY, 'Drawing and Sculpture'. *Studio International*, Vol. 171, No. 873, January 1966, pp. 26–29.

EDWIN MULLINS, 'Hepworth at Home'. *Daily Telegraph Colour Supplement*, 20 May 1966, pp. 32–36.

G.A. JELLICOE, *Studies in Landscape Design*, Vol. 11, Oxford University Press, London, 1966. pp. 5, 6, 12.

GENE BARO, 'Barbara Hepworth in her Times'. *Studio International*, Vol. 171, No. 878, June 1966, pp. 252–57, excerpts from autobiographical essay 'A Sculptor's Landscape'.

ALASTAIR GORDON, 'Barbara Hepworth – four drawings, four masterworks'. *The Connoisseur*, September 1966, Vol. 163, No. 655, pp. 24–27.

F. MARCUS ARMAN, 'Barbara Hepworth – London Exhibition'. *Sculpture International*, No. 2, 1966, pp. 54–57.

A.M. HAMMACHER, *Modern English Sculpture*, Thames and Hudson, London, 1967.

RONALD ALLEY, *Barbara Hepworth*. Catalogue of the retrospective exhibition at the Tate Gallery, London, April–May 1968. Notes by Norman Reid, Nicolete Gray and R.W.D. Oxenaar.

STANLEY JONES, *Twelve lithographs by Barbara Hepworth*. Studio International, June 1969.

A.M. HAMMACHER, *The Evolution of Modern Sculpture*, Harry N. Abrams Inc., New York, 1969.

ADRIAN STOKES, *Barbara Hepworth*. Introduction to the catalogue of the exhibition of sculpture, paintings and prints at Marlborough Fine Art, London, February–March 1970.

ALAN BOWNESS *Modern European Art*, Thames and Hudson, London, 1972, pp. 191–93.

DORE ASHTON, *Barbara Hepworth 'Conversation'*. Introduction to the catalogue of the exhibition at Marlborough Gallery Inc., New York, March–April 1974.

DOUGLAS HALL, *Hepworth*. Introduction to the catalogue of the travelling exhibition arranged by The British Council, 1975.

DOUGLAS HALL, *Barbara Hepworth, Late Works*. Intoduction to the catalogue of the exhibition at the Royal Botanic Gardens, Edinburgh, August–September 1975.

C. GIEDION–WELCKER, *Hepworth*. Introduction to the catalogue of the exhibition of sculpture at Marlborough Galerie AG, Zürich, August–October 1975.

PATRICK HERON, *The Pier Gallery, Stromness, Orkney*. Introduction to the catalogue of the permanent collection, 1978. Additional notes by Alan Bowness, pp. 5, 7–11, 23–31.

CHARLES HARRISON, *Unit One*. Introduction to the catalogue of the exhibition at Portsmouth City Museum and Art Gallery, May–July 1978. pp. 1–3. Notes on Barbara Hepworth by Alan Bowness pp. 4–5.

NICOLAS WADLEY, *Barbara Hepworth, Carving and Bronzes*. Introduction to the catalogue of the exhibition at Marlborough Gallery Inc., New York, May–June 1979. Notes by Alan Bowness.

MARK GLAZEBROOK, *The Seven and Five Society 1920–35*. Introduction to the catalogue of the travelling exhibition arranged by Michael Parkin Fine Art Ltd., August 1979–March 1980.

PETER MURRAY, *Barbara Hepworth*. Introduction to the catalogue of the exhibition at the Yorkshire Sculpture Park, July–October 1980.

CHARLES HARRISON, *English Art and Modernism 1900–1939*, Allen Lane/Indiana University Press, 1981.

R.W.D. OXENAAR, *Sculpture in the Rijksmuseum Kröller–Müller*. Catalogue, fourth English edition, 1981, pp. 267–68. Biography by Ellen Joosten, pp. 102–3.

CHARLES HARRISON, *British Sculpture in the Twentieth Century*. Catalogue to the exhibition at the Whitechapel Art Gallery, London, September 1981–January 1982, pp. 103–111.

MOELWYN MERCHANT, *Barbara Hepworth, Carvings*. Introduction to the catalogue of the exhibition at Marlborough Fine Art, London, July–August 1982.

TOM CROSS, *Painting the Warmth of the Sun*, Alison Hodge, Penzance/Lutterworth Press, Guildford, 1984.

St Ives 1939–64. Catalogue to the exhibition at the Tate Gallery, London, February–April 1985, pp. 190–95.

CORINNE MILLER, *Barbara Hepworth, Early Life*. Introduction to the catalogue of the

exhibition at Wakefield Art Gallery, May–July, 1985.

ALAN BOWNESS, *Barbara Hepworth, Late Carvings*. Introduction to the catalogue of the exhibition at the Elizabethan Exhibition Gallery, Wakefield May–July 1985.

BENEDICT READ *Sculpture in Britain between the Wars*. Introduction to the catalogue of the exhibition at The Fine Art Society, London, June–August 1986.

BOOK ILLUSTRATIONS

KATHLEEN RAINE, *Stone and Flower*. Poems 1935–43, with drawings by Barbara Hepworth. Poetry London, Nicholson & Watson, London, 1943.

PAUL MERCHANT, *Stones*. Poems with lithographs by Barbara Hepworth. The Rougemont Press, Exeter, 1973.

Acknowledgments

All photographs for the original edition were kindly supplied by Dame Barbara Hepworth. In preparing the revised edition the author and publishers received valuable assistance from Alan Bowness and from Brian Smith, curator of the Barbara Hepworth Museum, St Ives. They wish to acknowledge the following photographers: Alinari, E. C. Cooper Ltd, David Farrell, Foresees Photographic Ltd, Charles Gimpel, Arno Hammacher, T. D. Jenkins, Peter Kinnear, Paul Laib, Edward Leigh, Cornel Lucas, E. J. Mason, John Mills, Ministry of Public Building and Works photographer, Morgan-Wells, S. W. Newbery, Photo Studio (London) Ltd, Houston Roger, D. Saville, Lee Sheldrake, Studio St Ives Ltd, Rodney Todd-White, John Webb, United Nations photographer.

List of Illustrations

Measurements are in inches and centimetres, height first. Italic numerals within square brackets at the end of entries denote the Barbara Hepworth archive numbers.

1 Conversation with magic stones, 1973. Bronze, 31½ × 111 *(80 × 282)*. Edition of three groups and four of each individual piece. Tate Gallery, London (Barbara Hepworth Museum, St Ives); Scottish National Gallery of Modern Art, Edinburgh; Trinity University, Texas [567]

2 Barbara Hepworth, St Ives, May 1964

3 Barbara Hepworth, aged 2½ years

4 Herbert R. Hepworth, CBE, aged 21 years

5 Barbara Hepworth, aged three weeks, with her great grandmother holding her, her grandmother Gertrude Allison, her mother Gertrude Allison Hepworth and her father Herbert Hepworth

6 Barbara Hepworth, aged 10 years

7 Barbara Hepworth, aged about 18 years

8 The hands of the sculptor, 1960

9 Amedeo Modigliani, Head, *c.* 1913. Stone, 24½ *(62)*. Tate Gallery, London

10 Constantin Brancusi, Head of a Woman, 1908. Limestone. Collection unknown

11 Barbara Hepworth in Rome with her first husband, John Skeaping, 1926

12 Masaccio, The Tribute Money, *c.* 1427. Brancacci Chapel, Carmine, Florence

13 John Skeaping, Head of Barbara Hepworth, Rome *c.*1926. Marble, *c.*16 *(41)*. Collection unknown

14 Doves (group), 1927. Parian marble, L. 19 *(48)*. Manchester City Art Gallery [3]

15 Seated woman, 1928. Charcoal and ink. Private collection

16 Torso, 1927. Irish fossil marble, 14½ *(37)*. Private collection [8]

17 Toad, 1928. Onyx, L. *c.* 6 *(15)*. Private collection [114]

18 Infant, 1929. Burmese wood, 19 *(48)*. Tate Gallery, London (Barbara Hepworth Museum, St Ives) [24]

19 Figure of a woman, 1929–30. Corsehill stone, 22 *(56)*. Tate Gallery, London

20 Ben Nicholson photographed by Barbara Hepworth, *c.* 1931

21 Ben Nicholson and Barbara Hepworth at Happisburgh, 1931

22 Ivor Hitchins, Irina Moore, Henry Moore, Barbara Hepworth, Ben Nicholson and Mary Jenkins, Happisburgh, 1931

23 Ben Nicholson, Barbara Hepworth and Ben Nicholson, *c.* 1931. Pencil, *c.* 14 × 10 *(35 × 25)*. Private collection

24 Pierced form, 1931. Pink alabaster, 10 *(25)*. Destroyed (war) [35]

25 Ben Nicholson, Girl and mirror, *c.* 1933. Oil on canvas, 26½ × 21½ *(67 × 55)*. Private collection

26 Saint-Rémy, 1931. Collage on oil ground, *c.* 10 × 12 *(25 × 30.5)*. Private collection

27 Carving, 1932. Grey alabaster, 10 *(25)*. Private collection [43]

28 Woman with folded hands, 1932. Doulting stone, 18 *(46)*. Destroyed (war) [39]

29 Two heads, 1932. Cumberland alabaster, L. 15 *(38)*. Pier Gallery, Stromness, Orkney [38]

30,31 Sculpture with profiles, 1932. White alabaster, 7½ *(19)*. Tate Gallery, London [45]

32,33 Torso, 1932. African blackwood, 48 *(122)*. Aberdeen Art Gallery and Industrial Museum [41]

34 Profile, 1932. Green marble, 9 *(23)*. Private collection [40]

35 Wells Coates, Lawn Road Flats, Hampstead, 1934

36 Work by Nicholson, Mondrian and Hepworth at the 'Abstract and Concrete' exhibition, Reid and Lefevre Gallery, 1936

37 Figure, 1933. Pink ancaster stone, 12 *(30.5)*. Destroyed (war) [50]

38 Two forms, 1933. Pink alabaster 14 *(35)*. Private collection [51]

39 Two forms, 1933. Blue Armenian marble, L. 28 *(71)*. Private collection [54]

40 Figure (Mother and child), 1933. Grey alabaster, 26 *(66)*. Destroyed [52]

41 Two forms, 1934. White alabaster 4½ *(11.5)*, Base 11½ × 6 *(29 × 15)*. Private collection

42 Cup and ball, 1935. White marble, 10½ *(27)*. Private collection [70]

43 Discs in echelon, 1935. Darkwood, 20¾ × 9½ *(53 × 24)*. Museum of Modern Art, New York [73]

44 Forms in hollow, 1935. Plaster, L. 16 *(40.5)*. Destroyed (war) [71]

45 Holed polyhedron, 1936. Grey alabaster, L. 12 *(30.5)*. Private collection [*88*]
46 Two segments and sphere, 1935-36. White marble, 12 *(30.5)*. Private collection [*79*]
47 Monumental stela, 1936. Blue ancaster stone, 72 *(182)*. Destroyed (war) [*83*]
48 Ball, plane and hole, 1936. Teak, L. 18½ *(47)*. Private collection [*81*]
49 Two forms, 1937. Plane wood, 34 *(86)*. Destroyed (war) [*99*]
50 Two forms, 1937. White marble, 26 *(66)*. Private collection [*96*]
51 Conoid, sphere and hollow II, 1937. White marble, 11¼ × 18 *(28.5 × 46)*. Ministry of Public Building and Works [*100*]
52 Nesting stones, 1937. Serravezza marble, L. 12 *(30.5)*. Private collection [*90*]
53 Pierced hemisphere I, 1937. White marble, 14 *(35.5)*. Wakefield City Art Gallery [*93*]
54 Single form, 1937-38. Sandalwood, 45 *(114)*. Dag Hammarskjöld Museum, Backakra, Sweden [*104*]
55 Sculpture with colour and strings, 1939. Bronze cast 1961, 9⅞ *(25)*. Edition of nine. Private collections [*113*]
56 Forms in echelon, 1938. Tulip wood, 40 *(101)*. Tate Gallery, London [*107*]
57 Barbara Hepworth's studio, The Mall, c. 1931
58 Photograph taken by Barbara Hepworth of her son Paul, aged 12 years
59 Photograph taken by Barbara Hepworth of the triplets: Simon, Rachel and Sarah Nicholson, 1937
60 Drawing for sculpture, 1941. Gouache and pencil, 9½ × 14 *(24 × 35.5)*. Private collection
61 Circle, 1942. Gouache and pencil, 15 × 20¼ *(38 × 51.5)*. Private collection
62 Wave, 1943-44. Plane wood with colour and strings, interior pale blue, L. 18½ *(47)*. Private collection [*122*]
63 Sculpture with colour (oval form), pale blue and red, 1943. Wood with strings, L. 18 *(46)*. Private collection [*119*]
64 Two figures, 1943. Redwood and strings, 24 *(61)*. Private collection [*120*]
65 Landscape sculpture, 1944. Broadleaf elm with strings, L. 26 *(66)*. Hepworth estate (loan to Barbara Hepworth Museum, St Ives) [*127*]
66 Sculpture with colour (Eos), 1946. Hopton wood stone, 23 *(58)*. Private collection [*141*]
67 Elegy II, 1946. Grey elm, 20 *(51)*. Private collection [*134*]
68 Single form (Dryad), 1945-46. Cornish elm, 65 *(165)*. Hepworth estate [*132*]
69 Curved stone forms on pink ground, 1947.

Oil and pencil, 15 × 19½ *(38 × 49.5)*. Private collection
70,71 Pendour, 1947. Plane wood with colour, L. 28 *(71)*. Hirshhorn Museum, Washington, USA [*145*]
72 Two figures, 1947-48. Elm painted white, 48 *(122)*. Minnesota University, Minneapolis, USA [*147*]
73 Column, 1947. Oil and pencil, c. 16 × 9 *(40.5 × 23)*. Private collection
74 Rhythmic form, 1949. Rosewood, 41½ *(105)*. The British Council, London [*158*]
75 Bicentric form, 1949. Blue limestone, 62 *(157)*. Tate Gallery, London [*160*]
76 Pelagos, 1946. Wood with colour and strings, 16 *(40.5)*. Tate Gallery, London [*133*]
77 The hands and the arm, 1948. Oil and pencil, 12 × 15 *(30.5 × 38)*. Private collection
78 Hands operating, 1949. Oil and pencil, 21 × 10½ *(53 × 26.5)*. Private collection
79 Three reclining figures (Prussian blue), 1951. Oil and pencil, 13 × 20⅝ *(33 × 52.5)*. Private collection
80 Group II (People waiting), 1952. Serravezza marble, Base 20 × 11½ *(51 × 29)*, 10 figures the tallest 10 *(25)*. Private collection
81 Interlocking forms, 1950. Oil and pencil, 24 × 16 *(61 × 41)*. Private collection
82 Vertical forms, 1951. Hopton wood stone, 65½ *(166)*. Hertfordshire County Council [*169*]
83 Rock form (Penwith), 1951. Portland stone, incision painted black, 25½ *(65)*. St Ives Borough Council [*168*]
84 Curved form (Orpheus), 1956. Oil and pencil, 30 × 28 *(76 × 71)*. Private collection
85 Pastorale, 1953. White marble, L. 45 *(114)*. Rijksmuseum Kröller-Müller, Holland [*192*]
86 Figure (Churinga), 1952. Spanish mahogany, 49 *(124)*. The Walker Art Center, Minneapolis [*177*]
87 Single form (Antiphon), 1953. Boxwood, 81 *(206)*. Hepworth estate [*187*]
88 Phoenix, 1954. Yew, 36½ *(93)*. Private collection [*194*]
89 Oval sculpture (Delos), 1955. Scented guarea, L. 48 *(122)*. National Gallery of Wales, Cardiff [*201*]
90 Wood and strings (Solitary figure), 1952. Elm, 31½ *(80)*. Private collection [*178*]
91 Vertical form, 1955-56. Keruing, 35 *(89)*. Washington University, St Louis, USA [*207*]
92 Corinthos, 1954-55. Scented guarea (interior painted white), L. 42 *(106.5)*. Tate Gallery, London [*198*]
93 Curved form (Delphi), 1955. Scented guarea, 42 *(106.5)*. Ulster Museum, Belfast [*199*]

stone, 96 *(244)*. National Gallery of Canada, Ottawa [*295*]
134 Figure for landscape, 1960. Bronze, 103 *(261.5)*. Edition of seven. Exeter University; Barbara Hepworth Museum, St Ives; San Diego Society of Arts, USA; Stavanger Kunstforening, Norway; Hirshhorn Museum, Washington, USA [*287*]
135 Rock form (Porthcurno), 1964. Bronze, 96 *(244)*. Edition of six. Cornwall County Council; Mander Centre, Wolverhampton [*363*]
136 Sphere with inner form, 1963. Bronze, 40 *(101.5)*. Edition of seven. Rijksmuseum Kröller-Müller, Holland; Tate Gallery, London (Barbara Hepworth Museum, St Ives); Whitworth Art Gallery, Manchester; private collections [*333*]
137 Oval form (Trezion), 1962–63. Bronze, L. 57½ *(146)*. Edition of seven. The British Museum; Rijksmuseum Kröller-Müller, Holland; National Art Gallery, Wellington, New Zealand; Aberdeen Art Gallery and Industrial Museum; Abbot Hall Art Gallery, Kendal; University of California, Los Angeles; private collections [*304*]
138 Square forms with circles, 1963. Bronze, 102 *(259)*. Edition of six. Israel Museum, Jerusalem; Storm King Art Center, New York State; private collections [*326*]
139 Square forms, 1962. Bronze, *c.* 12 *(30.5)*. Edition of nine. Tate Gallery, London (Barbara Hepworth Museum, St Ives); private collections [*313*]
140 Rietveld Pavilion, Rijksmuseum Kröller-Müller, May 1965
141 Single form (September), 1961. Walnut, 31 *(78.5)*. Tate Gallery, London (Barbara Hepworth Museum, St Ives) [*312*]
142 Single form, 1962–63. Bronze, 21 ft *(640)*. Photographed against the Dag Hammarskjöld Memorial Library, United Nations, New York [*325*]
143 Three forms (Porthmeor), 1963. Alabaster, 10 *(25)*. Private collection
144 Night sky (Porthmeor), 1964. Oil and pencil, 28 × 23¾ *(71 × 60)*. Private collection
145 Three monoliths, 1964. Oil and pencil, 19 × 26 *(48 × 66)*. Private collection
146 Marble with colour (Crete), 1964. White marble, 54¼ *(138)*. Museum Boymansvan Beunengen, Rotterdam, Holland [*360*]
147 Construction I, 1965. Oil and pencil, 35 × 40 *(89 × 102)*. Private collection
148 Construction II, 1966. Oil and pencil, 40 × 35 *(102 × 89)*. Private collection
149 Forms in echelon on an orange ground, 1963. Oil and pencil, 18 × 22 *(46 × 56)*. Private collection

150 Genesis III, 1966. Oil and pencil, 30 × 40 *(76 × 102)*. Wakefield City Art Gallery
151 Sphere with colour (grey and white), 1965. Swedish green marble, 16 *(40.5)*. University of Michigan [*389*]
152 Two ancestral figures, 1965. Iroko wood, 49½ *(126)*. Private collection [*383*]
153 River form, 1965. American walnut, L. 74 *(188)*. Hepworth estate [*401*]
154 Two forms with white (Greek), 1963. Guarea wood, 37¼ *(95)*. Hepworth estate [*346*]
155 Two forms (two circles), 1963. Alabaster, 8¼ *(21)*. Private collection [*344*]
156 Two forms pierced, 1961–62. Alabaster, L. 11½ *(29)*. Private collection [*302*]
157 Figure (Merryn), 1962. Alabaster, 14 *(35.5)*. Private collection [*297*]
158 Small form (Amulet), 1960. Alabaster, 7½ *(19)*. Private collection [*282*]
159 Pierced form, 1963–64. Pentelicon white marble, 50 *(127)*. Tate Gallery, London [*350*]
160 Two figures (Menhirs), 1964. Slate, 30 *(76)*. Tate Gallery, London [*361*]
161 Two forms (Gemini II), 1966. Slate, 14⅛ *(36)*. Private collection [*412*]
162 Four rectangles with four oblique circles, 1966. Slate, 12 *(30.5)*. Private collection [*424*]
163 Three uprights with circles (Mykonos), 1966. Serravezza marble, 11⅜ *(29)*. Private collection [*413*]
164 Contrapuntal forms (Mycenae), 1965. Marble, 35 *(89)*. Museum of Fine Arts, Dallas, USA [*400*]
165 Vertical forms, 1965. Serravezza marble, 27 *(68.5)*. Private collection [*398*]
166 Three forms (Tokio), 1967. Polished bronze, 6⅝ *(17)*. Edition of nine. Private collections [*439*]
167 Marble rectangle with four circles, 1966. Serravezza marble, 33¼ *(84.5)*. Rijksmuseum Kröller-Müller, Holland [*421*]
168 Construction (Crucifixion), 1966. Bronze, 12 ft *(366)*. Edition of three. Salisbury Cathedral; Hepworth estate [*443*]
169 Sphere with inside and outside colour, 1967. Aluminium, 30 *(76)*. Edition of five [*444*]
170 Elegy III, 1966. Bronze, 51 *(129.5)*. Edition of six. Rijksmuseum Kröller-Müller, Holland; private collections [*429*]
171 Spring, 1966. Bronze, 30¼ *(77)*. Edition of six. **The Arts Council** of Great Britain; Hepworth estate (loan to Barbara Hepworth Museum, St Ives) [*430*]
172 Four-square (walk through), 1966. Bronze, 13 ft 11½ ins *(425)*. Edition of three. On

extended loan to Churchill College, Cambridge; Hepworth estate (loan to Barbara Hepworth Museum, St Ives); Harvard University, USA (loan) [433]

173 Three forms vertical (offering), 1967. White marble 91¾ (233). Private collection [452]

174 Three part vertical, 1971. White marble, 69 (175). Private collection [537]

175 Solitary form, 1971. White marble, 25½ (65). Hepworth estate [533]

176 Small one, two, three (vertical), 1975. White marble, 21¼ (54). Hepworth estate [579]

177 Rock face, 1973. Ancaster stone, 40½ (103). Tate Gallery, London [560]

178 The family of man, 1970. Bronze, 68 × 118 (173 × 300). Edition of two groups and four of each individual piece. First City Bank Corporation of Texas, Houston; Yorkshire Sculpture Park (extended loan from Hepworth estate) [513]

179 Two forms (divided circle), 1970. Bronze, 92 (234). Edition of six. Cleveland Museum, Ohio; Bolton Museum and Art Gallery; Greater London Council; Tate Gallery, London (Barbara Hepworth Museum, St Ives) [477]

180 Barbara Hepworth, 1972

181 Trewyn Studio, St Ives, 1959. (Now the Barbara Hepworth Museum)

Index

Italic figures refer to pages on which illustrations appear

215